抽象之眼
The Eye of Abstraction

2023.03.18-07.30

目錄

Contents

部長序

攝影技術的誕生，使我們得以在剎那間留存影像、留存回憶。攝影不僅具有紀錄的功能，亦是藝術創作的重要表現形式之一，既能述說生活、文化與歷史，亦能用來展現美學與概念。而隨著時代變遷、科學與技術的演進，與攝影相關的創意美學風格與鏡頭觀點也愈趨多元。當藝術家以獨具一格的取景視角，交互搭配不同的攝影技術、特殊材質與製作程序，更孕育出錯綜且精采的表現方式，並打開了我們觀看與理解世界的嶄新視野。

國家攝影文化中心本次推出「抽象之眼」展覽，在策展人精心擘劃下，引導觀眾從創作者角度出發，經由攝影家鏡頭慧眼下的不尋常「看」法，進入一向被我們所忽略、卻深具巧趣與寓意的影像世界中。而此展別具意義之處，則在於它以抽象美學為核心，呈現出臺灣攝影創作上對於抽象主題的感知與表現手法，讓觀賞者的視野不被外在物像所侷限，經由攝影家別出心裁的觀看之道進入影像，映照自身經歷，從而體會其間隱含的創作概念，並重新思考影像畫面建構與攝影裡層意涵。

國家攝影文化中心除典藏與保存臺灣珍貴攝影資產，自開館以來更策劃辦理多檔主題展覽，不只顯現臺灣多樣的攝影創作類型，同時帶領觀者以不同視野去認識與感受攝影。「抽象之眼」展鼓勵大家迎向一個新的攝影鑑賞方式，亦傳達出影像不僅是表達生活的載體、報導的敘事，也蘊含著創作者鏡頭下的詮釋與內心的話語。期許國家攝影文化中心能持續推介臺灣獨特且多元的影像藝術內涵，並以創新策展觀點與展覽呈現手法，為臺灣攝影藝術帶來更多激盪與發展的可能性。

文化部 部長

Minister's Foreword

The birth of photographic technologies has allowed us to capture an image in the moment. Photography not only bears the function of recording; it is also an important avenue for artistic creation. It can tell stories of life, culture, and history, and can be used to express aesthetics and concepts. Following the changing of the times, as well as the evolution of science and technology, the pertinent creative and aesthetic concepts as well as camera viewpoints have tended towards greater diversity. When the artist layers different photographic techniques, special materials, and production processes together using their unique perspective, this generates a complex and exciting mode of expression, opening a new horizon for us to view and understand the world.

In *The Eye of Abstraction*, an exhibition produced by the National Center of Photography and Images, the curator's meticulous organization leads the audience to take the perspective of the creator, entering those image-worlds that are often ignored, but are rich with wit and allegory, through the unconventional ways of 'looking' through the lens of the photographer. One meaningful aspect of this exhibition is the abstract aesthetics at its core, presenting the sensitivity to and expression of abstract themes in Taiwanese photographic creation, allowing the viewer's horizon to be uninhibited by external representations. Instead, the audience enters the image through the photographer's heartfelt way of looking, reflecting upon themselves, and from thence experiencing the creative concept hidden within, reconsidering the structure of the image and the meanings hidden within photography.

Aside from archiving and preserving Taiwan's precious photographic heritage, the National Center of Photography and Images has held and curated many themed exhibitions, not only to express Taiwan's diverse genres of photographic creation, but to also lead the viewer to know and feel photography through different perspectives. *The Eye of Abstraction* encourages everyone to move toward a new way of appreciating photography, communicating that images are not only vessels to express life, or carriers for a journalistic narrative, but also contains the interpretation and inner monologue of the creator. I sincerely hope the National Center can continually introduce Taiwan's unique and diverse contents of photographic art, bringing forth new possibilities for stimulation and development to the world of Taiwanese photography through groundbreaking curatorial concepts and exhibition methods.

Minister of the Ministry of Culture

館長序

攝影技術從類比演進至數位，影像藝術的創作手法與成像方式，在藝術家嘔心瀝血的創意巧思下，發展出多元且歧異的風格類型。儘管攝影的取景構圖、快門速度、曲線對比等因素都能影響最終的作品畫面，帶來不同的視覺感受，但賦予作品獨特美學風格的，除了拍攝者情感與概念的投注與表達，更在於他們透過鏡頭各具特色的攝影式的觀看之道。「抽象之眼」展特別邀請章光和教授策劃，除了聚焦於攝影家們對「美」別具隻眼的洞察力，同時鎖定臺灣攝影中的抽象式風格與表現方式，以別樣的策展觀點來挑戰人們對攝影的觀看習慣與認知，提供解譯攝影作品的不同視角。

「抽象之眼」展共集結了 25 位藝術家的精采作品，以 4 個主題來討論抽象攝影的類型，引導觀者以另類視角與觀點來重思眼前所見。「非象具象」中，生活中習以為常的物體，在鏡頭下透過快門捕捉、視角遠近交錯、光影錯綜等方式擷取，將熟悉的人與物，山谷與海洋等元素再次轉化。「理性與感性」將攝影作品與油畫及版畫作品並置展示，擴展光線、時間與色彩的維度，呈現虛實交錯的畫面感，凸顯創作者隱含的故事心境。「完形」則透過一連串對稱與鏡射的畫面，觸動人眼之於對稱形體的美感追求，驅使大腦於圖像進行直覺式的探索，在視覺中去感知並建構延伸、對稱、平衡或重複之美學。「物介質」之選件，玩轉材質與創造影像的方式，許多作品以數位手法轉譯，或將街巷風景掃描後變形重現，或以類比手法介入暗房沖洗過程，藥水與顯影劑在相紙與底片上流動，呈現捨去鏡頭後的影像創造的可能性。

本展提出 4 種影像呈現的抽象表現方式，意在引發觀者對於影像主體的思考，同時也以此來傳達創作者流動的意識與情感，揭示他們如何藉由攝影獨具的諸多形式特質，用抽象畫面來解構那些看似不足為奇、肉眼可見的景像，帶領觀者探討閱讀攝影的可能性。

國立臺灣美術館　館長

Director's Foreword

From analog to digital, the imaging modes and creative methods of photographic techniques have developed into ever diverse and multivarious styles and genres under the meticulous creativity and care of its artists. Composition, shutter speed, lines, and other factors can influence the final image of the work, bringing forth different visual effects. However, what gives the work its unique aesthetic style aside from the investment and expression of the photographer's conceptual affect has more to do with the artists' different and unique ways of photographic viewfinding. *The Eye of Abstraction* has specially invited professor Chang Kuang-Ho as curator. Aside from focusing on the observational prowess of the photographers, each with their own interpretation of beauty, the exhibit also locks in on the abstract styles and expressive methods of Taiwanese photography. Through differentiated curatorial viewpoints, it challenges viewers' habits and recognition towards photography, providing different perspectives with which to interpret photographic works.

The Eye of Abstraction brings together the exciting works of 25 artists, discussing the genres of abstract photography through 4 main themes, guiding the viewer to reflect on what they see with unique perspectives. In "Figurative and Non-Figurative", familiar objects in daily life are captured through the click of the shutter and the interplay of light and shadow, transforming anew familiar people and things, or elements such as valleys and oceans. "Sense and Sensibility" juxtaposes photographic works, oil paintings, and illustrations, expanding the latitudes of time and color, and presenting a visuality where real and fictional intermingle, highlighting the creator's story and state of mind. "Gestalt" stimulates the human eye's desire for formal balance through a series of proportional and refractive images. It forces the brain to conduct an intuitive exploration of the image, festablishing a perception of extention, parallelism, balance, or repetition in the visuals. The selection in "Material Mediums" plays with materials as well as methods of creating the image. Many works are re-interpreted using digital means, while street views change drastically after being scanned, and the analog method involves itself in the dark room process. As the developer solution runs along the photo paper and film, what arises are the possibilities of image creation after the lens has been done away with.

The exhibition proposes four abstract methods for the expression of an image, aiming to invite the viewer's reflection on the imaging subject. Simultaneously, it presents the creator's fluid consciousness and affects, revealing how they use abstract images to deconstruct mundane scenery visible to the naked eye through the many forms and aspects of photography, leading the viewer to explore the possibilities of reading photography.

Liao Zen-I

Director of the National Taiwan Museum of Fine Arts

策展論述

Curator's Statement

抽象之眼

章光和 / 本展策展人、世新大學圖文傳播系副教授

「藉由接收過往為繪畫所壟斷的寫實描繪任務，攝影開釋了繪畫使它
趨向偉大的現代主義神召——抽象。」[1]

——蘇珊・桑塔格（Susan Sontag）

蘇珊・桑塔格說：「在本質上，一張照片永遠無法像一幅畫一樣完全超越它的主題。同樣的，一張照片也永遠無法超越它的視覺本身——然而在某種意義上，這卻是現代繪畫的終極目標」。[2] 攝影發明後正反兩面評論當中最常被引用的一句話就是畫家德拉羅什（Paul Delaroche）所言：「從今以後，繪畫已死」[3]。繪畫並沒有死，也沒有消失，只是變得愈來愈不實用、愈看不懂、愈抽象。畫家畢卡索（Pablo Picasso）曾經告訴攝影家布拉賽（Brassaï）（布拉賽本來想當畫家）說：「攝影使得繪畫可以從所有文學敘述、奇聞軼事、甚至是繪畫的主題裡解脫」。[4] 繪畫超越了對於日常生活外在客觀的摹寫，而進入一個完全探討繪畫元素或觀念的主觀領域。從莫內（Claude Monet）的印象派，塞尚（Paul Cézanne）的後期印象派繪畫，畢卡索的立體派、達達主義、超現實主義，康丁斯基（Wassily Kandinsky）的抽象繪畫，杜象（Marcel Duchamp）的觀念藝術，一路下來繪畫藝術在攝影的逼迫下走出了自己的發展路線，不但在視覺理論、觀念與創作媒材的技巧上都有突破，而且結合了其他藝術做更多的發展。

繪畫進入一個可以完全集中焦點在顏色、線條、塊面、造型、筆觸、質感，甚至是行動觀念的互動領域。抽象的繪畫成立了，但是抽象的攝影應該是什麼呢？

看向車窗自身

我們發現觀看一張照片，裡面「題材的辨認」經常支配我們對它的理解。如果我們分辨不出照片裡的題材是什麼，我們甚至會懷疑這是一張照片嗎？羅蘭・巴特（Roland Barthes）認為「此曾在」（that-has-been）是攝影本質，他說：「我絕不能否認相片中有個東西曾在那兒，且以包含兩個相連結的立場，真實與過去。」[5] 這個真實與過去的本質是其它複製媒材所沒有的。他認為「攝影的指稱對象不同於其他任何複現系統的指稱對象」。此指稱對象就是被拍攝的客體，它「並不意指形象或符號所指示的可能為真的客體，而是指曾經置於鏡頭前，必然真實的物體，少了它便沒有相片」。[6] 所以我們看一張照片就是意識到照片裡有一個東西存在，這東西被攝影的復現能力所描述。

1. 蘇珊・桑塔格，《論攝影》，黃翰荻譯（臺北：唐山，1997），121。
2. 同上註，122。
3. Marina Vaizey, *The Artist as Photographer*, (New York: Holt, Rinehart and Winston,1982), 9.
4. Vaizey, *The Artist as Photographer*, 11.
5. 羅蘭・巴特，《明室》，許綺玲譯（臺北：台灣攝影工作室，1997），93。

羅蘭・巴特認為繪畫可以模仿一個真實景物畫出它的樣貌，而寫文章是由符號組成，這些符號的指稱對象（文章）也很可能是「不實在的空想」，但是照片不同，鏡頭之前總是需要一個「在」存在。由於如此的約束僅存在於攝影，所以他將其視為攝影的本質。所以如果沒有一個「在」呈現在照片中，我們幾乎不知要在照片裡看什麼。

羅蘭・巴特是從現象學方法去談觀看一張照片裡個人私密的情感，他認為「這樣一張張照片是無法與其指稱對象（所代表復現者）有所區別的，或至少不能馬上區分……」。[7] 就像是「車窗玻璃與窗外景物」，「慾望與其欲求對象」。他又說：「指稱對象緊貼著照片，由於這獨特的黏附性，若想調整目光對焦於攝影，便有極大困難」。[8] 也就是說，我們看照片是看向照片裡「在」的符號敘述，那如果這個「在」的符號敘述是抽象的呢？我會不會把窗外的景物焦點，調向車窗玻璃，看看車窗玻璃對我們產生什麼敘事呢？這個看向鏡中抽象的視覺呈現的可能性存在嗎？不是所有人都會以巴特的觀點看一張照片，但是將焦點從窗外調向車窗是我們從巴特那裡得到的啟發。

羅蘭・巴特談的攝影是以一個觀者（創作者、被拍者、觀者，三者之一）觀看一張充滿符號、人文生活的一般攝影照片，所以基本上沒有從創作者的角度出發，所以絕對會忽略創作者以攝影形式特質呈現的攝影。

蘇珊・桑塔格認為攝影風格中的「形式特質」──繪畫中的主要命題──在攝影中至多只居於次要地位，反而是照片裡拍的是「什麼東西」常常是最重要的。這意味著如果攝影在視覺上是不確定的，譬如，我們在太近或太遠的地方看著對象，失焦或是模糊不清的影像，我們不知怎樣對如此一張照片產生反應，除非我們知道它是這個世界的「什麼」片斷。[9] 也就是說在「形式特質」上，抽象式的攝影風格與內容是很難成立的，這其實牽涉到人們對於攝影的觀看習慣與認知問題。

攝影式的觀看之道

蘇珊・桑塔格說：「基本上攝影家被認為，應當不只是如世界本來的樣貌去顯示這個世界，應該透過新的視覺判斷，創造出激起興趣的力量。所以『攝影式的觀看活動』，意味著一種在『每個人都看到，卻把它視為太尋常之物以致忽略的東西』裡頭發現美的才能。」[10]，也因此發展出一種「視覺的英雄氣概」。攝影家不管付出多少代價，走遍千山萬水，尋找無人所見，等待千載難逢，耗盡洪荒之力量就為了以不尋常的「看」法，拍下一張大家忽略的周遭視覺。蘇珊・桑塔格說：「當一般的看的方式受到更進一步的擾亂──譬如對象被由它的環境孤立出來或被以抽象的方式處理──關於「什麼是美」的新的習慣便被捉住了。「什麼是美」變成只是「什麼是眼睛不能看見（或不曾看見的）」──那只有相機才能提供的斷裂的、破碎的、位置錯亂的景象。[11]

6. 同上註，93。
7. 同上註，15。
8. 同上註，16。
9. 桑塔格，《論攝影》，120。
10. 同上註，116。
11. 同上註，117。

美國攝影家保羅・史川德早在 1915 年以作品〈碗所組成的抽象圖案〉揭櫫一種新的現代主義攝影，接著整個 1920 年代，他從事的是特寫鏡頭的自然探討，因為鏡頭局部的特寫切割使得影像不易辨認，而有一種現代藝術抽象之美。對於另一個攝影大師愛德華・威斯頓（Edward Weston），桑塔格說：「1931 年愛德華・威斯頓所拍的〈甘藍菜葉〉看起來像聚集在一起的布所形成的瀑布，必得附上標題才能辨認出來。」[12] 兩位大師以攝影特殊的觀看方式開拓了新的視野，更發揚現代抽象藝術精神。

隨著時代的進步，桑塔格說：「通俗報刊的讀者們應邀隨著『我們的攝影家』參加『發現之旅』，拜訪像『從上往下看的世界』、『放大鏡下的世界』、『日常之美』、『人們不曾見過的宇宙』、『光的奇蹟』、『機械之美』等新的領域。也就是說當攝影大師們開發出新的視覺領域，也就引領人們更進一步認識新的視覺看法，就連通俗文化報刊也加入鼓勵的行列，連『從上往下看的世界』、『光的奇蹟』都有難得的美在裡面。」桑塔格說：「相機不僅使『藉由看的方式』（透過顯微攝影以及遠距離的偵查）更了解一件事物成為可能，它還改變『觀看』本身，因為它鼓勵『為看而看』的觀念。」[13] 為看而看，就在平日如常的一般事物裡看出一種巧趣，看出一種寓意，看出一種不是一般的視覺來。這樣的視覺文化流傳至今也快有百年之久，而人們也學會快速辨認出那相機才能提供的斷裂的、破碎的、位置錯亂的景象。精進再精進之餘攝影者必須一再提出更高深的英雄式觀看，才能挑戰觀者雷達偵探式的火眼金睛。

具象、非象、心象

時至今日攝影家直接拍攝一日常景物，清楚簡單但是不易辨認的實屬少見，因為人們看過成千上萬拍攝過的景物，再難辨認也不足為奇。但是像鐘順龍的〈星雨〉這樣具象卻又說不出這到底是什麼「景象」就會意趣橫生。這就是攝影本質上斷裂的、破碎的特性所造成的趣味。暗夜裡的雨滴在閃光燈照耀下晶瑩明亮，細雨在焦距外的移動與鏡頭逆光的光暈，製造了一種星際漫遊的氛圍。如果不是相機的拍攝，人的眼睛是看不見這樣神奇的景象的，難怪巴特從現象學角度一概不認同這些攝影者出奇玩弄相機的創意。相機在千百分之一的快門下凝結了人們經驗以外的視覺印象，流動的時序斷裂成一張張出奇的構圖，這就是攝影的魔術所展現的魅力。

相對於鐘順龍拍攝的小小雨滴，阮偉明的〈光之幽谷〉局部裁切壯大優美的地理景觀，也是直接展現攝影具象複製的能力，但是將光影、顏色、造型、明暗以外的寫實因素完全排除，而達到一種純粹的抽象趣味。這是相當難得的，日常生活視覺裡除非相當細小以至於我們忽略觀察，或是相當浩大壯觀全部的細節都融合消失，否則一般都難逃觀者一眼認出鏡頭裡的所「在」。溫暖的色光紋理，由黃橙轉紫變黑，光源神秘曲折，造型塊面感性層疊，我們迷失了鏡中的所在，進入純粹抽象意趣的欣賞，敞徉在〈光之幽谷〉中。攝影從發明以來與繪畫藝術互相模仿早已司空見慣。19 世紀攝影還未被認同之際，攝影的發明者爭相將攝影術依附在繪畫藝術之上，模仿繪畫題材內容。後來繪畫也模仿攝影鏡頭構圖甚至抄襲寫實照片。這種互相引入相關文化的正常發展成為一種上升螺旋，互相提攜進入更高的藝術殿堂。莊明景《老梅》系列作品利用水灘的反光映向紅潤天色，產生一種東方水墨情趣。尤其逆向天光，地面的沙石產生水墨

12. 同上註，119。
13. 同上註，120。

畫厚重渲染的黑色氣質，與大畫家朱德群的抽象畫有異曲同工之妙。應用地形地物天光雲影，再結合生活文化情感創作出一種視覺認同趣味實屬不易。繪畫與攝影融為一體在這裡看到明亮的曙光。

許淵富一系列 1960、1970 年代早期作品，其抽象的趣味其實隱藏在底片拍攝製作中，所產生高反差所引起的抽象趣味。傳統黑白攝影講究階調豐富變化，如此可以真實的複製現實情境，但是如果運用技巧去除中間豐富的階調，加大黑白的反差，視覺上就會抽象許多。因為黑白對比很大，非黑即白所以產生一種消去雜質去蕪存菁的抽象視覺。黑與白在畫面上成為一種「圖」與「地」的競爭關係，誰是「圖」是主角，誰是「地」是背景，於是我們的視覺在「圖」與「地」，「黑」與「白」，「實」與「虛」之間看見一個抽象的形塑，但是也試圖將抽象的圖形還原為現實的影像。而這個能力在視覺心理學裡就是完形心理學（Gestalt Psychology）裡的「圖地反轉」（Figure-ground organization）。一般觀者其實已經習慣可以解讀這般嫻熟手法的創意。但許淵富這一系列作品還是不愧為抽象攝影創作的一個經典。

相對於鐘順龍的「微細」、阮偉明的「宏偉」，林厚成運用的是「高遠」。黑白簡潔的構圖充滿抽象視覺的幻境，地平線推的老遠，如幻似夢。我們一時無法認清這個鏡頭前的「在」，一個又深又遠的鏡頭帶我們離開了一切現實，像是抽象但又有一種空間存在感，因為它既深又遠，運用高反差的明暗對比，消去了所有細節。找不到「在」，我們進入純粹幾何的構圖裡欣賞，卻又在偶然間出現人物存在。

秦凱的〈城市印象〉、〈歲月痕跡〉、〈出水芙蓉〉也是典型的攝影手法，運用局部放大、裁切超乎一般肉眼習慣性的觀看，在細節裡製造細節，讓我們在重複圖樣中迷失方向。以一個具象創作出另一個具象，具象非像。這樣的趣味永遠吸引著觀者與拍攝者的參與。

創作上運用同理心，將事物擬人化，美學上稱為「移情作用」。將屬於人類的思想感情與動作行為，轉移注入草木花鳥之中來從事創作。這似乎就會產生所謂的「心像攝影」。這一種攝影表現的藝術意涵是寄託於視覺元素之間的關係裡。最有名的作品當然就是美國攝影家史蒂格里茲（Alfred Stieglitz）拍攝的一系列雲彩作品他稱為《等同》（*Equivalents*）系列，[14] 而所謂的等同就是希望藉著雲影表現出自己內心心境。雲的造型變化不同，他企圖減少攝影影像裡對於事實的陳述，簡化事件的描寫，而強調光影構圖等等抽象的視覺元素。因為如果太過於具象的敘述外在世界（可惜偏偏攝影卻是最具有複製性與報導性），則觀者多半會注意影像表面的意義（雲像一隻兔子、獅子），也就是攝影的外延意義（denotation），那是影像符號的表象指示意（將雲彩的形狀看成某物來解讀），而忽略影像深層內涵的意義（connotation）。江思賢的《山》系列道出了這個心聲。他說「心開微光，雲居清澄，山隱於明境一般，離一切相」，他用一種快門「慢」的趣味，捕抓一絲無相的禪意。是不是山，像何等雲，其實都是看向攝影的外延意義，但是江思賢在這裡更希望觀者以一種總和內涵深層體會去欣賞這些影像所給出的意涵。

14. Edited by Michel Frizot, *A New History of Photography*, (Paris, Bordas, from the French edition), 662.

理性與感性的呼喚

「絕對主義」（Suprematism）是 20 世紀初俄羅斯抽象繪畫的主要流派由馬列維奇（Kazimir Malevich）在 1913 年創立。馬列維奇 1915 年創作〈黑方塊〉（*Black Square*）是在一張邊長 79.5 公分四方的白色畫布上畫了一逆光的黑色方塊。1918 年更發表〈白上之白〉（*White on White*）是一個漂浮擠壓在白色背景上的白色，象徵前衛科技的造型。絕對主義強調以純粹的感覺創作藝術，追求純粹幾何造型而不再描述現實世界的視覺。與其說馬列維奇的抽象畫是動腦的思考，它更是精神性的。[15]這次展覽特別安排了林壽宇的抽象畫〈而它來去匆匆〉，無意特別探討林壽宇的畫作內涵，但是從形式與精神上卻與絕對主義繪畫有大部分的相似性。林壽宇說：「白色是最平凡的顏色，也是最偉大的顏色；是最無的顏色，也是最有的顏色；是最崇高的顏色，也是最通俗的顏色；是最平靜的顏色，也是最哀傷的顏色。」馬列維奇從未來派（Futurism）追求前衛科技與速度的抽象視覺，建立絕對主義最高精神性的幾何繪畫，而林壽宇似乎略有探討幾何圖形間光影的問題。作品〈而它來去匆匆〉白色畫布上多層次的水平色帶表現出極簡的想法，繪畫可以探討的不再是生活的描述，而是白色條帶之間的空間感與光影的效果。蘇珊・桑塔格說：「在本質上，一張照片永遠無法像一幅畫一樣完全超越它的主題。同樣的，一張照片也永遠無法超越它的視覺本身——然而在某種意義上，這卻是現代繪畫的終極目標」。[16]我們舉林壽宇的作品做一個引證，對照於攝影創作，可以看到繪畫是如此的純粹，離開其描述的主題之後其創作領域依然如此寬廣。

相對於林壽宇作品具有理性水平與垂直的線條氣質，王攀元〈黑色的太陽〉顯得格外感性與風趣。兩個圓點一大一小在畫布的對角相望，遠看似有水墨暈染的層次，其實整張畫充滿筆觸力道。圓具有圓融的感覺，造型上像是眼睛、太陽、星球，一道頂在上緣的弧形像是山丘或是軌道。大小、明暗、黑白之間的引力互相牽引活潑了繪畫的描繪。

羅平和〈香格里拉蘭花島〉視覺上類似絕對主義作品，這是一張版畫作品。作者將當時設立蘭嶼核電廢料儲存場的省思以盲人點字的文字符號印在作品上。文字符號是任意的、武斷的，必須經過學習才能了解其意義，我們能看得懂任何文字符號是因為經過學習而來。羅平和〈香格里拉蘭花島〉作品上其實已經寫明作者對於核廢料這一件事的看法，這是作品要表達的內容，只是我們如果沒有學習過盲人點字那我們就看不懂作品裡真正的意義。我們想藉〈香格里拉蘭花島〉來談攝影符號的問題。攝影的影像是一種圖像符號（iconic sign），它和文字符號一樣是任意的、武斷的，必須經過學習才能了解其意義，這和以前人們認為攝影的圖像是不證自明的，是一種超越國界的訊息符碼正好相反。[17]攝影的影像和其他實體一樣，它的意義是依附在社會的定義之下。影像可以當成符號來做資訊意見的交換，來表達創作者的立場，但是必須在有限的範圍內意義才有可能出現。所以溝通其實是有支持某種預先的立場與傾向的，而任何照片的意義是需要在此立場的前後文脈（context）裡才會顯現。[18]羅平和〈香格里拉蘭花島〉在視覺上以抽象的形式展現，但其實它已經將人們不太容易一眼讀懂的影像轉譯成可以讀懂（如果學過盲人點字）的符號，這就像指揮家可以在樂譜的符號裡聽到波瀾壯闊的音樂一般。

15. Robert Atkins, *ART SPOKE* (New York: Abbeville Press, 1993), 202.

16. 桑塔格，《論攝影》，122。

17. Umberto Eco, Edited by Victor Burgin, "Critique of the Image", *Thinking Photography* (London: Macmillan Education Ltd, 1982), 32.

18. Allan Sekula, Edited by Victor Burgin, "On the Invention of Photographic Meaning", *Thinking Photography* (London: Macmillan Education Ltd, 1982), 84-87.

這一件作品不但挑戰了抽象視覺，它更揭示了攝影的圖像不是不證自明的這一件事。甚至羅蘭·巴特不認為攝影具有符號特質：「攝影不可分類，因為並無任何理由可以標明這一或那一情況。或許攝影也希望像個符號一般顯得肥壯、穩當而高貴，以求達到語言的尊嚴性。可是，要想有符號就需有標記，少了這一標記本原，相片只是沒有調和打勻的符號，變質了，像酸掉的牛奶。」[19] 具象的攝影不像文字符號可以精確傳達意義，它是變質的符號，那我們要如何解讀呢？

約翰·伯格（John Berger）在《攝影的異義》一書中談到一張照片會隱含很多看不見的意義。「照片的真正內容是看不見的，因為他源自於一場演出，但不是形式上的演出，而是時間的演出。可能有人會說攝影和音樂的關係就跟和繪畫一樣親近。我之前說過，照片見證了一項正在被執行的人類選擇。這項選擇不是在拍 X 或拍 Y 之間的選擇，而是在 X 時刻拍照或 Y 時刻拍照之間做選擇。記錄在任何照片（從最深刻有力到最平凡無奇）裡的物件，約莫都帶著同樣的重量，同樣的確信。差別在於強度，能夠讓我們察覺到『缺席』與『在場』這兩個極端的強度。在這兩個極端之間攝影找到了自身的適切意義。（攝影最普遍的用途就是用來紀念某個缺席）。」[20]

觀者常常看向照片中在場的東西，約翰·伯格說：「當一張照片記錄被看到的東西時，在本質上總是會指涉到那些沒有被看到的東西。他是從連續的時刻裡孤立、保留並呈現了某一瞬間。繪畫的力量取決於他的內部參照，繪畫對於畫面之外的自然世界的參照，從來不是直接的；繪畫處理的是自然界的對等物。或者，換個說法：繪畫詮釋世界，將世界轉譯成繪畫的語言，但攝影卻沒有自身的語言，學習閱讀攝影就和學習閱讀腳印或心電圖一樣。攝影處理的語言是事件的語言。它的所有參照都在自身外部，連續性由此而來。」[21] 約翰·伯格要說的是，每一張照片都有弦外之音，已經呈現的東西會召喚出它沒展現的東西。

牛俊強的作品〈邊界 -2〉探索宗教信仰與身體疾病間所存在的相互關係。照片中顯現的是一個耶穌基督的聖像，或是一個邪魔黑影端視觀者內心的認同。他認為疾病與死亡所帶來的恐懼是宗教信仰的邊界，這個模糊地帶以一張半透明的描圖紙表現的恰到好處，光明與黑暗的距離像是一層薄薄的信仰隔膜，需要突破，模糊不清。作品〈無題 -6〉企圖表現「神臨在的感受」，透明紙涵蓋的造型透過光影形塑，整個明亮的畫面帶來光線的觸覺感，有如一人體徜徉在聖光的照射下仰頭後傾享受一種神臨在的昇華感覺。

鄧博仁的《輕呼吸》系列試圖在都市叢林中尋找喘息的空間。粗獷的銀鹽粒子製造一種疏離模糊的感覺，不確定的方向，無目的的找尋，搖晃的鏡頭，扭曲的軀殼，似是逃避也像追尋，混亂模糊之間或許只要一個寧靜的輕呼吸可以拯救這失落的靈魂。

蔡昌吉的〈牆〉以三聯作的形式呈現一種抽象視覺思考的可能性。從左邊以一白色正方形居中要角，呈現極簡的抽象語意，居中顯大但是空而無物，以一種「空」展現其純粹極限的力量。空無是從四邊包圍而成，而四邊各有其不同的層次趣味，顯得更有看頭，但是這在視覺呈現上是一對互相倚賴的絕

19. 巴特，《明室》，16。
20. 伯格，《攝影的異義》，40。
21. 同上註，40。

配，「圖」與「地」，「無」與「有」，陰陽互生。進入中間一幅大膽採取上下對半黑白區隔的牆面，粗大簡約有如漂浮的北極冰山浮出心頭，委婉簡約的有如一抹微笑，相對於暗黑沈穩充滿細密剝紋的下半牆，白色的冰山是三聯作裡最溫暖的柔情色塊，比起左幅大白方塊這裡散發溫情。進入右邊一幅，整個抽象的結構再進一步分割成多個大小不等的水平區域。中間一豎直列反抗了平凡的安定感，有一種向上衝的力量，但卻也因為太居中又回到一種平衡感。現在唯一可以製造一些音樂的律動感的細節就是小小的長方塊，像是五線譜一般其上上下下的安排挑起一些浪漫的律動。如果我們同時觀賞這三聯作，我們體會到從堅硬霸氣的力量，轉入一種和煦婉約的情懷，再進入一種均衡跳耀的律動當中。有樂音，有舞蹈，有視覺的比例平衡，有結構、質感與細節變化相當精彩，真是饒富情趣的牆面。

江思賢的《海上星光》系列作品，「試圖在實景裡抽離元素，演繹出半夢半醒之幻影。藉由海岸搜尋標的與等待時機，或是介入畫面，利用海景天色、雲層風高、夜晚黎明、天際線的漁火，來營造出不同於一般視覺印象的影像。海上景象轉化光影幻境，畫面裏賦予隱藏著『我在』現場；時間動線融入空間，而讓『我』融入大海的浪聲風聲之中。」自述裡表現出詩意的畫面躍然紙上。海平面的清晨點點光明，希望的亮光終將降臨。但是如果我們純粹從感性的視覺閱讀它，暗黑的地平線上一點、兩點，漸漸的成排的光點迎面而來，背景音樂漸次隆隆作響，搖晃穿梭的飛船增添了一些科幻細節。是外星接觸的一刻嗎？地平線終於在雲光反照下現出星球的面貌，一線生機從黑暗中慢慢浮現。

1925 年德國包浩斯大師摩荷里・納基（László Moholy-Nagy）著作《繪畫、攝影、電影》（*Painting, Photography, Film*）一書，使得光線本身在 20 世紀的藝術創作中成為主體。對光線的明暗處理，納基以為「不再是輔助顯示物質的存在的媒介」而已；「它的目的是從最基本的視覺創造中，從直接的光線中產生圖像的空間」。他在暗房裡直接將實物放在相紙上曝光投影，製作「光畫」（Photogram）。「這種方式使得光的作曲成為可能，在這裡光線必須被至高無上的處理成一種新的創作方法，像繪畫裡的色彩和音樂裡的聲音一樣」。「在這裡真正的問題並不是一個客體，或者是一個感覺的表現，而是材料和形狀的量感、方向、位置和光線之間卓越的組織。因此出現一個新的真實」。[22] 藝術的精神性因子似乎並不再存在於摹寫充滿生命的外在，而是在於元素互為影響的關係裡。納基對於光線的新理論，不但將光線提昇為一個主體來表現其可能性，更是想藉此倡導一種新觀念與美學革命。

一樣是水影、光軌跡慢速快門的視覺表現，阮偉明的《夜航》系列更為簡約純粹，完全擺脫鏡頭前外在空間的敘事，進而讓光線成為主角展現出它的生命力與質量。人的眼睛無法留存光的軌跡，對於底片上慢慢累積的光線所造成煙火般燦爛的畫面，總覺得如夢一般的不可思議。《夜航》的創作精神有如納基以光線為主體的想法，將光的顏色當畫筆，或橫掃或抖動刷過畫面，色澤與細節變換各不相同。作者表現光線的內在空間時而如火焰般蕩紅激烈，時而清冷漫遊抖擻，時而霸氣橫掃千軍，時而靜穆的如一張古典油畫，完全將光線提升為視覺的主人翁。

林添福《煉石》詮釋臺灣北海岸地形，「繽紛的色彩，變幻莫測的紋理線條，組合成形象詭異的圖像，飛禽走獸、花鳥蟲魚、亦人亦物無所不像，而這種種，成了我鏡頭下《煉石》作畫的筆觸，我用鏡

22. László Moholy-Nagy , *Painting, Photography, Film*, Trans. by Janet Seligman (Cambridge, Massachusetts: The MIT Press, 1987), 32-37.

頭去描摹它們的筆鋒走勢，追隨自然的腳步」。臺灣北海岸地形的形成受到板塊擠壓，經過千百年的侵蝕，所以產生豐富的岩石紋理。像是一次次一層層塗了又抹，抹了又塗的油畫顏料堆疊出，層次分明色澤豐富，造型詭變的抽象油畫。

完形，一種「視覺場」的感知

1912 年德國心理學家馬科斯‧韋特墨（Max Wertheimer）首次對人們視覺「完形」（Gestalt）的心理作用了有系統的論述，誕生了「完形心理學」，其基本認為視覺元素的組織是所有心智的基本，這是與生俱來的，不假刻意學習的。他把視覺元素組織的因素名為知覺組織律。其包括：接近性（Law of proximity）、相似性（Law of similarity）、封閉性（Law of closure）、連續性（Law of continuity）、對稱性（Law of symmetry）與「圖地反轉」（Figure-ground organization）等相當有趣的視覺認知因素。19 世紀電磁學與重力場等物理領域因為大師林立所以成就顯著。物理學假設重力場、磁場內元素共鳴而凝聚在一起，馬科斯‧韋特墨受到此一理論影響，也認為人們知覺世界裡也存在有一「視覺場」。其認為人類對於任何視覺圖像的認知，是一種經過知覺系統組織後的形態與輪廓，而並非所有各自獨立部份的集合。例如我們看到一朵玫瑰花除了單純的形狀、顏色之外，我們之前對於玫瑰花的經驗與印象也都會加進我們對於它的感知裡面，形成一個整體的「場」的概念。

而完形心理學裡的視覺法則當中對稱性指出，人腦會在物體之間尋找中心點而將其形成對稱。將物體分成偶數個對稱的部分在感官上是令人愉悅，因此當兩個對稱元素未連接時，大腦會感知地連接它們以形成連貫的形狀。對稱對象之間的相似性增加了對象被分組以形成組合對稱對象的可能性。當我們一看到呂良遠《磐古》系列作品，我們就進入一個「視覺場」。要進行對於如此作品視覺的感知來解釋這一作品，最直接的我們感知一種對稱性的美。作品裡出現像岩石的質感，像蝶蛾的紋路，像蘭花的造型但是卻是什麼都不是。對於如此抽象的影像唯一合理的欣賞角度或許應該就是完形心理學視覺法則當中對稱性。對稱令人感官愉悅，對稱也是宇宙不變的道理。我們看到生物或動物的身體結構幾乎都是左右對稱，或是上下對稱。礦物植物結晶體或是花卉的形狀結構也都是以對稱的形式展開。甚至人們自己設計的剪刀、鑷子各種工具的形狀幾乎都是對稱的。可見此對稱視覺定律是與生俱來的，不用刻意學習的，我們愉悅於上下左右對稱的連續的視覺。

王艾斯《X-Y 建築立面》系列作品將龐然大物的地景建築局部做左右對稱的映射，產生一種像是生物造型的視覺。有的像貝殼，有的又後工業時代的機器，它像是隨時可以像生物一樣舞動起來。造物者以一種對稱平衡的方式呈現萬物的多樣性，不但可以利於運動，也方便防衛，物種對於此世界的反應留存在其基因當中，其隱藏著一種生存的美。但是不對稱的平衡感也不一定就是不美。

吳美琪的《YXX-The Flares》系列相較於前面呂良遠與王艾斯的作品，顯得不對稱又混亂許多。她將物件安排在一個充滿鏡射的空間當中，所以我們其實也可以感受到幾個歪斜的對稱軸心製造出搞怪的空間感，她聲稱是要印證愛因斯坦相對論裡空間的弔詭，可以被壓縮與扭曲。姑且不論愛因斯坦相對論裡的空間真實感如何，但是這裡作品扭曲與反射的景象的確看到完形的視覺法則。作品〈YXX-The Flares #6〉不對稱又破碎的平衡裡我們找到相似性的元素，就是吸管與吸盤。在背景相似材質之下我

們借由吸管與吸盤企圖定位這空間，但是因為太破碎，我們似乎只能在畫面中軸線找到左右平衡的對稱感。作品〈YXX-The Flares #10〉其相似性元素出現在塑膠管與花花綠綠的背景，我們無法透過封閉性來體現這一個空間，只能說一切在混亂當中有了平衡，而其空間扭曲壓縮似有些許相對論的趣味。

章光和 1994 年作品《植物誌一》，就以電腦影像處理方式產生一種四方連續圖案當成《植物誌一》作品的背景。這種對稱又連續的圖樣像花布壁紙一般，具有一種機械重複性，產生一種大量生產且單調庸俗的視覺趣味。它呼應了工業現代化之後電腦時代進一步產製了沒有「靈光」的虛擬視覺。高科技的電腦處理技術如萬花筒一般將影像切碎，然後上下左右對稱拼接出千變萬化的圖樣，他稱之為《植物誌 0.5》系列。其作品的解析度非常高，細節質感清晰可見，我們好奇這是什麼東西的「在」的存在，但是最後我們依然被完形心理學的視覺趣味所吸引。對稱的垂直中軸顯得莊嚴肅穆，而傾斜的對稱軸打破了機械的重複性而活潑起來。每一作品的個別細節也都因為對稱性而產生相似性的物件，而它們的造型顏色大小相似又產生另一愉悅的解讀。另外《植物誌 0.5》系列也有裝置作品。以鏡面將四方連續的影像做上下左右的無限延伸，反射影像的反射而形成一種無底無極限的視覺重複。觀者可以進入此裝置作品中，在此鏡射影像的鏡射空間裡一切的數學運算答案都是無極限的，它超越了我們的身體感知，而有一種迷失的效果。

物介質──材料物體系抽象之美

如果我們將攝影也視同一種創作媒介，就像是油畫顏料與畫布那樣，那麼我們會看到攝影的整個材料物體系。而這個材料的物體系它是隨著攝影發展的進化而一直在改變的。最簡單的體系分類就是傳統銀鹽攝影與數位攝影。而傳統攝影材料又分為黑白與彩色底片，正片、負片，黑白與彩色相紙。如果要加上成像的技巧所產生效果，那就要加上黑白與彩色暗房的相洗技巧與藥水。光是傳統攝影的成像運用材料與技巧交叉組合就變化多端，最簡單的例子就是將彩色負片當正片去洗相。當然這樣會得到一些詭異的結果而不是正常的照片，這正是研究攝影材料的物體系所要的結果。進入數位攝影時代也依然可以因為螢幕呈現、網路傳輸、軟體應用、印表輸出等而產生各式稀奇古怪的視覺作品。

陳春祿《開天》系列作品視覺上有如宇宙星雲華麗變幻。取名「開天」應是其效果有如盤古開天一般混沌初開幻化形成宇宙。作品中偶有出現佛像隱約成形於抽象彩色迷濛之間，那是因為作者將拍攝的佛像彩色正片浸泡於藥水之中，不正常的酸鹼侵蝕造就了藥膜面起化學變化，脫落位移，因此正常的成像受到破壞而有如此不尋常的抽象效果。這種巧合相當有趣，攝影本身無從拍攝到這種效果，而在數位時代之前，這種「類比」效果的控制確是成為一種另類的攝影技巧延伸。有志之士奮力開發各種底片塗抹藥水，破壞藥膜的技巧，可以局部控制，局部刮擦效果更是神奇，為的就是要改變顏色造型等因素，創造一種神奇畫面。但是一進入數位時代，這一切似乎顯得多餘。經過數位化的影像要修改顏色、明暗、造型、塗抹繪畫都已經是小事一椿，視覺效果不再是王道，作品要表現的意涵才是重點。所以如何評估一件具效果的作品，應該還是回到這個效果是否剛好貼切於作者的創意初衷。這裡《開天》系列作品寓意恰到好處。

張博傑〈時間顯影〉試圖將銀鹽攝影本質上的材料特性表現在一種與遠方友人互動的實驗上，結果饒富意涵。他將友人拍攝寄給他的底片埋藏於地下一年，然後取出來沖洗。結果長久浸淫在陰溼環境的底片因為發霉而長出有如植物樹枝造型的黴菌，造型趣味上也可以體會成海裡的珊瑚。影像似乎已經消失不可見，但是樹枝狀（珊瑚狀）的黴菌卻在四件連作中展現不同的構圖型態。我們看到有如夜間望向混濁星空的詩意，也渙散著一種陰鬱窒息的霉味，這是作者透過這樣一次互動的實驗所產生的人際隱喻嗎？爬滿菌絲發霉的人際關係？膠著缺氧瀕臨滅絕的（珊瑚）人際環境？我們再一次看到攝影材料在後現代創作形式中所表現的抽象意涵其實是相當豐富多樣。

傳統底片是一種「類比」訊息，透過顯微鏡高倍數的放大，肉眼可以看到其實銀鹽結晶顯影過後，並非如我們想像造型如一顆一顆無機結構的晶體，其實它更像植物根部交錯扭曲的有機結構。[23] 也就是說銀鹽攝影的基本單位還是相當感性的，每一個單位元素之間存在著模糊的邊緣。但是數位影像有如數位音樂一樣，以 0101 清楚單位元素來表現，所更清晰更歷歷在目。科技進步，人們追求更精準、更確定、更理性的數位科技發展是不可逆的，但是對於從事攝影沖印工作幾十年的李國民來說卻是有一種捨不得的情感。李國民收集底片片頭成痴，〈一痴三十年〉就是以彩色正片材料製造的效果來回應這一種關係。李國民在底片沖片後剩下無用的片頭裡看到「美」。有如美國抽象表現主義大師馬克・羅斯科（Mark Rothko）上下分段的抽象構圖，他將底片片頭的美呈現出來。雖說片頭是攝影材料的一小部分，但是透過他攝影英雄式的觀看，卻是看到藝術世界抽象表現的極致之美，一種沒有攝影「在」的存在美。這裡完全沒有鏡頭、對焦、景物，有的是底片過度曝光的邊際領域。片頭是一捲底片被拖出開拍的開場白，它完全無關緊要，有時為了保險還必須多浪費一些片頭。但是因為不同廠牌、型號、漏光情況、藥水等因素，每一次片頭產生的「美」就都會不一樣。太有意思了，但這也必須癡狂三十年才做得到吧！

相對於「類比」影像的感性訊號有一種朦朧美，「數位」影像如果極致的放大，我們會看到一格一格的色塊，每一個格子就像一個清晰的結晶體，其數位內容（每一格）記載著色相、明度、彩度。一張影像格子越多，影像的解析度越大，影像越清晰，整個檔案也就越大。影像的解析度影響檔案的大小，更影響電腦處理的速度，有時甚至會因為處理不來而當機，如此電腦進入呆滯或是無作用狀態。宇中怡〈當機時刻〉就是針對於數位時代電腦當機的回應。八張聯作看似東方山水畫的構圖，再仔細看，發現像是用同一個筆頭拖曳繪畫而成。數位時代我們早期接觸電腦總會碰到電腦中毒或是不聽話當機失效的時刻，此時可能全癱，也可能游標還行。宇中怡面對這個尷尬時刻，可能滑鼠的游標變成一長條色塊，隨著手的滑動製造出莫名其妙無鏡頭的畫面。擺脫不掉的游標筆頭，索性塗塗抹抹完成一幅一幅有趣的抽象畫自嘲。這件作品完全針對於數位影像硬體與軟體媒介因素上的特性做出了有趣的回應。

在暗房裡，相紙曝光之後在相紙上就會有一個潛像（肉眼看不見），潛像碰到顯影液就會顯影成像，之後必須定影才能成形，如果沒有定影在光線下，終將變成一團黑。如果打亂了這些材料與步驟，那就會有很多超乎潛像的影像會產生。章光和 1987 年開始創作《博物館》系列作品，以大型壁畫相紙曝光紐約自然歷史博物館拍攝的標本影像，進行繪畫般的顯影效果。以海綿沾著顯影液在大相紙上刷出影

23. Editors of Time-Life Books, *The Print: Life Library of Photography* (New York: Time Inc., 1970), 66.

像，如繪畫一般也可以加多一點水份做渲染效果。不想要潛像顯現就先施加定影。每一張作品都是獨版，因為每一次在漆黑的暗房如繪畫般的不確定施作，作品都會不同，但是很多作品都是同一張底片做不同的洗相而成。當時留存了一捲 40 英吋乘 30 英尺的捲筒壁畫相紙，2020 年想進入一個了結的時間點，好奇相紙不知有無過期，這就是《博物館水墨》系列的由來。老靈魂、老相紙、老底片、老手法。暗房進行中，一切的期待都因時間而改變，三十年的老相紙無法感應投影機照射過來的底片內容，潛像若有似無，博物館裡櫥櫃的遠古生物隱匿無蹤，隱約意識到的是時間的歷史痕跡，自己對於這三十年來叛逆洗相手法的回憶。而就在這一刻心想何不讓藥水與相紙回歸自我，展現材料物本質的原始趣味。在盡情的揮灑顯影液當中，依然看到藥水、相紙、中途曝光之間妙趣橫生的一面。其實原本《博物館》系列作品裡面所大量應用的藥水塗抹、洗刷、渲染的筆觸，就是在對美國抽象表現主義繪畫致敬。這裡更是拿掉了影像而純粹的留下抽象表現的想法。

直接讓顯影液與相紙共同婆娑起舞來創作實屬少見，但是陳彥呈的〈泉〉就是這樣。陳彥呈似乎了解作品最終成形的樣態，有如傳統國畫當眾揮毫，藥水直接傾流而下，一次成型，像是目睹一朵水墨荷花綻開眼前，當然實驗性質的因素應該也不可免，創意與創作總在未定之間。三聯作視覺上有如歌德教堂裡的高聳的花窗照射進來的聖光，層層疊疊綿延不絕。進入畫面像是在暗處找到片刻的沈靜，在亮光裡得到心靈的洗滌。三角形的結構搭起堅實的紋理，如寶石般的堅定，又如瀑布般奔流而下的豪邁。顯影液沖灌在相紙的動作，有如行為藝術一般。奔流而下的藥液馬上與明室下曝光的相紙產生顯影的效果。沒有鏡頭，沒有鏡頭前的「在」，這裡從攝影材料介質本身出發，創作者製造的「在」就是藥水奔流痕跡的片刻。這片刻包含作者對於父親（名字裡的「泉」）的懷念，寓意一種綿延傳承淵遠流長的感覺。

1921 年超現實主義大師曼・雷（Man Ray）以實物投影方式直接將小物品放在相紙上做曝光顯影，打破了沈悶的傳統紀實攝影框架。當然這種無相機的攝影早在攝影剛發明之時就有了。抽象繪畫在 20 世紀初剛剛崛起，這種既抽象又超現實的攝影影像在當時更顯前衛。一次曼・雷在暗房洗照片之際，無意間開燈照射了顯影中的照片，使得原來沒有曝光的部位突然過度曝光，而造成正負反像，而產生了一種「中途曝光」（Solarisation）的效果。這種正像負像交織的趣味很符合超現實的想法，也成為曼・雷特殊的藝術風格。許淵富的〈幻想樂〉與〈吹木笛者〉也是以同樣手法表現而成，只是許淵富的技法更為複雜，他可能運用多次底片翻製重疊洗相才達成如此神秘的視覺趣味。〈吹木笛者〉視覺上有如一股青煙裊裊蜿蜒律動而上，大大小小的區塊形成一位樂師的臉龐，帶來音樂的曼妙感。〈幻想樂〉進入純粹造型視覺，有如一個迷幻的曼陀羅，一股磁鐵的吸力由中央向四面伸展磁性，像是轉動音樂的迷幻視覺圖騰，我們陶醉在這個視覺曼陀羅的對稱與旋轉當中。

傅拉瑟（Vilém Flusser）在其《攝影的哲學思考》（*Towards a Philosophy of Photography*）一書中對於文字書寫與影像「再現」的精闢討論表示，影像主客體易位地以自身取代世界而非將世界呈現給人類。

傅拉瑟認為技術性圖像（由機具製作出來的圖像，例如攝影）不易解讀，因為人們視其為理所當然而以為不需解讀，它們的意義似乎已經自動浮現在影像的表面。技術性圖像不同於手工的影像，它自動複製量產，改變了人們對於影像的感知方式。影像似乎和影像的意義存在於同一真實層面上，所以技

術性圖像揭示的不再是需要解讀的符號（symbols），而是指陳著世界的徵兆（symptoms）。技術性圖像這種明顯的非符號性，使的觀眾在觀看影像時失去對它的察覺，不把它當成影像而是看向世界的一扇窗。人們信任技術性圖像，就像他們信任自己的眼睛一樣。他們所批評的不是圖像，而是評論其視野（vision），評論「透過圖像所看到」的世界。[24] 這點巴特在《明室》中也認為，攝影永遠懷著它的指稱對象，彼此相黏，有如欲望與其欲求對象，有如車窗玻璃與窗外的景象，由於這個獨特的黏附性，想要調整目光對焦於攝影上，分辨出指稱對象與照片，就會有困難。[25] 傅拉瑟認為圖像是居於人與世界之間的中介物。人「存在」意即他與世界之間沒有直接的橋樑。圖像是用來將世界引介成為人們可以觸及和可以想像的東西；圖像將世界引介給人們，但它仍然將自己橫亙在人與世界之間，這意味著圖像破壞人與真實世界的「存在」關係。圖像原本應該是描繪與指引世界的地圖，如今卻變成為銀幕，它不但沒有將世界呈現給人們，反而以自身取代世界而作一次重新的呈現（re-present）。這種圖像破壞人「存在」的程度，最後使得人不再解讀圖像，而是將未經解讀的圖像再往「外在」世界投射。世界變成類似圖像的東西，成為場景和情境的關係，而人活著是為了配合他製作的圖像。[26]

賴珮瑜引用卡爾維諾（Italo Calvino）所撰寫的《看不見的城市》（Invisible Cities），自述 2005 年的《●Word》作品說：「旅人馬可波羅不斷地向忽必烈敘述他旅行的經歷，馬可波羅的語言敘述就像是對城市的語言轉譯，穿越了時間與空間、過去與現代，坐在宮殿裡聆聽的忽必烈，則藉由語言構成了一張馳騁想像的地圖，那投射性的、看不見實體的城市，卻經由想像遊走於異地的時空，城市在忽必烈的腦海中形成了一種多層次的真實」。語言轉譯世界透過想像腦海裡的城市層次豐富許多，但是攝影機械式的複製世界，卻是製造一個人與世界之間的帷幕，更真實一點的說法就像即將到來的虛擬實境（3D Virtual Reality），我們捨棄真實世界而沈溺於虛擬假象。這一點是後現代藝術理論批評的共識。

賴珮瑜的《●Word》作品似乎也在探討這個問題。「在作品中●的出現，就尤如城市的語言轉譯與再次閱讀，而真實何在與符號的轉載則是吸引我創作的主要動機。在作品裡，所有城市招牌上的文字被●所隱含著，文明膨脹的脫序感使作品中的●不斷流變著。」城市裡商業起起伏伏，店面開開關關，高樓大廈此起彼落，繁榮沒落榮枯有時。但是人「在單一的平面空間裡，卻承載與相鄰著不同的多重空間，符號在瞬時的語意被城市的壓縮感所炫惑，而身體感卻在無人的多重空間裡穿透、遊走、超越單一空間懸浮」。

閃爍的燈號、閃爍的文字建構起龐大的消費文明，人們迷失在這樣的一個都市叢林裡。走透全世界超級大都市，這樣的消費文明似乎都一樣，她將其稱為「原鄉」的所在。

賴珮瑜運用數位影像技巧將一個個的圓點安排在每一個商業招牌的文字上。依照前後透視所產生的大小文字，就轉譯成大大小小的圓點。此時去除影像剩下的轉譯圓點呈現的就是「原鄉」的所在。像是一種充滿科技感、現代感、井然有序的結構佈局。圓點帶有一種親和力與安全感，其所形成的千變萬化的「原鄉」一點都不孤寂，這一片燈海力抗透黑的背景所傳來的空無。空無有如黑洞，但是招牌的

24. 維蘭·傅拉瑟，《攝影的哲學思考》，李文吉譯（臺北：遠流，1994），頁 35-36。
25. Roland Barthes, Trans. By R. Howard, *Camera Lucida* (New York: Farrar, Straus and Giroux, 1981), 6.
26. 傅拉瑟，《攝影的哲學思考》，30-31。

圓點卻是星光一般，組成一個多層次的城市形塑。如果沒有數位向量繪圖軟體與技術，類似作品應該很難完成。

實物投影將物品直接放置在感光的材料上做沒有相機的攝影，其實是最原始最具突破性的攝影創意。攝影剛剛發明時就有「光畫」（Photogram），1921 年超現實主義攝影大師曼・雷（Man Ray）創作《Rayograph》，1925 年納基創作光畫，如今你趴在影印機上也可以被掃描成像出一張人體投影。我們仔細思考廣義的攝影的原理，會發現影像是靠「成像物」與「成像源」合作而完成。例如底片或相紙是「成像物」它是最終成像的物品，而實物或光是「成像源」它是被表現出來的源頭。一個會感受光線的「成像物」接受「成像源」的訊號而形成影像。氣象局透過雷達收集溫度、氣壓、濕度這些東西都不是光線，但是可以製作出相應的氣象影像。其實光線本身也只是一種「波」的形式，我們眼睛看不見的「波」太多了，紫外光、X 光、Gamma 射線都比光波短，而紅外線、微波、雷達則比光波長。所以科學家可以利用宇宙傳來的各式各樣的光「波」射線來型塑宇宙起源，來探討空間與時間。因此基本上如果我們將攝影定義成，有一種「波」穿透底片投射在相紙上，那幾乎所有東西都是底片。因為不論是反色稿或是透色稿只要可以被收集它身上的「波」就可以被成像，製造出一張照片。而這個概念已經將我們這個「物介質」的抽象攝影概念推進到最極致了。

洪譽豪《非虛構》系列作品是使用「攝影測量法」，擷取實景的立體環境，使用「點雲」資料運算再製。這系列是拍攝自臺北市中山北路條通附近的巷弄與招牌，使街道的線條彎曲並構築像漩渦的圖像，是作條通在燈紅酒綠下吸引人的想像。

結語，抽象攝影解構的可能

超越主題，回歸視覺，對於攝影藝術來說是一件難事。「抽象之眼」集結了二十多位藝術家的作品，整理出「非象具象」、「理性與感性」、「完形」、「物介質」四個單元，提出合理解構抽象攝影藝術的可能性。這個策展命題意思是攝影之鏡（鏡頭、鏡子）中不只有紀實的敘事、報導的寫實、生活的寫照，也存在著一種攝影者自己或呢喃或咆哮的視覺表達。它引導我們迎向一個新的看的領域。「抽象之眼」潛藏著一種自我暗示，自我覺醒的提示。標示著觀者以一種創作者表現抽象視覺之眼的獨特眼光去欣賞，去了解這一次展出的作品。蘇珊・桑塔格說：「攝影一面教導我們一種新的視覺符碼，一面改變並擴大我們對於『什麼是值得我們仔細看的』或是『什麼是我們有權利去觀察的』這類理念。它們是一種『看』的文法，甚至更重要的是一種『看』的倫理。」[27]

整個策展絕大部分都是相當抽象的攝影作品，雖說沒有太大爭議的攝影「看」的倫理問題，但是卻大大地強調了攝影「看」的文法問題。想要從「非象具象」、「理性與感性」、「完形」、「物介質」四個命題當中揭示出抽象攝影的「看」的文法。引導觀眾以一種另類的抽象之眼來觀看攝影，以期建立大家對抽象攝影的可讀性與愉悅性有更近一步的體會。

27. 桑塔格，《論攝影》，1。

The Eye of Abstraction

CHANG Kuang-Ho / Curator of the exhibition,
Associate Professor, Dep. of Graphic Communication, Hsih Hsin University

"By taking over the task of realistic picturing hitherto monopolized by painting,
photography freed painting for its great modernist vocationist abstraction"[1]

—*On Photography*, Susan Sontag

"For it is in the nature of a photograph that it can never entirely transcend its subject, as a painting can. Nor can a photograph ever transcend the visual itself, which is in some sense the ultimate aim of modernist painting."[2] The invention of photography had generated both positive and negative comments, and the most frequently quoted comment was Paul Delaroche's "Painting is dead." But painting did not die or disappear at all, just became less functional, harder to understand, and more and more abstract. Pablo Picasso once told photographer Brassaï who had wanted to be a painter that "photography has arrived at the point where it is capable of liberating painting from all literature, from the anecdote, and even from the subject".[3] Painting has gone beyond the objective imitation of commonplace things and become issues of subjective elements and ideas. Impressionist artist Claude Monet, post-impressionist artist Paul Cezanne, cubist artist Pablo Picasso, abstract artist Wassily Kandinsky, and conceptual artist Marcel Duchamp, among other artists of Dadaism and Surrealism, developed new theories, ideas, materials and techniques of painting, as well as combining it with other genres all while photography was thriving.

Painting began to focus on colors, lines, chunks, forms, strokes, and texture, or it became conceptual actions and interactive with the audience. Abstract painting had been established, how about abstract photography?

Looking Toward the Windowpane

When we are looking at a photo, identifying what is in it usually is our major concern. If we fail to recognize its theme, would we then begin to wonder if it is a photograph at all?. Roland Barthes contended that the nature of photography was that-has-been, "...in Photography I can never deny that the thing has been there. There is a superimposition here: of reality and of the past."[4] The photographic duplicates of reality or the past is unique in terms of its medium. "... photography's referent is not the same as any other referent of any other system of representation."[5] The referent mentioned is the object photographed, it is "...not the optionally real thing to which an image or a sign refers but the necessarily real thing which has been placed before the lens, without which there would be no photograph."[6] Thus we sense the objects in a photo, the object is depicted by the photography's capacity of representation.

1. Susan Sontag, *On Photography* (New York: Rosetta Books, 2005 version), 72.
2. Ibid, 73.
3. James R. Mellow, "Art", *New York Times*, 17 Dec., 1972.
4. Roland Barthes, *Camera Lucida: Reflections on Photography*, Trans. by Richard Howard (New York: Hill & Wang, 1981), 76.
5. Ibid, 76.
6. Ibid, 76.

Barthes believed that painting simulates a real scene, and an article composed by signs and their referent (article) could be "impractical fantasy". On the contrary, a photograph needs a real existence in front of the lens. Such a condition is only for photography, thus Barthes took it as the essence of photography and if there is nothing existing in the photo, we wouldn't know what to look at.

With phenomenology, Roland Barthes discussed the personal affection in a photograph and thought, "A specific photograph, in effect, is never distinguished from its referent (from what it represents), or at least it is not immediately or generally distinguished from its referent...",[7] like "the windowpane and the landscape", or "desire and its object". Barthes further pointed out, "In short, the referent adheres. And this singular adherence makes it very difficult to focus on photography".[8] In other words, when we look at a photo, we are looking at the narrative of the signs "being" in the photo. What if the signs of "being" are abstract? Would we zoom out to the window and see what the window glass is narrating? Is it possible to look at the abstract visual presentation in the mirror? Not everyone looks at photos with the perspective of Barthes, but we are inspired by Barthes to zoom out from the scene outside to the window.

Barthes discussed photography from the perspective of a viewer (compared to the roles of the creator or the figure being photographed) who looks at a photo full of signs or a photo of ordinary life. He did not take the angle of the author and inevitably would overlook the nature of photography presented by the authors.

Sontag thought the "formal qualities of style—the central issue in painting—are, at most, of secondary importance in photography, while what a photograph is of is always of primary importance."[9] It means in the case that the visuality in photography is certain sure, like if we see things from too far away or too close, unfocused or blurred, we don't know how to respond to it, unless we are aware that each photograph is a piece of the world. In other words, it is very difficult to define the styles and contents of abstract photography in terms of formal qualities because it involves the viewer's perception and habits.

Photographic Seeing

According to Susan Sontag, photographers are not only representing the world as the world appears, but should stimulate interests with new visual judgment. Thus "photographic seeing" means to discover beauty that "everybody sees but neglects as too ordinary."[10] It also results in a heroism, for photographers overcome many obstacles, travel extensively, seek unseen things, wait for unusual opportunities and consume all their energy to provide extraordinary "seeing" that allows the audience to ignore the surroundings. "When ordinary seeing was further violated—and the object isolated from its surroundings, rendering it abstract—new conventions about what was beautiful took hold. What is beautiful became just what the eye can't (or doesn't) see: that fracturing, dislocating vision that only the camera supplies."[11]

American photographer Paul Strand's 1915 work *Abstract Patterns Made by Bowls* kicked off a new genre of modernist photography, followed by his pursuit of natural images with close-ups throughout the 1920s. The close-ups of partial objects made images hard to identify, but presented the beauty of modern abstract art. And

7. Ibid, 5.
8. Ibid, 6.
9. Sontag, *On Photography*, 71.
10. Ibid, 69.
11. Ibid, 70.

regarding American photographer Edward Weston, Susan Sontag described his *Cabbage Leaf* in 1931 "looking like a fall of gathered cloth, the audience wouldn't identify it without knowing the title."[12] The two photographers have broadened perspectives by using unusual ways of seeing and carried forward essential properties of modern abstract art.

Susan Sontag observed that readers of the popular press were invited to join "our photographer" on a "journey of discovery," visiting such new realms as "the world from above," "the world under the magnifying glass," "the beauties of every day," "the unseen universe," "the miracle of light," or "the beauty of machines," among other new perspectives created by eminent photographers. They led the public into new ways of seeing, including the publishers of popular press. There is precious beauty to be found even from gimmicks like "the world from above" or "the miracle of light". Sontag pointed out that "cameras did not simply make it possible to apprehend more by seeing (through microphotography and teledetection). They changed seeing itself, by fostering the idea of seeing for seeing's sake."[13] Seeing for seeing's sake is to discover interests, implications or visions beyond ordinary things. Such visuality has been developed for nearly one hundred years and people have learned how to quickly identify the broken, fragmental and misplaced images. Therefore accomplished photographers must keep proposing profound and heroic ways of seeing in order to challenge the trained and detective-like eyes of the viewers.

Figurative, Non-figurative, and Mindscape

Today's photographers are shooting commonplace things and scenes because the audience has seen all kinds of images, there are very few things that are so rare people couldn't identify. But Chung Soon-Long's *Stardust* series is especially intriguing with its figurative but indescribable images. It is an example of the fascination generated by broken and fragmental pieces. Raindrops crystalized by flashing light in the dark of night, and auras created by moving and unfocused lenses in drizzle produce an ambiance of space odyssey. Without cameras, such a marvelous scene can't be seen by our naked eyes. It was the reason why Roland Barthes, from the phenomenological perspective, did not agree with the inventive operation of cameras. The images captured by 1/1000 shutter speed provide people with unusual experiences through the marvelous compositions of flowing images in disconnected timeframes; it is the charm of photography.

Contrast to Chung Soon-Long's tiny raindrops, Yuan Wei-Ming's *Cave Light* crops a magnificent geological scenery that powerfully demonstrates photography's capacity to represent figurative images. It excludes realistic elements and addresses only light, shadow, form, and tone to present pure abstraction. It is precious because we won't experience the "being" captured by the lenses when the themes are so trivial in our everyday life, or too grand for us to see the details. Within the warm light beams turning from yellow or orange to purple or black by mysterious illumination are layers of chunks stimulating the audience's sensibility. We are lost in the mirror but are absorbed by the pure enjoyment of abstraction laid out under the *Cave Light*.

The mutual imitation of photography and painting began once photography was invented and became very common. In the 19th century, before photography was recognized as art, photography creators were eager to attach photographic techniques to painting or imitate the contents of painting. Later painting also imitated pictures framed by lenses, even duplicated photos. Such a mutuality drives the two arts spiraling upward and reaching a higher status of artistry. Mike Chuang's series work *Lao-Mei* presents a taste of eastern ink painting

12. Ibid, 71.
13. Ibid, 72.

by the reflection of pinky sky on the watershore. The reversed light draws black ink painting on the sand beach, reminiscent of the abstract painting by acclaimed artist Chu Teh-Chun. Both artists have successfully transformed daylight and shadows created by changing clouds into a landscape that the audience can relate to their daily activities. Such an extraordinary maneuver gives us some ideas of the perfect mixture of painting and photography.

Hsu Yuan-Fu's works in the 1960s and 1970s contain abstract elements present in the contrast that film is able to capture. Conventional black-and-white photography focuses on the delicate changes of grayscale, and once the contrast is accentuated, the visual effects of abstraction are evident. Black-and-white photographs give an atmosphere of visual purity with the composition of figures in the foreground and the place in the background. Between figure and place, black and white, or solid and void is the formulation of abstraction, and the attempt of restoring reality from abstract images. Considering the Figure-ground Orgainzation in Gestalt Psychology whose maneuvers are quite familiar to the audience, the series work of Hsu Yuan-Fu is undoubtedly a classic of abstract photography.

Compared to Chung Soon-Long's delicacy and Yuan Wei-Ming's grandeur, Lin Hou-Cheng applies a style of "deep and far" to create illusional images in his black-and-white abstract compositions. In a dreamy picture, the horizon is pushed so far away that the audience has problem recognizing the "being' in front of the lens. A deep and far lens takes us away from reality to a far and deep space, abstract but substantial. Due to the contrast between brightness and darkness in this deep and far space, all details seem to vanish. Failing to locate the "being", the audience nevertheless can appreciate the occasionally present human figures within the pure geometric compositions.

Dennis K. Chin's *City Impression*, *Remains of Time*, *Surfacing Lotus* apply typical photographic techniques, such as partial enlargement or cropping to present images beyond the habitual seeing of the naked eye. They create details in detail, and the audience gets lost in the maze of repeating patterns. A figure is created by another figure, which is no longer figurative. Such maneuvers always intrigue photographers to participate and audience to watch.

Evoking the audience's empathy by personifying non-human objects in creation is called "transference" in aesthetics. Attributing human characteristics and human thinking to animals or plants seems to produce the so-called mindscape photography. It is a genre that expresses artistic concepts through the relationships between visual elements. One of the most well-known mindscape photographers was Alfred Stieglitz who had a series of works titled *Equivalents*.[14] In this series the author expressed his own state of mind with the changing shapes of clouds. Stieglitz tried to reduce the realistic narrative in his photographic images and simplify the depiction of events; the composition of light and shadows, among other abstract elements, were outlined. When the outside world is realistically described (photography happens to have the greatest power of duplication and reportage), viewers easily pay attention to the appearance (clouds in the shape of a rabbit or a lion, for instance). It is the denotation of photography, meaning the apparent ideas (seeing clouds as certain things according to their shapes), and the deeper ideas (connotation) are overlooked. Chiang Ssu-Hsien's *Mountain* series expresses this concern, "Dim light in mind, refreshing living over the mountain enveloped in clouds, staying away from all things." Chiang captures a pleasure of "slowness" as well as a figureless sense of Zen with the shutter of his camera. Whether it is a mountain, or what the clouds look like, they all belong to the denotation of photography, and Chiang wishes to provide the audience with deep connotation contained in his images.

14. Ed. by Michel Frizot, *A New History of Photography* (Paris: Bordas, from the French edition, 1994), 662.

The Call of Sense and Sensibility

The Suprematist School was founded by Russian abstract artist Kazimir Malevich in 1913. In 1915, Malevich created *Black Square*, a black square over backlight on a 79.5cm edge square white canvas. In 1918 he created *White on White*, a floating white square over a white background, symbolizing advanced technology. Suprematism emphasized creating art with instinct, pursuing pure geometric forms instead of depicting the real world. Rather than describing Malevich's abstract painting as philosophical, it is spiritual. [15]

This exhibition includes Richard Lin's abstract painting *And It Came to Pass* without particularly discussing its connotation, given its formality comparable to suprematism. Lin said, "White is the most common shade, the great colorlessness with great hue. White is sublime, and white is popular; white is peaceful, and white is sorrowful." From the pursuit of advanced technology and speed in Futurism, Malevich established the highest spirituality in geometric suprematism. Richard Lin seemed to have indirectly addressed the light and shadow in his geometric abstract paintings. The layered horizontal shades on the white canvas of *And It Came to Pass* has a taste of minimalism. Thus painting as an art genre no longer focuses on depicting lives in reality. It could be about the sense of space or the effects of light and shadow. Susan Sontag also said, "For it is in the nature of a photograph that it can never entirely transcend its subject, as a painting can. Nor can a photograph ever transcend the visual itself, which is in some sense the ultimate aim of modernist painting."[16] Richard Lin's work exhibited here is used as evidence that compared to photography, painting is absolute and has very broad themes for its creation.

Compared to the rationality in Richard Lin's vertical and horizontal lines, Wang Pan-Yuan's *Black Sun* is sensibly humorous. Two dots, one big and one small on opposite corners of the canvas express tension of the strokes through ink wash. The round shapes could be eyes or planets, like the sun and a star, and the curve above them could be a hill, or the orbit of the planets. The contrast of big and small, bright and dark, black and white have greatly livened up the painting.

Lo Pin-Ho's *Shangri-La's Orchid Island* is a carved print with the visual quality of suprematism. It is the Braille about the construction of nuclear waste storage in Orchid Island. Texts or words could be arbitrary, and we won't understand them without learning how to read them first. *Shangri-La's Orchid Island* has expressed the author's position on nuclear waste storage, but most of us don't understand how to read the Braille, so I use it to discuss the signs of photography. Images of photography are iconic signs, they are also arbitrary and must be understood through learning. It is the opposite of what people had believed in the past that photography was self-evident and could play the role of cross-border communication.[17] Like all other signs, the meanings of photographic images are generated through a social frame. Within a certain framework, images are used as signs to express the author's opinions, which usually already took a standing or showed an inclination, although they won't manifest unless they are read in a certain context. The form of Lo Pin-Ho's *Shangri-La's Orchid Island* is visually abstract, in fact, it has translated images into readable signs (if one knows how to read Braille), not unlike a conductor who can imagine the magnificent symphony simply by reading the music notes.

"Photography is unclassifiable because there is no reason to mark this or that of its occurrences; it aspires, perhaps, to become as crude, as certain, as noble as a sign, which would afford it access to the dignity of a language. But for there to be a sign there must be a mark; deprived of a principle of marking, photographs are signs which don't take,

15. Robert Atkins, *ART SPOKE* (New York: Abbeville Press, 1993), 202.
16. Sontag, *On Photography*, 73.
17. Umberto Eco, Edited by Victor Burgin, "Critique of the Image", *Thinking Photography* (London: Macmillan Education Ltd, 1982), 32.

which turn, as milk does.[18] "How do we decode figurative photography that fails to convey meaning as precisely as words, and at the same time attempts to do so using transmutative symbology?

In *Understanding the Photography*, John Berger indicated that a photograph contained multiple but invisible meanings. He said, "The true content of a photograph is invisible, for it derives from a play, not with form, but with time. One might argue that photography is as close to music as to painting. I have said that a photograph bears witness to a human choice being exercised. This choice is not between photographing X and Y; but between photographing at X moment or at Y moment. The objects recorded in any photograph (from the most effective to the most commonplace) carry approximately the same weight, the same conviction. What varies is the intensity with which we are made aware of the poles of absence and presence. Between these two poles photography finds its proper meaning. (The most popular use of the photograph is as a memento of the absent.)"[19]

The audience often sees what is present in a photograph. John Berger further pointed out, "A photograph, whilst recording what has been seen, always and by its nature refers to what is not seen. It isolates, preserves and presents a moment taken from a continuum. The power of a painting depends upon its internal references. Its reference to the natural world beyond the limits of the painted surface is never direct; it deals in equivalents. Or, to put it another way: painting interprets the world, translating it into its own language. But photography has no language of its own. One learns to read photographs as one learns to read footprints or cardiograms. The language in which photography deals is the language of events. All its references are external to itself. Hence the continuum."[20] Here John Berger suggests that each photograph contains an underlying implication, and what is presented would evoke what is not presented.

Niu Jun-Qiang's *The Borderline* explores mutuality between religious faith and diseases. Is the figure in this photograph the divine figure of Jesus Christ or the profile of a devil decided by the mindset of the viewer? Niu Jun-Qiang believes that the fear of diseases and death is on the borderline of religious faith, which is perfectly depicted by the artist with a blurred area on a translucent tracing paper. Brightness and darkness are divided only by a thin paper, when it is not broken through, it always remains vague. Niu Jun-Qiang's *Untitled-6* attempts to capture the scene of a descending holy spirit. The figure shaped by light and shadow on the translucent paper carries out a sense of touch on the bright plane. It seems to be a human figure lying under holy light and enjoying the sacred moment when God arrives.

Teng Po-Jen's *Quiet Breathing* wishes to find fresh air in the urban jungle. A vagueness is created by rough silver halides. Uncertain direction, aimless search, an unstable lens and deformed body, it is escaping, it is pursuing. In the chaos, one only wants to breathe gently to save their lost soul.

Tsai Chang-Chi's *The Wall* is a three-piece work that explores the possibilities of abstract visuality. The white square from the left piece is a minimalist abstract vocabulary, large but empty, demonstrating the extreme power of "void". The void is enveloping the scene from four sides, and each side is at a different layer, showing different interests. The visual richness relies on the perfect match of the graphic and its background, the "with" and "without", and the Yin and Yang. The middle work brings the audience to the audaciously divided black and white and up and down. The roughly sketched chunk is reminiscent of a floating iceberg or a reticent smile above the peeling murky wall with fine cracks. The middle piece is tender compared to the other two pieces, it emits an

18. Barthes, *Camera Lucida: Reflections on Photography*, 6.
19. John Berger, *Understanding A Photograph* (London: Penguin, 2013), 20.
20. Ibid, 20.

air of affection. The right piece cuts the abstract structure into grids of different sizes aligning horizontally, and the vertical column in the center rebels against the ordinary expectation of stability and brings out an upward energy. On the other hand, it being at the center gives out a sense of balance. The details in the tiny rectangles are rhythmic, not unlike music notes dancing up and down on a staff. Looking at the three pieces at the same time, we first feel a domineering power, then a tender care, then rhythmic leaps. Music, dance, visual balance, structure, and texture, it is a wall of marvelous details and charm.

Chiang Ssu-Hsien's series work *Starlight of the Sea* "aims to extricate the elements from the scene, enacting the phantasms between dreaming and consciousness. Through the waiting and searching for a subject on the seashore, or the scenes of involvement, I use the scenes of the sea and sky, where the clouds are thick and the winds are high, at dusk or at dawn, or the lights of the fishing boats, to cultivate an image different from most visual impressions. The scenes on the ocean transform the fantasies of light and shadow; the image holds the hidden gift of 'myself' present in the scene. The passage of time flows into the space, allowing 'myself' to become one with the sea, the waves and the wind." The poetic statement of the artist is also shown by his photographs. The bright dots on the ocean surface before daybreak suggest the coming of daylight, and if we observe them with visual sensibility, we will notice, at the horizon, one, two, three, gradually a row of illuminating dots are moving toward us, accompanied by louder and louder background sounds. The shuttle-like boats are something out of a sci-fi episode have we been contacted by aliens? The glow is finally reflected at the horizon, contouring the planet we are at, and a beam of hope emerges slowly from the darkness.

In 1925, professor at the Bauhaus László Moholy-Nagy published *Painting, Photography, Film*, a book that elevated light as the subject of art in the 20th century. Regarding light gradations, he thought that light was not just a medium assisting the representation of physical existence but that it created the space of images. Moholy-Nagy produced "photograms" by directly projecting objects on photo papers in a darkroom. "This course leads to possibilities of light-composition, in which light must be sovereignly handled as a new creative means, like colour in painting and sound in music."[21] Here the issue is not about an object, or an expression of feelings, but the excellent organization of the volumes, directions, and positions of the materials, shapes, and light. Thus a new truth appears. The spirituality of art seems to be no longer for the depiction of a lively outside world, but within the relationships between the mutually influencing elements. Moholy-Nagy's new theory about light made it the subject of expression, and a revolutionary idea of aesthetics.

Yuan Wei-Ming's *Night Flight* series also deals with water reflections and light trails as his visual style and it is more absolute by completely breaking away from the spatial narrative in front of the lens. Light became the major element, demonstrating its quality and power. Human eyes can't retain light trails, thus we often are amazed by the firework-like effects. Similar to Moholy-Nagy's endeavors, light is the subject of *Night Flight*. Light acts like paint brushes, stroking or waving through the plane with different hues and changing details. The author gives light an inner space in exciting red flames or lonely loitering. Sometimes it is like a triumphant army, sometimes it is as solemn as a classic oil painting. Light is the solo theme of the work.

Lin Tian-Fu's *Alchemy* interprets the seashore of northern Taiwan with "Brilliant colors, volatile lines and grains. They constitute odd images of birds, beasts, flowers, bugs, fishes, among all kinds of creatures. All of them are my pen strokes, and I apply and trace them with my camera lenses. I follow the paces of nature." The topology of the North Coast is formed by plate convergence and thousands of years of erosion. The rich variety of rock grains is like a picture painted over again and again by oil paints, and an unpredictable abstract work is born in the multiple layers of hues.

21. László Moholy-Nagy , *Painting, Photography, Film*, Trans. by Janet Seligman (Cambridge, Massachusetts: The MIT Press, 1987), 32-37.

Gestalt, A Sensibility of Visuality

In 1912, psychologist Max Wertheimer proposed a systematic discourse on the gestalt principles of visual perception, which gave birth to gestalt psychology. Gestalt psychology explains that the organization of visual elements is fundamental to our cognitive process, it is intrinsic, instead of learned. Wertheimer attributed the perceptual organization to the law of proximity, law of similarity, law of closure, law of continuity, law of symmetry, and figure-ground organization. This very inspiring theory stood out after the tremendous progress of the discoveries of electromagnetism and the gravitational field in the 19th century. Eminent physicians began to see the gravitational analog of electromagnetism as a whole, and under its influence, Wertheimer's theory assumed that in human perception there was a "visual field". In other words, Wertheimer believed that human's understanding of any visual figure, its form or profile, came from the organization of our cognitive system; they were not collections of individual parts. When we see a rose, we see its form and color, and together with what we have learned or experienced about roses previously, our feelings about it become a "field".

According to the law of symmetry of gestalt psychology, human brains will spontaneously find the center of an object and see it as symmetric. Seeing things in pairs or in symmetry delights us, and when two identical objects are not connected, human brains will sense it and form the connection automatically through comparing their similarities or grouping them. Lu Liang-Yeavn's *Pan-Gu* series leads us into a "visual field" immediately when we see it. To interpret this work through our visual cognition, we first notice the beauty of its symmetry. The grains in the work could be of rocks, butterflies, or orchids, or could be none of them. The law of symmetry in gestalt psychology is the only angle of appreciating this abstract work. Symmetry pleases us, which is the unchanged law of the universe. Almost all of the beings, plants or animals, are symmetric, either left-right or up-down. Mineral crystals and flowers are symmetric, and tools like scissors and shovels are also symmetric, they are the proof that the law of symmetry is intrinsic, not learned, and we naturally enjoy the matching parts from left and right or up and down.

Wang IS's *X-Y Building Facade* projects symmetric components from gigantic buildings to create images of creatures. Some of them look like seashells, some of them look like post-industrial machines which might be activated any time and move like animals. The Creator gave life a great variety with symmetry and balance, making them easy to move and easy to defend themselves. All lives respond to their inheritance by saving their genes in their life lines, a hidden beauty of survival. On the other hand, balance from asymmetry also could be beautiful.

Compared to the works of Lu Liang-Yeavn and Wang IS, Wu Mei-Chi's *YXX-The Flares* seems to be chaotic. She puts things in a room full of mirrors, making the audience feel uneasy in the space of slanted axes and a distorted center. The artist claims that she is proving Albert Einstein's spatial relativity which compresses or twists space. Leaving Einstein's theory alone, we do see visual principles of gestalt psychology through the reflections and refractions in this distorted space. *YXX-The Flares #6* is asymmetric, broken, but balanced, in which we find deducible elements, namely straws and suction cups. With similar backgrounds, we try to define the space with straws and suction cups, but they are in pieces, and we can only find a sense of balance through the central axis on the plane. We find plastic tubes over colorful backgrounds in the artist's *YXX-The Flares #10*, which is a closed room we fail to define but find the fun of relativity in the compressed and twisted space and the balance it reaches in chaos.

Chang Kuang-Ho's *Botany* from 1994 has rows of square images generated by computer as its background. The wallpaper of continuous and symmetric flowery patterns has a taste of monotone and mediocrity from the mechanic repetition. It is about the auraless virtual images in the modern industrial and digital era. Advanced computer programs process images into kaleidoscopic patterns through left-right and up-down symmetric

collages. The work the artist calls *Botany 0.5* demonstrates clear details from very high resolution images. It inspires our curiosity about what is "being" there and we never get away from the fun discovered by Gestalt Psychology. The vertical axis in the middle brings out a solemn air, and the slanting axes liven it up by breaking up the mechanic repetition. The details of each work look similar because of their symmetry, and different forms, sizes and colors stimulate different pleasure in seeing them. *Botany 0.5* has an installation, the images are extended vertically and horizontally by mirrors left and right, up and down. The infinite repeating visual effects are experienced when we enter the installation. In this space of multiple reflections, all the answers to math are infinity, which is beyond our physical sensation, and we get lost in it.

Material Mediums—The Abstract Beauty in the System of Objects

If we take photography as an art medium, comparable to the canvas of oil painting, we will see the entire system of objects of photographic materials. This system of objects changes as the development of photography changes. The simplest categorizations of this system are traditional silver halide photography and digital photography. And in the category of traditional photography there are black-and-white or color films, negative and reversal films, black-and-white or color photo papers. If the techniques and effects of developing the images are included, the photo papers and chemicals for black-and-white or color photographs applied in darkrooms are also a part of the system. There are all kinds of combinations of materials and techniques: one example is to develop color negative films with the process of developing reversal films. The outcomes might be very weird, but the unusual photos are exactly the study of the system of objects we wish to look into. And in the category of digital photography, the monitors presenting the images, network transmission, software, layouts, among other tools for various unusual visual works are also a part of the system.

Chen Chun-Lu's *The Creation* series presents magnificent views of nebulae, and the title *The Creation* suggests the murky universe before Pan-Gu separated the heaven and the earth. Figures of Buddha vaguely emerge from the abstract images, which are created by soaking the color reversal films in chemicals. The coated sides were eroded by acid or alkali, resulting in a peeling or displacement of the coats. The abstraction comes from the unusual process of damage. Photography can't have such effects by taking photos, and before digital techniques, such alternative maneuvers were deemed an extension of photography. Many interested people tried to invent chemicals that could partially break or scratch the coats to create amazing effects in colors or styles. And with the coming of the digital era, all these efforts became useless, for digital tools can easily change colors, greyscales, forms and textures. Thus the visual effects are no longer an issue, instead, photography focuses on its connotation. To evaluate a work with special effects, we look at how close the effects are to the original intention of the author, and the *The Creation* series is a perfect example.

Chang Po-Chieh's *Contrast Medium of Time* attempts to express the material properties through an experiment with his response to a friend far away. The outcomes are very profound. Chang Po-Chieh buried the films his friend mailed him and did not develop them until one year later. In the dankness underground, mold sprawled over the films with the patterns of tree branches or coral reefs. The original images seem to have disappeared, and the tree branches (or coral reefs) demonstrate different compositions on each of the four-piece works. The audience sees the poetry and melancholy in the starry sky, at the same time, experiencing the suffocating smell of mildew. Is the author creating a metaphor for human relationships by doing this interactive experiment? It is another example of making use of photographic materials for postmodern art, abstract but containing multiple meanings.

Traditional films process analog messages: if looking at them through a high-power microscope, we will realize that silver halides are not like the crystals of inorganic substances, they are like the organic structures of interwoven plant roots.[22] The basic unit of silver halide photography is very sensible, because the border of each unit is blurred. They are not like digital images and digital music, the basic units 0101 clearly represent the works. The advancement of technology inevitably drives people to pursue more precise, more definite and more rational digital tools. Nevertheless, Lee Kuo-Min who has worked on developing film for decades feels it's difficult to put silver halide photography away. Lee Kuo-Min crazily collects film leaders, his *A Fool for Thirty Years* is produced by leaders of color reversal films. In the useless film leaders, he sees incomparable beauty. Reminiscent to American expressionist painter Mark Rothko's abstract compositions of divided upper and lower parts, Lee Kuo-Min found the beauty from film leaders. Although the leader is a very small part of a roll of film, the artist sees the unparalleled aesthetics of abstract art through his heroism of vision. It is the beauty of existence without "being" photography, no lens, no focal point, no scene but the horizon made by over exposed films. The leader of a roll of a film is pulled out to kick off the shooting, it matters little, and sometimes more of this part will be wasted in case something goes wrong. But in Lee Kuo-Min's creation, different effects of the works unfold because of the leaders from different brands or batches of films, different degrees of light leaks, or different chemicals being applied. Such excitement couldn't happen without thirty years of infatuation.

Contrary to the beauty of vagueness in analog photography, in digital images we can see grids of color chunks if we enlarge them to the maximum. The grids are like clear crystals and each of them carries information of value, hue and chroma. The more grids an image has, the higher resolution it is, and the bigger the file is. The resolutions of images, or the sizes of files affect the speed of the computer's processing of these images, and computers may crash when a manipulation goes wrong. A crashed computer is frozen and completely useless. Yu Chung-I's *The Moment of Crash* is her response to the problem in the digital era. The eight pieces are reminiscent of eastern ink landscape paintings, and looking closely, they are made by dragging around the same brush. When we began using computers and encountered a crash or problems due to a virus, they may have completely locked up, or sometimes froze but with the ability to move the cursor. Encountering such a moment, Yu Chung-I might make a long color chunk with her cursor first, then unintentionally draw the whole picture. She might find she couldn't get rid of the pen head and decide to complete one after another abstract painting. This project is responding to the hardware and software of digital tools and images in the most inspiring way.

In a darkroom, latent images (invisible to naked eye) on photo paper will take shape during the exposure. But the final image won't be fixed until the imaging by the developer is done, otherwise the photo paper will turn black in the light. Many unexpected images could be produced if the process of development is disturbed. Chang Kuang-Ho began his *Museum* series in 1987, using mural-sized photo paper to expose images taken of the specimens from the American Museum of Natural History in New York. The imaging effects were similar to that of painting by spreading the developer over the photo paper with sponges. With more water, the sponges could be applied for an effect much like an ink wash. The author didn't fix the images when the latent images emerged. Each work was a solo version because of the uncertainty of making them in the darkroom. Several different works were created using different methods of developing the same film. In 2020, the artist wished to make a conclusion with a leftover roll of 40×30 foot photo paper; whether it was still good to use or not was not clear. Thus the *Museum* series was born from an old soul, using expired photo paper, film, and old techniques. In the darkroom, what had been expected was changed in time, for the thirty-year old photo papers did not fully respond to the projection. The latent images appeared indistinctly, and the ancient creatures from the cabinets in the museum

22. Editors of Time-Life Books, *The Print: Life Library of Photography* (New York: Time Inc., 1970), 66.

did not show at all. Vaguely, the artist became aware of the historical traces in time, and recalled his thirty years of experience of developing films with alternative methods. At this moment, Chang Kuang-Ho thought, why not let the photo paper and chemicals play the roles they used to be and represent their original nature. There was a lot of fun discovered in the photo papers during the process of exposure through the artist's free application of the developer. In fact, the inking, brushing, and washing in the *Museum* series is the artist's homage to American abstract expressionism by radically extracting images from the planes and leaving the expressing style alone.

There are very few works making use of developer and photo papers directly, and Chen Yan-Cheng's *Fountain* is one of them. The artist seemed to have known that having fixer drift down would create very similar images of Chinese ink painting. The one time exposure is not unlike witnessing an ink lotus blooming in a flash of time. The experimental attempt is not ignorable, for creativity and creation always remain uncertain. Visually, the three-piece work is reminiscent of the holy light shining from high stained glass into a Gothic church, beam after beam and layer after layer. Once the audience looks closely at the planes, a moment of tranquility is found at a murky corner, or a thread of enlightenment is passed over from the brightness. Triangles constituted by drifting flows have the solid grains of gems, or like a powerfully falling cascade. Pouring developer over photo papers is like action art to have the images show immediately by flowing liquid in daylight. No lens, no "being" in front of the lens, the work is made of photographic materials. The "being" created by the author was at the moment when developer flowed, which was his action in memory of his father (whose name had the character " 泉 ", means "fountain"), symbolizing the continual pedigree.

In 1921, surrealist artist Man Ray projected small objects over exposed photo papers, breaking up the frame of dull documentary photography. In fact, such cameraless imaging had happened even earlier than the invention of photography. Abstract painting took shape in the beginning of the 20th century, and Man Ray's abstract and surrealist imaging was especially avant-garde at that time. One time Man Ray unintentionally switched on light in a darkroom, resulting in over-exposure on the parts supposedly not to be exposed at all, and created reversed images. The midway exposure became "solarisation", and the interplay of negative and positive generated very interesting effects that fit the ideas of surrealism, becoming Man Ray's signature style. Hsu Yuan-Fu's *Fantasy* and *Clarinet Player* were produced by the same ideas and with more complicated methods. Hsu duplicated and stacked the films to create the mysterious effects. The *Clarinet Player* looks like a waft of smoke rising, and a musician's face is shaped by irregular pieces, giving out a wonder of music. *Fantasy* is in pure visual forms, a psychedelic mandala extends its magnetism toward all directions. It is hallucinating graphics in rolling music, and we are absorbed into the symmetry of the rotating mandala.

In *Towards a Philosophy of Photography*, Vilém Flusser discussed the representation of writing and imaging, the latter took over the status of the subject. Images present themselves to the world, instead of presenting the world to the audience. Flusser thought it was difficult to decode technical images (images produced by apparatus, such as photographs) because people believed that "they do not have to be decoded since their significance is automatically reflected on their surface."[23] Different to traditional images, technical images could be massively reproduced, changing our way of perceiving images. Images and the meanings of images existed on the same level, "what one sees on them therefore do not appear to be symbols that one has to decode but symptoms of the world through which it is to be perceived. This apparently non-symbolic, objective character of technical images leads whoever looks at them to see them not as images but as windows. Observers thus do not believe them as they do their own

23. Vilém Flusser, *Towards a Philosophy of Photography* (London: REAKTION BOOKS, 2006), 14.
24. Ibid, 15.
25. Barthes, *Camera Lucida: Reflections on Photography*, 6.

eyes. Consequently they do not criticize them as images, but as ways of looking at the world."[24] Similar to Roland Barthes' opinions that photography always has its referent, and they adhere one another, just like desire and its object, or a windowpane and the landscape it frames.[25] Flusser pointed out that "images are mediations between the world and human beings. Human beings 'exist', i.e. the world is not immediately accessible to them and therefore images are needed to make it comprehensible. However, as soon as this happens, images come between the world and human beings. They are supposed to be maps but they turn into screens: Instead of representing the world, they obscure it until human beings' lives finally become a function of the images they create."[26]

In the 2005 statement about her ● *Word*, Lai Pei-Yu referred to Italo Calvino's *Invisible Cities*, "Traveler Marco Polo continues to explain his travel experience to Kublai. His narrative is translated from city to city, passing through time and space, the past and the present. Listening to it in the palace, Kublai imagines a world map. The projected, invisible cities exist in a different world through imagination. In Kublai's mind, a multiple layers of truth is formed." The world translated by languages is greatly enriched, and the cities mechanically duplicated by photography have a screen between the individuals and them. It is commonly believed, in postmodern art theories, that the coming of three-dimensional virtual reality makes us give up the real world and indulge in a false reality.

● *Word* seems to bring this issue to discussions. "The ● in the work suggests the language of cities is reread, and we are mainly motivated by the gap of truth and the transformation of signs. In this work, all the words on the signboards are concealed by ●. The sense of disorder in inflated civilization makes the ● change endlessly." Businesses in a city rise or fall, stores open or close, buildings expand or shrink, industries prosper or decline. And humans "in a flat space are carrying multiple spaces that are adjacent to one another. We are dazzled by the meanings of signs in a flash of a moment by the compressed cities as our physical sensations are penetrating, wandering or floating through the multiple spaces." Glistening lights and sign boards construct a gigantic civilization of consumerism, and people get lost in the urban jungles. Every megacity in the world has the same situation, and the artist calls them "hometowns".

With digital techniques, Lai Pei-Yu replaces the words on business sign boards with dots according to their dimensions from different perspectives. The images translated by dots of different sizes are where the "hometowns" are. With an ordered composition and an ambiance of modern high-tech, these dots give out a sense of security and amicability. The changing "hometowns" are not lonely, rows of lights penetrate the black background and pass on messages of void. Void might be like blackholes, but these dots are like stars, shining over the multi-layered city. Without the techniques provided by digital vector illustrators, works of this type couldn't be achieved.

Photographs produced by projecting objects on photosensitive materials was the most creative breakthrough of photography. Photograms were created right after photography was invented, from Man Ray's *Rayograph* in 1921 and Moholy-Nagy's photograms in 1925, to the images one makes by stooping over the Xerox machine. Carefully considering the principles of photography, we realize that images are produced by the substances of imaging and the sources of imaging. Film and photo paper are the substances of imaging, and the objects to be projected and light are the sources of imaging. Photosensitive substances receive messages from the source and formulate images, not unlike the weather forecast center receives information about temperature, air pressure, humidity from radar and transforms them into corresponding images. Light is waves, and there are waves we don't see, like ultraviolet light, X-ray, and Gamma Ray with frequencies shorter than visible light, or Infrared, microwave and radar which

26. Flusser, *Towards a Philosophy of Photography*, 9-10.

have frequencies longer than visible light. Scientists therefore are able to trace the origin of the universe to explore time and space with all kinds of waves. If we define photography as a kind of wave penetrating film and projecting on photo paper, films becomes the major material of photography. The images can take shape on inverted color copies or transparency copies as long as they are able to collect the "waves" and become photos. These ideas have pushed the material mediums of abstract photography to the extreme.

Hung Yu-Hao's *Non-Fiction trace* series applies photogrammetry to capture real three-dimensional scenes and reprocesses them using a Point Cloud. This series takes pictures of alleys and sign boards in the Chung Shan N. Road area, and the curvy streets creating imaginary whirlpools are especially attractive in the redlight district.

Conclusion—Possibilities of Deconstructing Abstract Photography

Beyond themes, returning to visuality is very challenging to the art of photography. *The Eye of Abstraction* presents works of more than twenty artists and categorizes them into four subthemes, namely Figurative and Non-Figurative, Sense and Sensibility, Gestalt, and Material Mediums. The goal is to propose the possibilities of deconstructing abstract photography. The curatorial agenda is to clarify that the lens (and mirror) of photography is not only applicable for documenting or reporting reality, or recording life, it could also be used to express the visual forms of the photographer's murmurs or shouts. It leads us to a new perspective. *The Eye of Abstraction* ambiguously carries a reminder of self-awareness of the extraordinary perspective of the author as an audience. Just as Susan Sontag's words remind us, "In teaching us a new visual code, photographs alter and enlarge our notions of what is worth looking at and what we have a right to observe. They are a grammar and, even more importantly, an ethics of seeing."[27]

Most of the presented works are abstract. The ethics of seeing is not a big issue here, but the grammar of seeing is greatly emphasized. The attempt is to reveal the grammar through the four subthemes: "Figurative and Non-Figurative", "Sense and Sensibility", "Gestalt", and "Material Mediums". The audience is led to see photography through an eye for alternative abstraction. Hopefully it will provide a readable and enjoyable experience of abstract photography.

27. Sontag, *On Photography*, 1.

專文

Essays

「象外之象、景外之景」
——閱讀「抽象之眼」的語境 [1]

黃文勇 / 台南應用科技大學美術系副教授

一、關於光的書寫

攝影（Photography）的詞源，源自「Photo-Graphie」，意指：「光的書寫」，攝影（作品），之所以能成像，必需依賴「光」的元素才能描繪事物的本體。如果從柏拉圖（Plato）所描述的「洞穴比喻」的觀點，只憑透過觀景窗窺見所見到的，猶如被禁錮在洞穴裡的囚犯所窺見的可見世界，也許，只能看見「現實」世界的表象樣貌。「肉眼」所能看到的，只是外在世界樣貌的形體，也許透過「心眼」，才能穿透現實視界與察覺，進而詮釋那「看不見」的內心世界所能展現千幻景象，陳述一種辯證的思維方法。創作者如能透過理性的思維、認知的情感找到「光」的溫度與能量，也許才能顯像自我「真實」世界的影像情感。

攝影（影像）不是用來告訴觀賞者「拍到什麼」，而是藉由創作的行為作為一種介面與觀賞者相互對話，甚至，讓閱讀者從對話中感知到什麼是影像自身？影像創作者所要表達的，不在於將現實世界的景像真實的記錄成為存在的證據，而是在於探究對影像的感知後所擬真變異的創作過程，如何在一個無以名狀的存有觀念，沉潛探究建構一種影像的觀看與凝視的想像。

雖然，攝影（影像），記錄了瞬間性的消逝，見證了「死亡」的過程，凝結成為瞬間性當下的存在之物。始終扮演著一種倖存物，總是向他者召喚時間的留存，但它依然保留一種純粹的證實，以淺浮雕的姿態，向我們招搖展現另一種復活的狀態（儀式）。然而，影像所能承載的並不是永恆，而是「片刻的當下」，是回不去的時空弔祭物。或許，影像也不應被視為「此曾在」（that-has-been）或是「消逝」的蒼白印記。它具有一種「被感知」的內容物，自身擁有向他人展現魅力的本能，提供被閱讀與再詮釋，從物質介面所能承載的意含，延異（Différance）[2] 指向精神層面的知覺思維。

二、「抽象化」的語意

在思想與理論體系的建構下，為了方便往往發展出圖式（schema）[3] 的認知概念及觀點，使得我們將「寫實」與「抽象」截然的對立化，這好比一個人嚮往個人內在的生活，追求形而上的精神層面，另一方

1. 語境（context）：最早由波蘭人類學家布朗尼斯勞 · 馬凌諾斯基（Bronis aw Malinowski）在 1923 年提出。他區分出兩類語境，一是「情景語境」，一是「文化語境」。也可以說分為「語言性語境」和「非語言性語境」。本文所指的語境是聚焦在「抽象之眼」的議題，所形構發展出來的「語言」、以及非語言的「圖像」語境。
2. 延異（Différance）：德希達自創的術語。由「差異」（difference）與「延緩」（deferment）兩個詞合成。有兩層意義：一，是向外「擴散」；二，是「延宕」，即語言的意義最終都不可獲得。意義只能是一個不斷各外擴散的過程。解構主義，維基百科，瀏覽日期：2022 年 7 月 20 日，https://zh.wikipedia.org/zh-tw/%E8%A7%A3%E6%A7%8B%E4%B8%BB%E7%BE%A9。
3. 所謂圖式（schema），是人腦中已有的知識經驗的網路。社會知覺的基礎是被認知事物本身的屬性，但認知者的主觀因素也會對知覺的過程和結果產生重要的影響。

面又不得不面對現實的生活，有所渴求，使得陷入之間跨越的隔閡與斷層。也許，我們應該先釐清概念或語境（context）之間的差異，或者，應該在這些差異以外，試圖探索出這兩者賴以形成，卻從未被質詢過的自明底蘊。也許，我們也不應再探究他們之間的差異性，而應去探究那個支撐「寫實」或「抽象」的共同之本，以及那些共同構築成像、成形的共通因素。

「抽象化」（Abstraction）[4] 是面對「原型」（prototype）的文本（text）透過觀察、分析後再進行詮釋與表述的方法，是思維的辯證過程，是經過「抽離」、「解構」之後「演繹」詮釋的語言方式；亦是，一種「心境」與「造境」的情感語境。創作者透過有意識的藝術創作行為，將眼見現實世界的對象物進入到一種「抽象性」精神層面的思考狀態，給予重新理解與再詮釋。其概念如蒙德里安（Piet Mondrian）對一棵樹進行觀察、閱讀之後運用數理的分析，將樹的型態與結構，以抽離形象的減法美學，進行抽離與解構的思維演繹，以一種純粹的推理方式，從假設性的命題出發，運用邏輯的規則，導出另一命題的思維過程，推演出相對性的詮釋法則，體現出其「抽象」的美學概念，塑造自己的風格氣質。

蒙德里安面對一棵樹進行觀察、分析、解構與演繹過程

以影像（排除繪畫）創作而言，無論是「寫實」或「抽象」的形式、風格，都是透過光學原理的機械操作所擷取的參照「文本」，而其文本的「原型」皆為「現實」之景物。創作者因個人的思維模式，運用「原型」的樣貌進行「微觀」或「宏觀」的觀看模擬、轉譯與詮釋，是為第二層面概念。再藉由個人的偏愛與美感的認知，進行形式化的擬仿（simulation）與技術演練的解構重組表現，展現另一演繹的樣貌，這是第三層面的思考。通常，我們都以這幾種層面所呈現的樣貌，作為閱讀與研究的依據，解讀創作過程及觀念介入的爬梳與分析，也許，難免會造成表象閱讀判準的失衡與定義的偏見。然而，不管從哪個角度切入或用什麼理論、觀點作為研究的核心，都難以力求完美，只能說：提供一種詮釋的方便法說。

「抽象之眼」所探究的，即是試圖從上述的幾種層面的思維觀點切入，探討創作者在創作「心境」或者是「心思」的狀態。不難理解影像創作的目的，並非再現「眼見為憑」的自然物，當透過觀景窗對著某個景像模擬框取的過程（process），已經從這個模擬的對象產生了一個新的關係以及新的思維。同時；在模擬的詮釋過程中，也試圖消弭原本所模仿的再現對象（真相），企圖重新找到一種閱讀及詮釋的方式。從觀景窗所「框取」的，是察覺可見世界存在的實相呈現；另一反射的「鏡面」卻表現不可

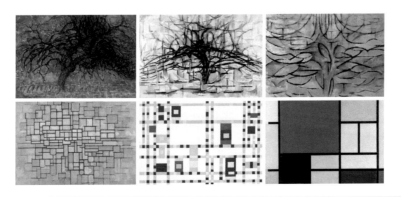

蒙德里安（Piet Mondrian）面對一棵樹進行觀察、分析、解構與演繹過程

Courtesy of Kunstmuseum Den Haag, Museum of Modern Art, Mondrian/Holtzman Trust, The Kröller-Müller Museum, Gemeentemuseum Den Haag.

4. 「抽象化」有「抽出、引出」（draw from）的意含。希臘哲學家亞里斯多德（Aristotle）認為，抽象化是一種心靈得到普遍性概念的過程。張淑媚，抽象化，國家教育研究院，瀏覽日期：2022 年 8 月 15 日，https://terms.naer.edu.tw/detail/1df786a3a0294bb3689aa5e1ac188762/?seq=7。

見的內在隱喻與情感，是通往內心世界感知的樣貌。如是，所見（呈現）之影像，不管是虛相、是實相，皆為妄相，猶如《圓覺經》所云：「諸幻盡滅，覺心不動，幻滅滅故、非幻不滅」，創作者因迷心妄動起意識心，這個「幻」，是現象的幻想、妄想的想像，不在於現實世界的表相，而在於心中幻化境界的浮光掠影。以「心眼」將實相幻化為虛相的想像，如「空中花、水中月」，皆為暫存幻相，所言抽象，即非抽象，是名抽象。

三、從「原型」的觀察到「格物」的解構演繹

影像，長久以來承受一種被記憶所存在的表象性質之「物」。然而，影像一旦被知覺，即能轉換顯現為一種與「物」完全不同的實存（existence）概念，成為「影像—物」，而「影像—物」在變成表象的過程中，在被知覺的當下，使得影像自身成為創建一種主體性的表徵。其所形構（展現）的畫面卻是多重的思維，它穿透了時空交錯的變異性與承載虛實之間的雙刃性格。觀賞者，可以透過凝視「影像—物」重新找到閱讀方式以及詮釋的方法，透過不同前理解的認知與情感，重新獲得另一種再詮釋的閱讀方式。從原本的被動內容（狀態）轉進到超越影像自身的意識想像，讓閱讀者擴充想像的空間格局，容許它者自由的描述！就如同人們能夠在雜亂且統一性的沙泥中，找到屬於自己喜歡的石頭（貝殼）般的魔幻力量。

顯然，影像不全然是一種心理內容，影像本身也不構成自我存在的意識，只存在於對「影像—物」的意識之中。當影像脫離它本身「原型」的內容，才能向他者表述其精神性的意涵，成為「精神物」。影像，既不在靈魂之中，也不在意識中實存，更難以依附在任何地方立足，只能依賴創作者的觀照，藉由意識流創造某種可被感知、想像的「影像—物」。然而，「影像—物」是有其形態的，必需透過身體感官和神經的媒介作用與意識交流後所感知的產物。猶如某種靈魂所引發的情感語言（符號），這種符號語言是一種過渡（transition）[5]，藉由引入象徵性的編碼語彙所構成，再試圖進入一種心思的演繹手法將物質性的「影像—物」轉譯為某種精神性的狀態，猶如一些在靈魂中引發某些情感的符號與語境，始終扮演一個辯證者的角色，終結了事實樣貌的真實性。

唯有將影像放到思想體系，依照個人身、心、靈的對應發展出相對應的關係時，影像的存在性才能作為表述思想的表徵物，進而從「影像—物」昇華到「心」與「意」的合體，直入「境」的唯識境地。

「抽象之眼」，似乎向我們拋出一個以「影像」之名，試圖探討面對影像的觀看之道與格物的詮釋態度，以及面對影像演繹的思辯，直入創作情感的剖析爬梳各自感知的獨特性。這些影像雖然不具體的描繪什麼景象（物件），卻能令人感受到單純的色彩、構成、形態之間微妙的變化，並能從微觀的世界觀看其中極致的關係與奧妙，探究宏觀的視野，傳遞一種純粹的人類情感，是沉默、狂喜、優雅、絢麗、壯闊……。觀賞此類的作品沒有必要去執意創作者拍了什麼，因為：「什麼也沒拍到。」解讀這樣的抽象作品，倒不如說：「去與作品之間對話，完成一場冥想」。這也許是創作者創作的初衷，希望依靠單純的色彩結構、與畫面的情境，就能直接表達自己的情感與深邃的內心世界，去感染他人的情緒與思緒，具有一種非常療癒的功能，像似施展一種魔幻的藝術儀式。可以發現當色彩或構成發展到一定程度的時候，會奇妙的展出比任何具體事物形象更為強大的精神力量。很顯然的畫面中所呈現出來

5. 過渡（transition）：指事物由一種型態轉變為另一種型態；由一階段進入另一階段的交替時期。

的那些紅色、藍色、深紫色或是黑、灰階調，並非簡單的顏色本身，而是創作者自我精神世界的投射。即便，創作者在現實生活上遭遇到的困頓，也能在作品中提煉出色彩的能量與創作的喜悅，這就是藝術的精神性也是抽象性影像藝術的精髓。

如此不具體、不確定的影像，不是挑釁觀賞者的感受度，而是經由創作者找到自己一種創作的脈絡系統，允予將結構給於自在的解放與解構，在重疊、鏡像和移動的坐標，在垂直與水平線之間反覆，在微觀與宏觀的視野，企圖將歷史與回憶的關聯切割，形成了一種非視覺感官糾纏的邊界，顯然，這邊界在這裡不在於「此曾在」的記憶與「片刻的封存」，而是，介於身體的感知與知覺系統、介於多重敘事的觀看（觀想）部署，呈現一種恆常性的流變與不確定性的介質，以遺忘對抗記憶、以圖像學對抗地形學、以心像對抗模仿。鬆動影像（攝影）原被賦於描寫現實世界摹本的使命，掙脫再現現實世界的任務。

能夠把影像的感受力化繁為簡、抽離現實的樣態，顯然足以證實創作者對於影像有一定的「信仰」程度，才能自我建構「抽象性」思維的觀點影像，且具差異性，是作為一種觀念總體無限的延異，表現出不被奴役性的自由。

四、「眼」與「心」所感知的造景與造境

影像所展現的美感，不在於技術上的操弄，在於創作者對拍攝對象的感知能力與觀看的詮釋態度，所呈現作品的意境，仰賴於創作者的品味與感知之間的連結。肉眼之「可見」，是對現實的、客觀的，作為視覺、觸覺存在有感的描繪。然而，透過「心眼」，則出自於個人主觀的，較為理性與感性互為主體的認知，有某種隱藏性，涉及一種指涉或者是差異性，這種指涉是一切「不可見」思維邏輯的感知。影像都具有「意有所指」藉由「寓情於景」而形成知覺脈絡的情境之下，進入語境所建構與詮釋的解析，往往處於感性與理性擺盪之間、在推論與誤判游離之間、在表象與內觀神遊之間、在造景與造境選擇之間……思索、解構、建構……反反覆覆……。顯然，影像所形成的結構關係，不是隨意的以某種形式或物質的感覺材料所組構的，必然有隱藏著某種情感元素為基礎，才能有足夠的能量去支撐那被理性化表現的情感，使得影像自身脫離現實世界的薄膜，將所謂「可見」（現實）的影像，轉化（轉譯）為「不可見」的知覺影像。

一張張抽象性的圖像與線性的佈局，猶如詩詞的格律的平仄，如音樂性的賦格與變奏，差異在曇花一現和恆久性之間。詮釋手法離不開微觀細微明察秋毫的紋理、宏觀視野幻化的大千世界、解構後重組變異的隨意賦形、原型質變後的情境浪漫構成、圖層疊加後的超然物外，伴隨著相互融合的漸變顏色，賦予人們深沉的想像與解讀，破除了攝影的再現與敘事性功能，傳遞人類豐富的情感，擁有多重層次的想像！強烈的介入現實世界，又企圖從現實世界的場景抽離到更純粹的真實世界的造境，並把無關於影像所能展現的內容給於去除，有時，加入一些與原來沒有關係的元素（影像），透過數位科技虛擬特質的處理表現，超越「大象無形」的體現。有時，在高畫質的功能顯像，細微深入提供觀賞者微距（微觀）的觀看方式，同時，又能展現出另一種讓閱讀者合理想像的超越真實性的「擬真」（simulation）感受，一起融接、並置，塑造成為另一種合理表述的空間場景，像似一種充滿戲劇性、想像的魔幻劇場。有些出竅的影像，原存於藝術家心理之中，頓時幻化為心象，在這相當抽象的構形，幾乎是一種純粹的形式，彷彿心中藏匿了一個老禪的觀想所流露出寓禪於五行之中，賦予各種禪意的品味與意境。

這是抽象性影像的獨到之處，不只可以詮釋「眼睛」可見感官世界的景象，更能以「心眼」將不可見但可感知、可感受的世界，幻化為抽象擬真的造境！是一種勾引「他者」靈魂迷戀，喚出鬼魅招搖的巫術；也是一面能照見所處社會現象、觀察文化視覺、迷戀自我慾望對話以及預測未來擬像（simulacrum）的巫鏡。它並非假借描繪現實世界的「再現」（representation）而成就，而是以有形之相，隱涉感官世界的意識存在，或者探究內在隱喻的表現，才令人無以名狀的動容。作品的背後是思維最為深淵之所在；亦是靈魂可望寄託之處所。創作者，如何在自身的時代透過自己的感知，對環境變異、時代變遷、生活議題、文化現象、視覺符碼的解讀與認知，轉譯成視覺影像的「真、性、情」能量，以及運用數位的編碼，承載那「輕如鴻毛，重如泰山」的影像魅力與溫度，展現最為精明的佈局與格調？藉由對「可見」世界的觀感，所封存「時間的切片」，透過語境（context）的轉譯，對人與空間（場域）、人與時間……的認知與知覺，詮釋「不可見」影像觀點與意涵。

五、結語

以影像作為表現的載體，必需具備感性與感知，更要以時間感的累積與接收度契合，才得以藉由「光的書寫」流竄出於體內一股騷動與靈魂！它穿越了自身向我們投射出實體的證物，又剝離現實的表膜、展現自身的魅力。我們之所以能感知影像的存在，以及感受影像自身的魅力之所在，是基於視覺感官受到這種擾動的指數所引誘，觸動了思維上的想像基因，挑起情感面或前理解的經驗值，所閱讀後的感觸，得到一種悸動與狂喜！這種「擾動」與「失序」的現象指數，具有一種恆常變異的狀態，瞬間凝結又消逝，充滿不確定性的現象，如同，詩歌形式與心理情感之間進行的交流與拉扯，處在一種統一性的幻境之中擺盪，將眼中之景所面對的現實（慾望）轉化為心中對「真實性」辯證的思維狀態，給予結構修辭的演練與重組的詮釋。

即便如此，影像還是無法被理解的。因它具流動性與變異性，且具有一種指向性，他只能被感受、被凝視，我們只能靠情感（思維）投射於「影像一物」，進入想像或聯想。如果無法面對影像閱讀而有所感應，那就應回到影像自身的表象世界，在當下的自身情境下閱讀，才能向感知系統發出召喚。這正如影像為何闋如在我們的記憶中，因為我們不在場，只有在對眼「凝視的當下」，知覺的感官系統才能被啟動，才能感知那「欲辯已忘言」的情境！

參考文獻

1. 法蘭斯瓦‧余蓮（Francois Jullien），《淡之頌：論中國思想與美學》，卓立譯（臺北：桂冠出版社，2006）。
2. 雅克‧德希達（Jacques Derrida），《書寫與差異》，張寧譯（臺北：麥田，2015）。
3. 尚 - 保羅‧沙特（Jean-Paul Sartre），《想像》，杜小真譯（上海：上海譯文，2008）。
4. 莫里斯‧梅洛 - 龐蒂（Maurice Merleau-Ponty），《知覺現象學》，姜智輝譯（上海：商務印書館，2001）。
5. 莫里斯‧梅洛 - 龐蒂（Maurice Merleau-Ponty），《可見的與不可見的》，羅國祥譯（上海：商務印書館，2007）。
6. 莫里斯‧梅洛 - 龐蒂（Maurice Merleau-Ponty），《眼與心－身體現象學大師梅洛龐蒂的最後書寫》，
 龔卓軍譯（臺北：典藏藝術，2007）。
7. 柏拉圖（Plato），《理想國》，吳松林譯（臺北：華志文化，2018）。

Images Outside Images, Scenes Outside Scenes
——The Context[1] of *The Eye of Abstraction*

HUANG Wen-Yung / Associate Professor, Dept. of Fine Arts, Tainan University of Technology

I. Drawing with Light

The word "photography" originated from "Photo-Graphie", meaning drawing with light. The images of photography take shape by light, as light illustrates objects. Using Plato's "Allegory of the Cave", what we see through the viewfinder is as limited as what the prisoners see reflected on the wall. Our "eyes" see the physical appearance of the world, and our "mind's eye" observes and interprets the kaleidoscopic scenes inside the mind, demonstrating dialectical thinking. A creator is able to develop the images of our feelings to the "truthful" self by discovering the warmth and energy of "light" through rational thinking and cognitive empathy.

Photography (imaging) is not to tell the audience "what is captured", but to have dialogue with the audience through the author's actions. Is it possible for the audience to sense the essence of images? The image creators don't attempt to document the real world, but to investigate the creating process of stimulating or transfiguring scenes through people's cognition of images. They dive into the possibilities of constructing a way of seeing and a vision of gazing within the indescribable view of existence.

Photography (imaging) captures the vanishing instant of time, witnesses the moments of "dying", and materializes flashes of existence. Photography is the survivor, summoning the pasts of others. It maintains a pure evidence, a light relief, showing an alternative state or the ritual of revitalization. Images don't carry out eternity but the present moment, they are the offering of irreversible time and space. Images might not be taken as "fading" traces of "that-has-been" because their content can be "perceived", they have the power to express, or to be read and reinterpreted. Through material mediums, their "différance"[2] refers to the cognition at the spiritual level.

II. Abstraction in Language and Meanings

A schema[3] is developed for easier understanding of cognition and viewpoints within the framework of theories, which inevitably polarizes "realism" and "abstraction". It is like a person pursuing inner spirituality but has to face the needs of everyday life, his or her desires fall into the discrepancy between the two ends. Perhaps it is necessary to clarify the gaps between concepts and contexts, and to explore, beyond their differences, the essence that decides their formation that never had been looked into. On the other hand, perhaps we should leave their differences behind, and go forward to find common elements and factors nourishing the development of "realism" or "abstraction".

1. "Context" was first phrased by Polish anthropologist Bronisław Malinowski, who categorized two contexts, "context of situation" and "context of culture". Or, there are linguistic context and non-linguistic context, and the context this essay refers to focuses on the language and graphics developed for the issues explored by the "Eye of Abstraction".
2. "Différance" is a term coined by Jacques Derrida, meaning "difference" and "deferral" of meaning. "Différance" consists of two layers of connotation, 1. The "dissemination" of meaning, and 2. The "postponement" of meaning, thus the ultimate signified is never attained. Meaning is an unending chain of signification. "Deconstruction", Wikipedia, browsed on Jul 20, 2022, https://en.wikipedia.org/wiki/Deconstruction.
3. Schema is the network of experience formed in human brains. Social cognition is based on the nature of the cognized, but one's subjective view will influence the process and outcome of cognition.

Abstraction[4] is to reinterpret and re-narrate the "prototypic" text through observation and analysis. It is a process of dialectical thinking, a language for the interpretation through "extraction", "deconstruction" and "deduction". It is the sentimental context for the making of scenes. Through conscious action of art, creators bring what we see in reality to "abstract" and spiritual reasoning for a new understanding and reinterpretation. Similar to Piet Mondrian's representation of a tree, he analyzed its forms and structures with geometric methods, and distilled its image down to his minimalist aesthetics. It is the evolution of extractive and deconstructive thinking. Setting out from a hypothesis, through the rules of pure deduction and principles of logic, an alternative path emerges for a relativity of interpretation. It is the realization of "abstract" aesthetics, as well as a personal disposition.

The evolution of Piet Mondrian's observation, analysis and deconstruction of a tree

The creation of images (excluding paintings), "realism" or "abstraction", captures referral texts by making use of the mechanism of light and optics. The prototypes of texts are the objects and scenes in reality. Setting out from personal perception, a creator stimulates or translates the "prototypes" through either "micro" or "macro" perspectives and creates concepts of the second level. Then with personal preferences and aesthetics, the creator continues expressing his or her ideas of the third level by formal stimulation and technique exercise. Usually we conduct our research by looking into each level to comb through the concepts utilized in the creation, which inevitably leads to biases caused by superficial understanding. Nevertheless, there is no perfect academic approach, no matter what theories or viewpoints are applied, thus any study does nothing but provide an angle of interpretation.

The Eye of Abstraction is an attempt to approach each of the aforementioned levels and explore the "mindscape" of creators. The creation of images no longer follows the rule of "seeing is believing". Once a scene is framed by the viewfinder, the process of generating a new relationship and new ideas with the objects to be simulated has begun. Furthermore, during this process, the original objects (truth) are to be eradicated, replaced by new views and interpretations. The scene "framed" by a viewfinder is the representation of the true appearance of the world, and the reflection on the "lens" is a metaphor of implicit sentiment, a mental landscape. Thus the presented images, true or false, are all illusional. Just like the Sutra of Consummate Enlightenment, "When all of the phantasmata die away, the enlightened mind would still remain impregnable; when all the phantasmal have come to termination, the non-phantasmal would remain interminable." The minds of creators are stirred by phenomenal "fantasies", and illusional imaginations that flash in their obsessed minds are not really appearing in the real world. The "mind's eye" transfigures the real into the imagination, and the fantasies are as ephemeral as the "flowers in the sky, moon over the water". After all, the abstract is not truly abstract, although it is called abstract.

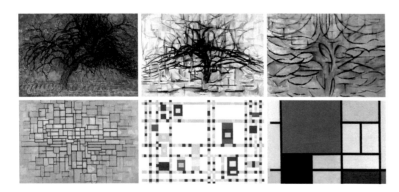

The evolution of Piet Mondrian's observation, analysis and deconstruction of a tree

Courtesy of Kunstmuseum Den Haag, Museum of Modern Art, Mondrian/Holtzman Trust, The Kröller-Müller Museum, Gemeentemuseum Den Haag.

4. (Abstraction) suggests "abstracting" or "drawing out". Aristotle used abstraction to explain how human could come to know universals. Chang Shu-Mei, " Abstraction", National Academy of Educational Research (Chinese), browsed on Aug. 15, 2022, https://terms.naer.edu.tw/detail/1df786a3a0294bb3689aa5 e1ac188762/?seq=7.

III. The Deconstructive Path from Observation to Investigation of the Prototypes

Images have been recognized as ostensible "things" whose existence, throughout history, is due to people's memories. Nevertheless, once images are sensed, their existence will be able to transform into a state different than that of "things", becoming "imagery-things". When "imagery-things" surface, images, the moment they are sensed, play the role of the symbols for the establishment of subjectivity. The composition formed (presented) by images consists of multiple trajectories of thinking, running across the variables interlaced in space and time and the duality of virtual and real. Gazing upon "imagery-things", the audience rediscovers their cognition and affection that are divorced from their pre-understanding, and develops new ways of reading and interpretation. Images therefore expand beyond their passive properties to fulfill the enlarged imagination of the audience, allowing the others to describe them freely. It is as magical as finding a gem or a precious shell in the indistinct mess of gravel and sand.

Obviously, images are not completely a type of psychological content, and do not constitute self-consciousness. They only exist in the consciousness toward "imagery-things." An image can only express its spiritual connotation when it breaks away from its "prototype". Images don't exist in souls, neither do they in consciousness, or any other place but in the concern of their creators. They are cognized by sensible and imaginable "imagery-things". On the other hand, the morphology of "imagery-things" must be experienced through the interaction between physical sensations and neurological functions. Like a language (a sign system) of sentiments evoked by souls, it is a transitional[5] status, formulated by symbolic codes and vocabularies. Attempting to enter people's minds in order to translate physical "imagery-things" into spiritual state, these signs and contexts of sentiments are dialectical, they terminate the true appearances of things.

Only when the images are put into the context of systematic thinking, and corresponding relations to the personal body, mind and soul are developed, the existence of the images are able to signify or represent one's thoughts, and elevate "imagery-things" to the unity of "mind" and "will"—the sublime status of consciousness.

The Eye of Abstraction is an attitude, in the name of "images", attempting to investigate how images are looked at or contemplated upon. It analyzes how sentiments generated from distinct personal cognition and are contained in the creation. Although they don't portray realistic scenes or objects, the audience is able to feel the simplicity of colors and forms in the compositions of these images, as well as the delicacy of the subtle relations between them. A macro world is projected through the micro world and passes around pure human emotions; silence, ecstasy, elegance, brilliance or generosity. Appreciating works of this genre, we don't have to concentrate on what is captured by the lens, not because they might not capture anything, but because they encourage the audience to meditate during their interaction with the artworks. It might be the original intention of their authors to express their feelings from deep inside with straightforward compositions, colors and scenes. It is magic to influence how others feel, like a ritual of art, it has the power of healing. We also found that, when colors or forms in images grow beyond a certain degree, they demonstrate a spiritual power greater than any physical thing. The red, blue, black, dark purple or grayscale on the planes are more than colors, they project the spiritual world of the authors. When frustrated by obstacles in life, artists are still able to extract energy from colors and enjoy their creation. It is the spirituality of art, as well as the quintessence of abstract image art.

5. Transition: the phase when one thing is transforming into another state.

Such intangible and unclarified images are not to challenge how the audience feels, but for the creators to figure out their own context. They liberate or deconstruct the structures, allowing overlapping or reflected images to move along coordinates, and reciprocate between vertical and horizontal lines. In either micro or macro view, they break away from historical or memorial links to formulate a non-visual border. The border is not about the "that-has-been" memory or "seal up an instant moment", but lies between bodily sensation and perceptual system, between the deployments for the seeing (thinking) of multiple narratives. It shows the properties of a constantly flowing and changing medium that resists memory by forgetting, resists topography by iconography, and resists imitation by mental imagery. At last, photography, which is given the mission to represent reality, is freed by these images.

Being able to simplify the complicated senses and extract them from reality is evidence that the authors possess "faith" in images so they are able to construct their own abstract views. Their individual views are the limitless extension of the concepts as a whole, expressing a will against deprivation of freedom.

IV. Scene Building and State Building Sensed by Eyes and Minds

Aesthetics presented by images are not indicative the skills of the authors, but rely on their perception of the objects they photograph, and their interpretation of seeing. The artistry of their works relies on the integrality of the authors' taste and perception. What we "see" from our naked eyes is our depiction of seeable, touchable and sensible themes, they are realistic and objective. What we see from our "mind's" eye is subjective perception, coming from the interaction of our rationality and sensibility. It is somewhat obscure, referring to certain differences, and such reference is the perception of all "unseeable" thinking logic. All images are signifying something, and under the perceptual context formed through their metamorphic scenes, the images are brought into the analysis constructed or interpreted in the context. They often swing between sensibility and rationality, between deduction and misjudgement, between outward and inward, between scene making and state building... contemplation, deconstruction, construction... to and fro... Apparently, the structural relations formed by images don't come from randomly selected forms or materials, there must be some affectional elements to support the rationalized sentimentality. So the images are able to break away from the membrane of the real world, and transform (translate) the "visible" (reality) into the "invisible" perceptual images.

One after another abstract images and their linear deployment are comparable to the rhymes of a poem, or the variations of a fugue. The only difference is their ephemeral appearance or everlasting existence. The creator's interpretation is either a very detailed scrutinization, or a macro view of the kaleidoscopic world, or the free forms of recombination after deconstruction, or a romantic occasion transformed from prototypes. Overlapped images become something else, accompanied by gradually changing colors, giving the audience great imagination that destroys the functions of photography, namely representation or narration. On the other hand, they pass around rich human affections, and generate multiple layered ideas. Images strongly intervene in the world, they extract themselves from the real world and at the same time reconstruct scenes of the real world. Content unrelated to the making of images is removed, while some of the unrelated elements are added, and through the virtuality of digital technology, the embodiment of shapeless mass emerges. High resolution images allow the audience to closely observe them and reasonably develop responses to the "simulation" beyond realism. They connect, juxtapose, and shape an alternative scene for expression. Although reasonable, they are a dramatic, imaginative, and magic theater. Some "out-of-body" images that had been stored in the minds of artists suddenly imprinted themselves into their mindscape, becoming almost purely abstract forms. It is like an old perception of Zen hidden in one's mind for a long time which is eventually revealed in the five elements, giving out a taste and all kinds of senses regarding Zen.

It is the unparalleled trait of abstract images, they interpret the visible scenes as well as the invisible but sensible or recognizable world. They construct a state of abstract authenticity. They allure the souls of "the others", they are witchcraft summoning ghosts. At the same time, they mirror social and cultural phenomena; they are the wizardry of simulacrum regarding narcissism or prophecy. Abstract images don't depict or "represent" reality, instead, through shaped appearances, they obscurely refer to the conscious existence of sensations. The investigation of the inner metaphor touches us tremendously without clear motive, for the profound thoughts behind them are where the souls can rest. How does a creator perceive and decode changes in the environment and times, the issues in life, cultural and visual signs, and translate them into the power of truthfulness? How does a creator apply digital tools to carry out images either "as flamboyant as feathers or as heavy as mountains" and transform their charms into clever compositions? Through people's feelings of the "visible" world, the sealed up "slices of time" are translated, in the context of cognition and senses, to interpret the "invisible" connotations and viewpoints.

V. Conclusion

The conditions of expression via images are sense and sensibility, and is accepted gradually over time. Through the "drawing with light", it evokes our agitating souls. They go beyond themselves and cast tangible evidence over us and slough off the membrane of reality to demonstrate their charm. Because our visions are disturbed and enchanted, we are attracted to the existence of the images and our imaginations are inspired, our emotional experiences are reminded. After reading them we are so moved and ecstatic, for the agitation and disorder are constantly changing, they coagulate and disappear instantaneously, and the uncertainty is reminiscent of the mental and emotional struggles we find in poetry. They swing in uniformed illusion and transform reality (desires) in the scene we are facing to dialectical thinking upon "truth", endowing new rhetoric structures and renewed interpretation.

Nevertheless, images are still beyond our comprehension. They are capricious and unpredictable, and they are pointing at something. They can only be felt or gazed at when we project our sentiments (thoughts) on them and make them "imagery-things" with our imagination or association. If we fail to respond to them, we shall return to the appearances of the images and read them from the present situation we are in so we can summon our perceptual system. This explains why we have so very few images in our memory if we are not present. Only when we are "gazing at something at the moment" can our perceptual system activate, and therefore be able to experience the state of becoming speechless when trying to articulate our thoughts.

Bibliography

1. Francois Jullien, *In Praise of Blandness: Proceeding from Chinese Thought and Aesthetics,* Chinese version, trans. by Jou Li (Taipei: Laureate Publishing, 2006).

2. Jacques Derrida, *L'écriture et la différence,* Chinese version, trans. by Chang Ning (Taipei: Rye Field Publishing Co., 2015).

3. Jean-Paul Sartre, *L'Imaginaire,* Chinese version, trans. by Du Xiao-Jen (Shanghai: Shanghai Translation Publishing House, 2008.

4. Maurice Merleau-Ponty, *Phénoménologie de la perception,* Chinese version, trans. by Jiang Zhi-Hui (Shanghai: Commercial Press, 2001).

5. Maurice Merleau-Ponty, *The Visible and Invisible,* Chinese version, trans. by Lou Kuo-Xiang, (Shanghai: Commercial Press, 2001).

6. Maurice Merleau-Ponty, *Eye and Mind*, Chinese version, trans. by Gong Jow-Jiun (Taipei: Arco Books, 2007).

7. Plato, *The Republic*, Chinese version, trans. by Wu Sung-Lin (Taipei: Hwachih Publishing, 2018).

論抽象攝影之美學

徐婉禎／台南應用科技大學美術系助理教授

如果將「攝影」理解為「攝取影像」的簡稱，即「對影像的攝取」，這裡便區分為「攝取」以及「影像」兩部分。「攝取」乃攝影藝術家對影像所採用的光學作用行動模式，而其中涉及的「影像」又有「被選取的影像」以及「被呈顯的影像」之分。攝影藝術家對被選取的影像，進行光學作用的行為，將所得以影像形式呈顯在觀看者眼前，完成了攝影藝術創作的整體過程。

一、洞穴之喻

細究攝影藝術創作的整體過程，不免令人聯想到柏拉圖（Plato）於其《理想國》（The Republic）第七卷開篇所論及的〈洞穴之喻〉（The Allegory of the Cave）。

文中，柏拉圖假借其師蘇格拉底（Socrates）之口，敘述了這個比喻。蘇格拉底描述一個地底下的洞穴，囚犯們被囚禁居住在這個洞穴之中，他們的身體被用鍊子固定四肢、頭部頸子，以致無法起身行動也無法轉頭往後看，僅能直視前方，甚至也不能看見自身及其他同伴。

囚犯所面對的是洞穴的岩壁，身後高舉著正燃燒的火炬，囚犯雖感受到火炬為洞穴帶來光亮，卻看不到也不知光亮的來源。囚犯與火炬之間有一堵矮牆，矮牆遮蔽了正往來穿梭搬運物品的人，所搬運的物品有人體或各式生物的模型，物品很高大，超過矮牆的高度，致使火炬將物品投影在囚犯眼前的壁面，囚犯因此看到眼前來回移動形如人體或各式生物的影子。搬運者有時會停下來相互交談，聲音在洞穴中產生回音，囚犯因此以為他們所聽到的，是眼前的人影或各式生物影子所發出的聲音或彼此之間的對話。

洞穴裡的囚犯們運作智識，以其眼之所見、其耳之所聽演繹出一套可解釋眼前「事實」的學問，試圖從中找出規律邏輯並預測未來將發生的「事實」。囚犯們將可解釋性以及可預設性當作絕對真實的真相，所建構的學問則被當作絕對的真理。

其實，洞穴有一個對外的出入通道，通道可通往地面之外。如果此時有一個囚犯，不知原因地得以掙脫鎖鏈，會發生什麼事？

他看到同伴以及同伴身後的火炬、矮牆、往來搬運的搬運者和人體及各式生物的模型，驚覺過去所見皆非真實。他可能站起身轉向出口看去，因為洞外強光的刺激而暈眩以為自己產生錯覺。他可能沿著通道爬出洞穴，終見洞外世界的日晝更替，影子的出現變化與在水面出現倒影，都源自太陽光的存在。以前洞穴裡面生成的是影子的學問，洞穴外太陽光的世界才是實在的學問，藉此他瞭解了幻象與實在的真假區別。

在這個隱喻里，柏拉圖以洞穴將世界區分為洞內的現象界和洞外的觀念界，現象界是建基在物質世界或經驗世界感官經驗的流變性，不變的知識（epistem）只存在於觀念思想的理型（idea）世界。〈洞穴之喻〉將人類感官所感知的流變性知識，視為有缺陷、虛假不真實的幻象，而真正的知識則應來自恆定不變的真實存在，即完美的「理型」。洞穴劃分了感官假象的洞內世界，以及理型真相的洞外世界，柏拉圖認為唯有掙脫感官認知的枷鎖束縛，方能走出洞外、進入理型世界，從而認識到真實存在而獲得自由。

二、攝影之術

誠然，柏拉圖〈洞穴之喻〉是針對人類知識建構所做的比喻，我們卻從中聯想到「攝影之術」的微妙相應。

攝影起源於暗箱（Camera obscura）的針孔成像，暗箱外的物象因為光學作用，經過針孔而成像於暗箱內的屏幕。經過長時間發展，或增加更多複雜的零件，或改使用不同的材料，致使攝影技術有更多變化的可能，然而基本的暗箱成像原理並沒有改變。攝影將「被選取的影像」轉而變成「被呈顯的影像」，攝影的暗箱正如同柏拉圖所比喻的洞穴，區隔了「被選取的影像」以及「被呈顯的影像」兩個世界。

因為「被選取的影像」來自生活的現實，因為攝影的機械性光學作用的立即性反應，使得長久以來我們將經過攝影所呈顯的影像，也當作具有客觀性的複製真實、具有證據力的紀實報導，照片成為反映真實的檔案文獻。很長時間以來，攝影都歸屬於「科學技術」，或可作為畫家繪畫輔助的工具，但從未跨進「藝術」範疇，例如：十七世紀荷蘭黃金時代畫家維梅爾（Johannes Vermeer），其畫作特有的光影和質感，即被學者推斷為以暗箱輔助繪畫的呈現。攝影作品不被納入藝術展覽之中，1855 年在巴黎舉行的世界博覽會上，攝影作品沒有出現在美術畫廊部分，而是被陳列在工業展廳裡，凸顯顯其技術性而非審美性的價值。

直至十九世紀，1839 年 8 月，路易・達蓋爾（Louis Daguerre）公開展示了一項新的機械技術（即達蓋爾攝影法），攝影對畫家不再只是輔助技術，其媒材所引入的特殊性成為畫面創造新形象的可能，「以光作畫」將攝影帶向藝術創作的領域，並影響當時印象主義者對光與色隨時間變化的追逐。

三、抽象攝影

當攝影成為藝術創作，我們不得不從猶如柏拉圖〈洞穴之喻〉的洞穴走出來，不得不思索暗箱內外「被選取的影像」以及「被呈顯的影像」之間的關係，進而發現攝影作為藝術之主體創造的層面。攝影藝術家自主決定所採用的光學作用行動模式，按其所欲選取所欲拍攝的影像，按其所欲傳達之形式內涵去呈顯影像，每一個環節都是主體創造力的可能發揮。

當攝影所呈顯的影像，不再作為真實之證據而背負敘事功能的重擔，攝影所呈顯的影像可以脫離具象，展現為「為藝術而藝術」（Art for art's sake）的抽象純粹。

「為藝術而藝術」（Art for art's sake），藝術自身即具完整性，藝術自身即具有價值，藝術作品或可為各種非藝術目的而作，但藝術作品的價值評斷乃在其藝術性，「藝術不是道德」、「藝術不是實用」、「藝術不是其他」，藝術價值無須透過說教或道德的功能而獲得。康德（Immanuel Kant）於 1790 年《判斷

力批判》論及審美判斷，便提出審美之無利害關係（disinterestedness）說：「審美不涉及功能，有別於一般快感、功利、道德之活動；審美不涉及概念，有別於邏輯判斷。」康德是針對觀者對藝術作品之審美判斷進行論述，無利害的純粹性也是為藝術而藝術的純粹性。

「抽象之眼」之策展，以「被呈顯的影像」之抽離原「被選取的影像」來定義「抽象」攝影，將抽象攝影分為四大子題展出作品，企圖分類討論抽象攝影之藝術性議題：一、「非象具象」以萬花筒式的影像破碎、重複、拼合，將具象影像給抽象化；二、「理性與感性」又再分為無機構成之理性「冷」抽象影像以及有機情緒之感性「熱」抽象影像，進行理性與感性、冷與熱的類比對照；三、「完形」思及符號（sign）對觀視者心理的意義作用，符號對人之能產生意義，在於其「能指」（signifer）與「所指」（signified）之間「指涉作用」的建立；四、「物介質」從攝影藝術家所採用的光學作用行動模式出發，材質實驗及技術實驗產生超出既定認知的視覺實驗。

四、彩虹之眼

彩虹是如何生成的？彩虹的存在模式為何？

彩虹的生成需要同時有三個元素：太陽光、水滴、觀察者，三者缺一不可，並且三者之間要達到特殊的「關係」（relationship），例如太陽光照射水滴的角度、例如觀察者仰望觀看的角度，彩虹存在的模式就是「關係性」的存在模式。

抽象攝影抽離了具體形象，喪失了敘事教化功能，成為純粹形式化的抽象影像，而如果作品要達至「為藝術而藝術」的美學價值，那就必須如同彩虹，要有三要素的同時存在：現實世界中被選取的影像、光學成像作用下所呈顯的影像、抽象攝影影像的觀看者，三者缺一不可，並且三者之間要達到特殊的「關係」，也就是抽象攝影的美學存在模式是一種「關係性」的存在模式。

「因陀羅之網」是源自佛家的概念，在「因陀羅之網」裡面，每單個地方都有所有其他地方的形象，這就像鑽石的一個切面反射出鑽石的所有其他切面，只要看到一個物體，就能看到所有的物體。對此，佛教哲學唯識學派的結論是，最終存在（ultimate existence）乃根據是否對其有認知而決定，如果對它有所認知，它就存在；如果沒有認知，它就不存在。認知的關係網絡決定是否存在。

「當彩虹出現時，即使它是在空中，看起來似乎和天空是分開的，雖然彩虹離開了天空就不存在。這樣的顯現依賴於由原因與條件聚合決定的相關事件。就因而言，清明的天空可以顯示任何呈現的東西，就是因。就條件而言，陽光、雲彩和雨後濕度的聚合就是條件。當因和條件結合，依賴於這個因與條件的彩虹就出現了，儘管它並不存在。」[1]

1. 溫蒂・哈森坎普、賈娜・懷特編著，《哲蚌寺對話錄：達賴喇嘛與科學家談心智、正念覺察力和實在的本質》，丁一夫譯（新北市：聯經，2021），75。

抽象攝影畢竟是攝影，依賴現實世界影像的選取，不能無中生有，離開了現實世界的影像，抽象攝影就不存在。然而，抽象攝影的美學決定於原因與條件的聚合，決定於觀看者的介入（engagement），觀看者從旁觀的第三人稱，轉而變成介入其中的第一人稱。抽象攝影作品也從獨立於觀察者的物性存在，轉而變成有觀看者介入的情境脈絡，也就是一種「關係」的連動。

抽象攝影藝術家進行創作不必遵循既定的邏輯，他自由地選擇、隨心所欲地強調，表現出抽象的「形」外之音所顯現的韻律詩性。抽象攝影的美學不取決於獨立於觀看者的畫面物性，而是取決於觀看者介入作品之中共同建立的情境脈絡，共同產生一種連動關係。抽象攝影的美學，即是「彩虹之眼」的產生。

On Aesthetics of Abstract Photography

Woanjen HSU / Assistant Professor, Dept. of Fine Arts, Tainan University of Technology

We can understand photography as "capturing images", which consists of "capturing" and "images", the former is making use of an optical phenomena, and the latter is imaging. "Imaging" is either about "selected images" or "presented images". Artists present selected images using optical methods for the audience to complete their actions for the art of photography.

I. The Allegory of the Cave

Any study on the art of photography brings us to *The Allegory of the Cave* in the beginning of Book 7 of Plato's *The Republic*. Using the words of Socrates, Plato described a group of prisoners incarcerated in a subterranean cavern with their necks and legs fettered, and their bodies chained. They couldn't get up, couldn't even turn their heads to see the other inmates next to them. They remained in the same spot, and could look forward only.

In front of them was the rocky wall of the cavern, behind them and higher up were burning torches. These prisoners saw light, but had no idea what the source of the illumination was. Between the torches and the prisoners was a low wall, blocking the prisoners from laborers who were moving things. The things they carried up cast shadows on the rocky wall before the eyes of the prisoners, they appeared to be human images or shapes of animals. Seeing the moving creatures on the wall, and hearing the chatter of the movers and the echoes in the cavern from time to time, the prisoners assumed the sounds were made from the conversations between the shadows.

Reasoning what they were seeing and hearing, prisoners in the cavern deduced what the "truth" was and tried to predict what might happen in the future based on the logic they developed. To them, as long as the phenomena was explainable and predictable, their deduction must be correct, and the knowledge they constructed must be absolute truth.

In fact, there was an exit of the cavern, which led to the ground level outside. What would happen if one of the prisoners broke free from their constraints?

The freed prisoner would see his inmates, the torches behind them, the movers, and the objects in the form of all kinds of creatures moved by them. He would be surprised that all he had seen and believed was false. He might get up and turn toward the exit, and feel dazzled and delusional by the strong light from outside. He might crawl to the exit and leave the cavern and for the first time experience the diurnal cycle, seeing the changes of shadows in light or his own reflection on water. All these came from sunlight, and compared to what he thought he knew of the outside, the knowledge he had learned in the cavern made him understand the difference between imagination and reality, true and untrue.

In this allegory, Plato compared the inside of the cavern to phenomena, and the outside to concepts. Phenomena change just as the physical environment or sensational experience change, and the unchanged epistem exists only in the world of ideas. From the view of *The Allegory of the Cave*, sensational knowledge that keeps changing is defective, false and delusional, and the truth and true knowledge come from unchanged existence and the perfect

mode of "ideas". The Allegory of the Cave divides the world into the false sensations inside and the true ideas outside, and one earns his freedom by knowing the true existence.

II. Techniques of Photography

The Allegory of the Cave was Plato's view about the construction of knowledge, and it subtly corresponds to the techniques of photography.

Via camera obscura using a tiny hole, images outside of it will be projected onto the inside screen through an optical effect. This was how photography began. After a long time of development, more components with complicated functions were added to the dark boxes, more choices of materials were provided, and a greater variety of techniques were developed. Although the optical principles of photography never changed, the emphasis of "selected images" was replaced by "presented images". Camera obscura is more like the cave described by Plato, dividing the two worlds of "selected images" and "presented images".

"Selected images" come from the reality of everyday life and the immediate operation of mechanical optical effects. For a long time, we believed that the images created by photography must be objective duplicates of truth, they are reportage with evidence, or archives documenting real events. Photography had been categorized as scientific technique or a tool assisting painters in drawing (example was Johannes Vermeer, during the Dutch Golden Age, whose art had the unusual quality of light and shadow, and researchers suspected he applied camera obscura for his painting). Photography had never been considered "art", and was never included in art exhibitions. During the Paris Exposition Universelle in 1855, photographic works were not displayed in art galleries, but in an industrial exhibition hall. It was credited by its technique, not its aesthetic.

In August, 1839, Louis-Jacques-Mandé Daguerre openly demonstrated a new mechanical technique of photography (later being called Daguerreotype). Photography was no longer deemed as an assisting art tool, it was a new medium for extraordinary and inventive images. "Drawing with light" brought photography into the field of art, and influenced the pursuit of light and colors reminiscent of the impressionist artists.

III. Abstract Photography

As photography became an art, we had no choice but to walk out from Plato's cave and contemplate the relationship between "selected images" and "presented images" outside of the cave, and the meanings of photography as an art. Photographers decide what optical methods they are using, capturing images they choose, and present them the way they wish to express; each action comes from their subjective creativity.

As images created by photography are no longer obliged to present evidence of truth, photography breaks awayfrom figurative images and becomes pure abstraction, becomes "art for art's sake".

"Art for art's sake" (Latin: ars gratia artis, French: l'art pour l'art) asserts that art is complete in itself, it possesses intrinsic value. Although artworks can have all kinds of functions, they are judged by their artistry. "Art is not moral issues", "not utilitarian", and "art is not something else". The value of art doesn't come from moral imperatives. In *Kritik der Urteilskraft* (*The Critique of Judgment*) published in 1790, Immanuel Kant argued that the judgment of aesthetics was disinterested, it was not for any purpose, and it was different to other activities for pleasure, utilitarianism, or morality. The judgment of aesthetics didn't involve concepts, and was devoid from logic. Kant's discourse on the audience's judgment of aesthetics also supports the argument of pure art for art's sake.

The curatorial perspective of *The Eye of Abstraction* defines abstract photography with "presented images", away from "selected images". It covers four sub-themes to explore its artistry. They are 1. "Figurative and Non-Figurative": Abstraction of figurative images by breaking, repeating, or collaging them like a kaleidoscope; 2. "Sense and Sensibility": The contrast of cold sensibility and warm senses in abstract images; 3. "Gestalt": To the audience psychologically, signs establish reference between the signifiers and the signified; 4. "Material Mediums": Optical effects applied by photographers, and their experiments on materials or techniques that are unconventional to people's visual experience.

IV. Eye of a Rainbow

How is a rainbow formed? How does a rainbow exist?

There are three conditions for a rainbow to form: sunlight, water droplets, and the observer. If any one of the three elements is excluded, no rainbow will appear. Furthermore, these three elements must be in a particular "relationship", such as the angle of sunlight shining on the water droplets, or the angle of the observers lifting their heads to view it. The existence of a rainbow relies on such a "relationship".

Divorced from figurative images, abstract photography lost its function of narrative, becoming pure forms of abstract images. When a work is meant to accomplish the aesthetic value of "art for art's sake", it must be like a rainbow with the particular relationship satisfying the three conditions. They are comparable to: selected images in reality, presented images through optical effects, and the observers of the abstract photographs. Not one of them can be missed, and all of them must reach a certain "relationship". In other words, the aesthetic of abstract photography also exists in a certain relationship.

Indra-jāla (Indra's Net), a Buddhist concept, explicates that every place has images of other places. Like each side of a diamond is reflecting the other side, when one angle is seen, the whole thing is seen. Yogācāra School of Buddhism emphasizes the concept of "Ultimate Existence", which is decided by the viewer's perception. If it is perceived, it exists; if it is not perceived, it doesn't exist. In other words, the net of perception and relationship decides its existence.

"Like a rainbow appearing in the sky, although it seems to be separated from the sky, it doesn't exist without the sky. Such appearance comes from the reliance on causes and conditions. In terms of causes, the clear sky shows anything. In terms of conditions, it requires the assembly of sunlight, clouds and humidity after rain. A rainbow appears under the combination of causes and conditions, although it doesn't truly exist." [1]

After all, abstract photography is still photography, it captures images from the real world. It can't make up images. Abstract photography can't exist without images coming from the real world, and the causes and conditions of its aesthetic are decided by the engagement of the viewers. Engaged, the role of the viewer changes from the third person on the sidelines to the first person and becomes directly involved. The physical existence of abstract photography that had been independent from the viewer becomes a part of the "relationship" because of the engagement of the viewers.

1. Ed. by Wendy Hasenkamp, Janna R. White, *The Monastery and the Microscope: Conversations with the Dalai Lama on Mind, Mindfulness, and the Nature of Reality*, Chinese version, trans. by Ding Yi-Fu (New Taipei City: Linking Publishing, 2021), 75.

Abstract photographers don't have to follow conventional rules, they can choose their themes and emphases freely and express the rhythmic or poetic nature of form, as well as ideas beyond form. The aesthetics of abstract photography is decided by the situational context and correlated involvement co-constructed by the authors and the engaged audience. In short, the aesthetics of abstract photography is comparable to the forming of the "Eye of a Rainbow".

蘇珊・桑塔格（Susan Sontag）說，基本上攝影家被認為應當不只是如世界本來的樣貌去顯示這個世界，應該透過新的視覺判斷，創造出激起興趣的力量。所以「攝影式的觀看活動」，意味著一種在「每個人都看到，卻把它視為太尋常之物以致忽略的東西」裡頭發現美的才能。「非象具象」意指在平日如常的一般事物「非像」裡看出一種「具像」巧趣，看出一種寓意，看出一種不是一般的視覺來。

According to Susan Sontag, photographers are not only representing the world as the world appears, but should stimulate interests with new visual judgment. Thus "photographic seeing" means to discover beauty that "everybody sees but neglects as too ordinary." "Figurative and Non-Figurative" suggests to find the interests of the figurative in the non-figurative, find implication behind ordinary visions.

秦　凱　Dennis K. CHIN

林厚成　LIN Hou-Cheng

江思賢　CHIANG Ssu-Hsien

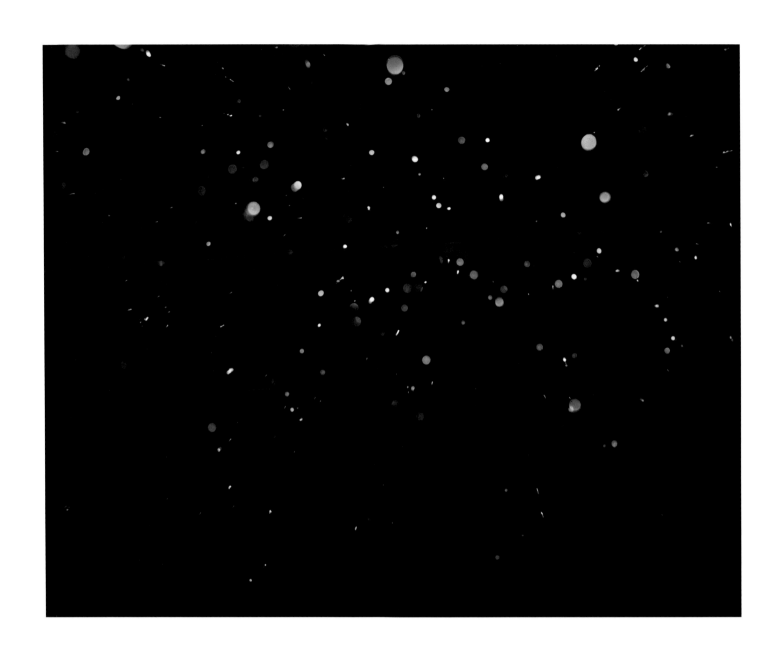

鍾順龍〈星雨 A-11〉
2007 ｜相紙輸出｜ 111×139 公分｜藝術家提供
CHUNG Soon-Long ｜ *Stardust A-11*
2007 ｜ Digital print ｜111×139 cm ｜ Courtesy of the artist

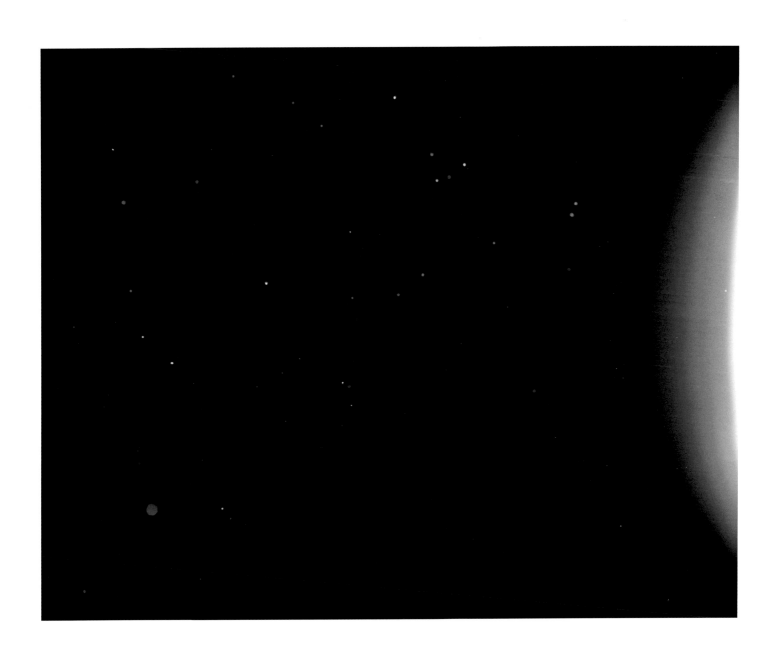

鍾順龍〈星雨 A-43〉
2007 ｜相紙輸出｜ III × I39 公分 ｜ 藝術家提供

CHUNG Soon-Long ｜ *Stardust A-43*
2007 ｜ Digital print ｜ III × I39 cm ｜ Courtesy of the artist

鍾順龍〈星雨 B-15〉
2007 ｜相紙輸出｜ 111×89 公分｜藝術家提供
CHUNG Soon-Long ｜ *Stardust B-15*
2007 ｜ Digital print ｜ 111×89 cm ｜ Courtesy of the artist

鍾順龍〈星雨 B-19〉
2007 ｜相紙輸出｜ 111×89 公分｜藝術家提供
CHUNG Soon-Long ｜ *Stardust B-19*
2007 ｜ Digital print ｜ 111×89 cm ｜ Courtesy of the artist

鍾順龍 〈星雨 B-20〉
2007 │ 相紙輸出 │ 111×89 公分 │ 藝術家提供

CHUNG Soon-Long │ *Stardust B-20*
2007 │ Digital print │ 111×89 cm │ Courtesy of the artist

鍾順龍 〈星雨 B-23〉
2007 │ 相紙輸出 │ 111×89 公分 │ 藝術家提供

CHUNG Soon-Long │ *Stardust B-23*
2007 │ Digital print │ 111×89 cm │ Courtesy of the artist

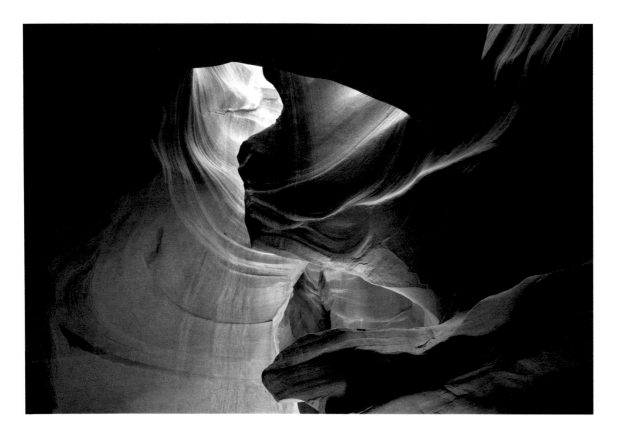

阮偉明〈光之幽谷 A04〉
1997 ｜ 噴墨輸出 ｜ 64×96 公分 ｜ 藝術家授權

YUAN Wei-Ming ｜ *Cave Light A04*
1997 ｜ Inkjet print ｜ 64×96 cm ｜ Courtesy of the artist

阮偉明〈光之幽谷 A11〉
1997 ｜ 噴墨輸出 ｜ 64×128 公分 ｜ 藝術家授權
YUAN Wei-Ming ｜ *Cave Light A11*
1997 ｜ Inkjet print ｜ 64×128 cm ｜ Courtesy of the artist

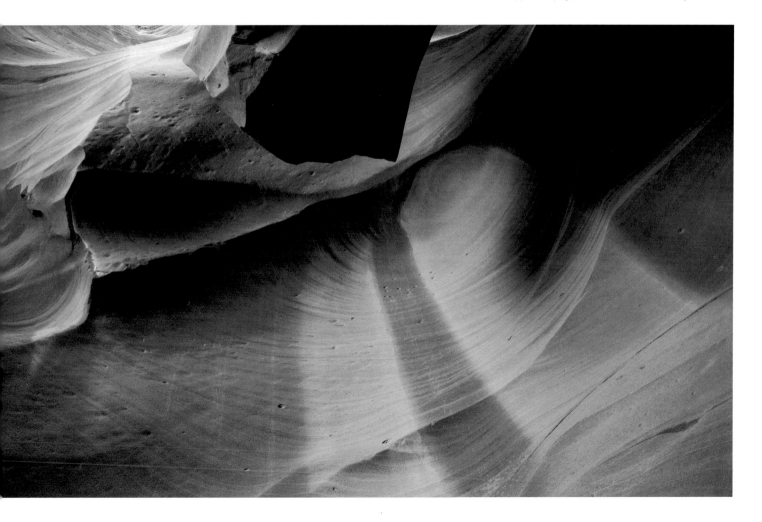

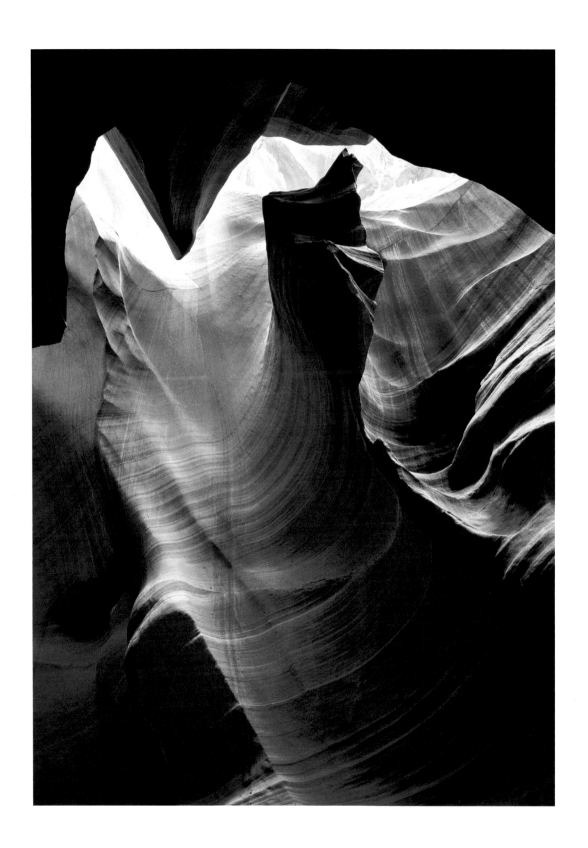

阮偉明〈光之幽谷 A02〉
1997 | 噴墨輸出 | 92.4×66 公分 | 藝術家授權

YUAN Wei-Ming | *Cave Light A02*
1997 | Inkjet print | 92.4×66 cm | Courtesy of the artist

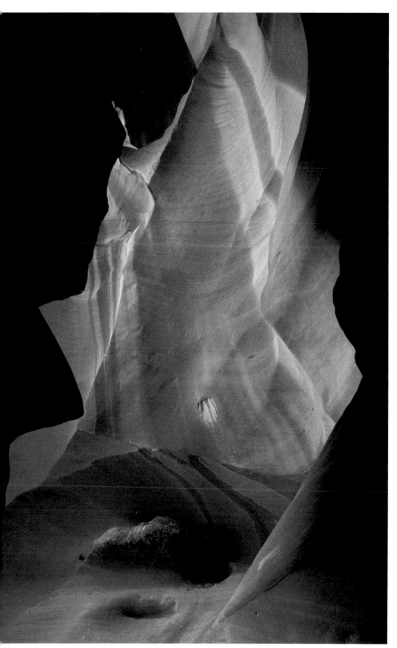

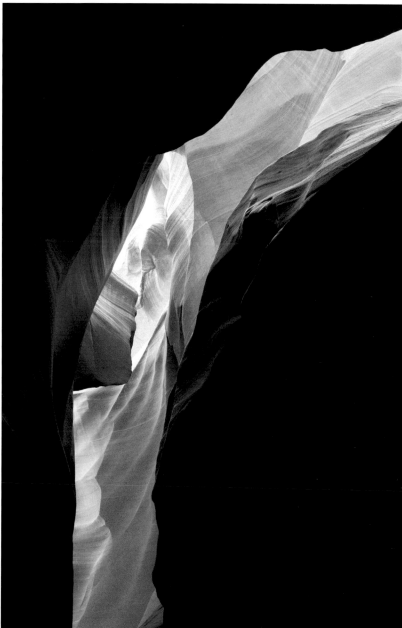

阮偉明〈光之幽谷 A07〉
1997 │ 噴墨輸出 │ 94.3×65 公分 │ 藝術家授權
YUAN Wei-Ming │ *Cave Light A07*
1997 │ Inkjet print │ 94.3×65 cm │ Courtesy of the artist

阮偉明〈光之幽谷 A03〉
1997 │ 噴墨輸出 │ 94.3×65 公分 │ 藝術家授權
YUAN Wei-Ming │ *Cave Light A03*
1997 │ Inkjet print │ 94.3×65 cm │ Courtesy of the artist

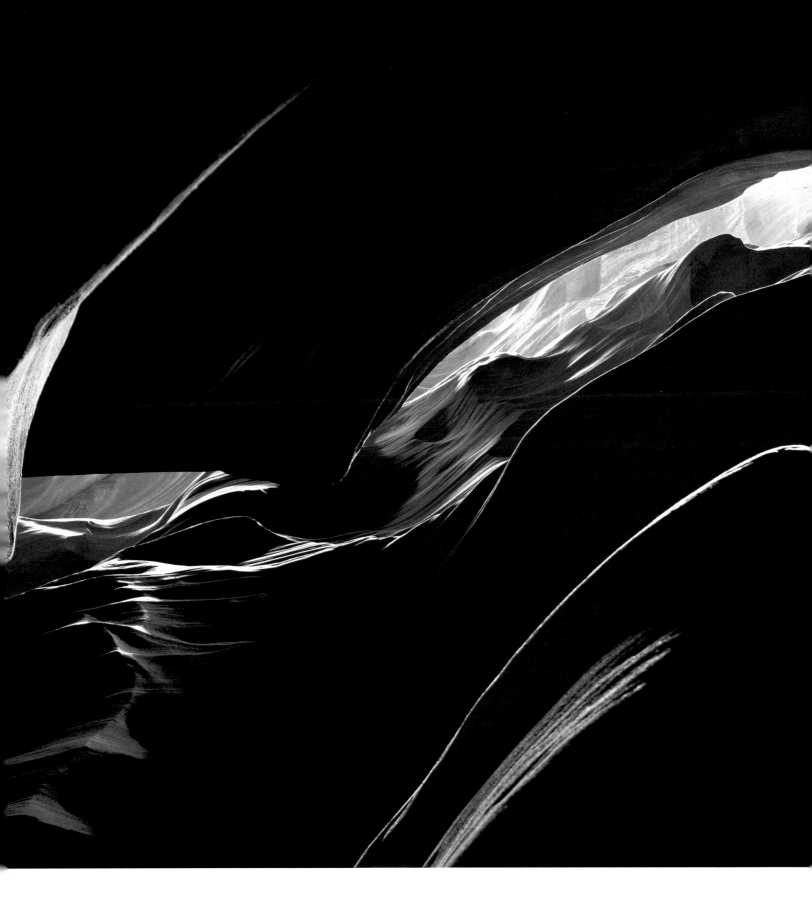

阮偉明〈光之幽谷 A10〉
1997 ｜ 噴墨輸出 ｜ 64×128 公分 ｜ 藝術家授權
YUAN Wei-Ming ｜ *Cave Light A10*
1997 ｜ Inkjet print ｜ 64×128 cm ｜ Courtesy of the artist

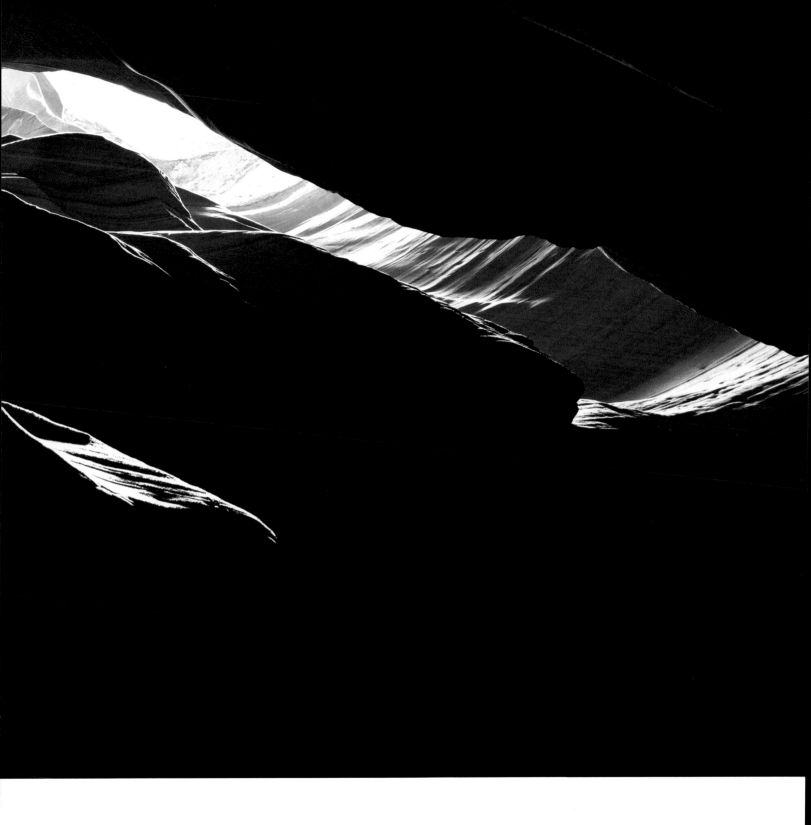

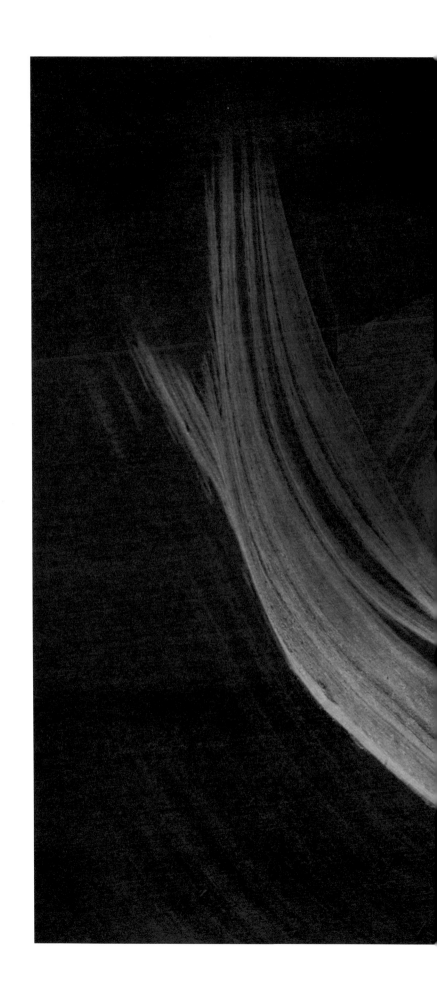

阮偉明〈光之幽谷 A15〉
2013 ｜ 噴墨輸出 ｜ 64×92.4 公分 ｜ 藝術家授權
YUAN Wei-Ming ｜ *Cave Light A15*
2013 ｜ Inkjet print ｜ 64×92.4 cm ｜ Courtesy of the artist

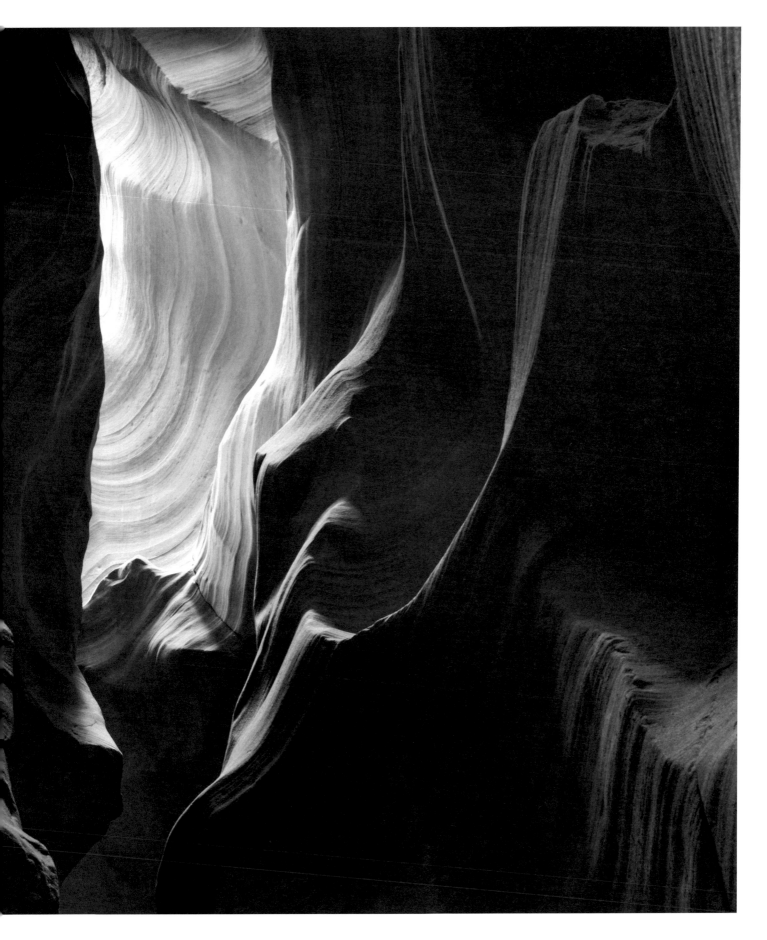

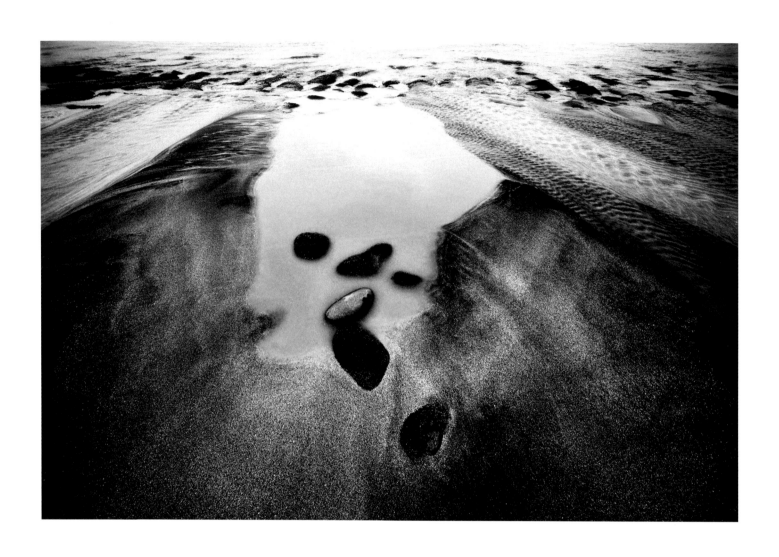

莊明景〈老梅〉
2009-2015 │噴墨輸出│ 100.2×145 公分
國家攝影文化中心典藏

Mike CHUANG │ *Lao-Mei*
2009-2015 │ Inkjet print │ 100.2×145 cm
Collection of the National Center of Photography and Images

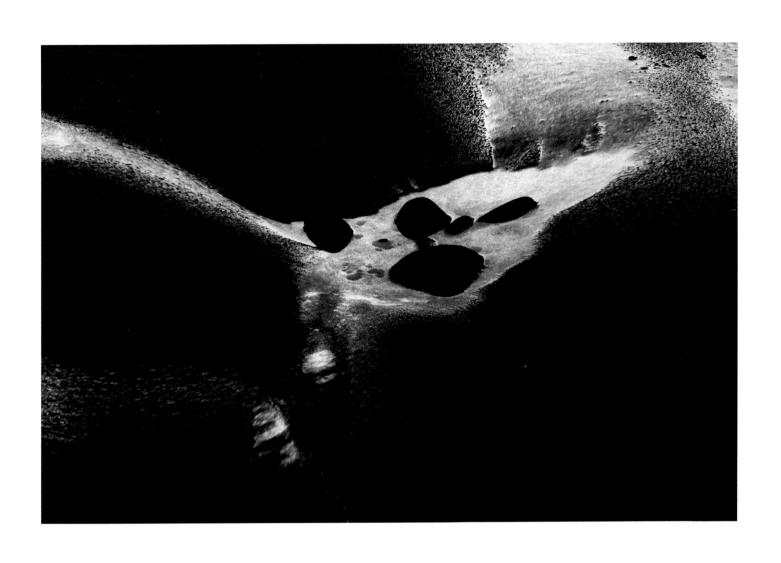

莊明景〈老梅〉
2009-2015 ｜ 噴墨輸出 ｜ 100.2×145 公分
國家攝影文化中心典藏

Mike CHUANG ｜ *Lao-Mei*
2009-2015 ｜ Inkjet print ｜ 100.2×145 cm
Collection of the National Center of Photography and Images

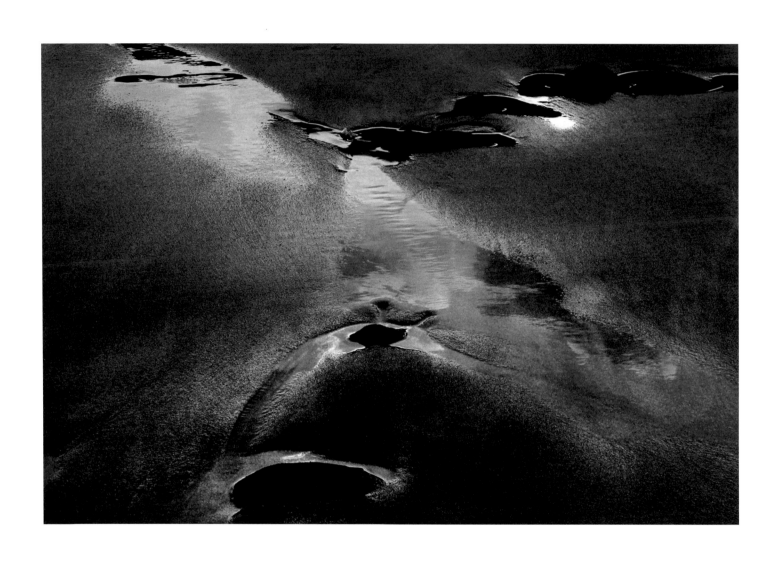

莊明景〈老梅〉
2009-2015 ｜噴墨輸出 ｜ 100.2×145 公分
國家攝影文化中心典藏

Mike CHUANG ｜ *Lao-Mei*
2009-2015 ｜ Inkjet print ｜ 100.2×145 cm
Collection of the National Center of Photography and Images

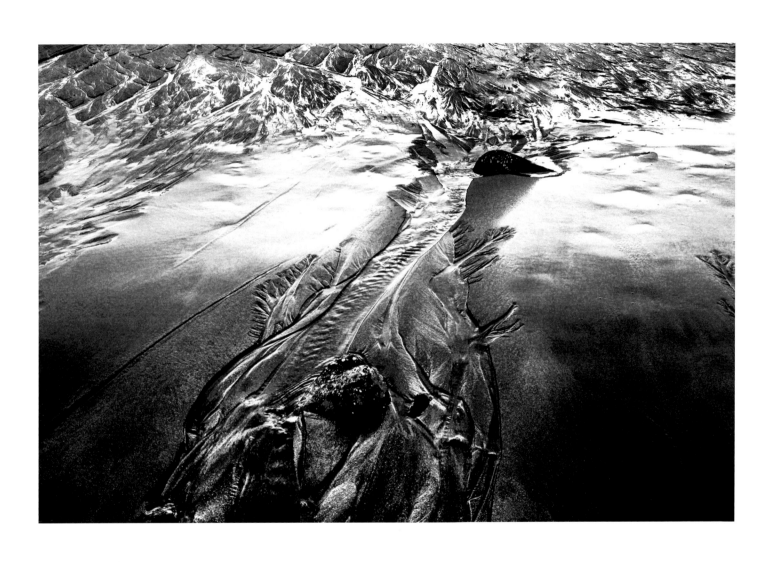

莊明景〈老梅〉
2009-2015 │ 噴墨輸出 │ 100.2×145 公分
國家攝影文化中心典藏

Mike CHUANG │ *Lao-Mei*
2009-2015 │ Inkjet print │ 100.2×145 cm
Collection of the National Center of Photography and Images

許淵富〈峰〉
1982｜明膠銀鹽相紙｜39×59 公分
國家攝影文化中心典藏

HSU Yuan-Fu｜*Peaks*
1982｜Gelatin silver print｜39×59 cm
Collection of the National Center of
Photography and Images

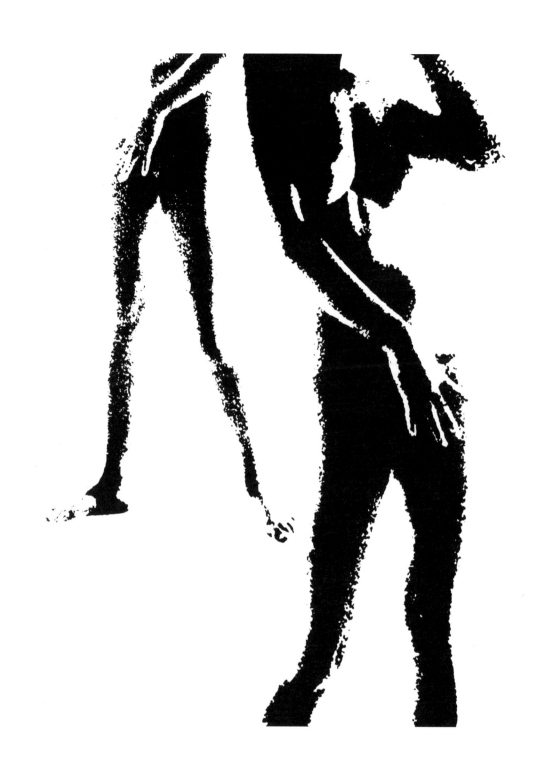

許淵富 〈羞〉
1965 ｜ 明膠銀鹽相紙 ｜ 58×49.5 公分 ｜ 國家攝影文化中心典藏
HSU Yuan-Fu ｜ *Shyness*
1965 ｜ Gelatin silver print ｜ 58×49.5 cm
Collection of the National Center of Photography and Images

許淵富 〈袒〉
1966 ｜ 明膠銀鹽相紙 ｜ 60.5×47.5 公分 ｜ 國家攝影文化中心典藏
HSU Yuan-Fu ｜ *Nude*
1966 ｜ Gelatin silver print ｜ 60.5×47.5 cm
Collection of the National Center of Photography and Images

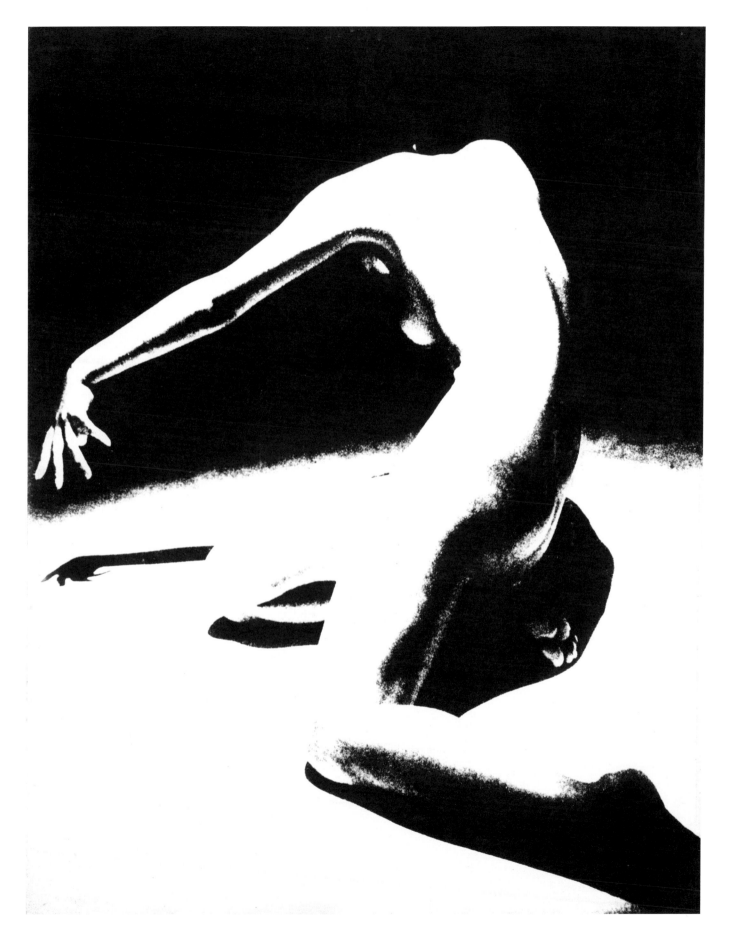

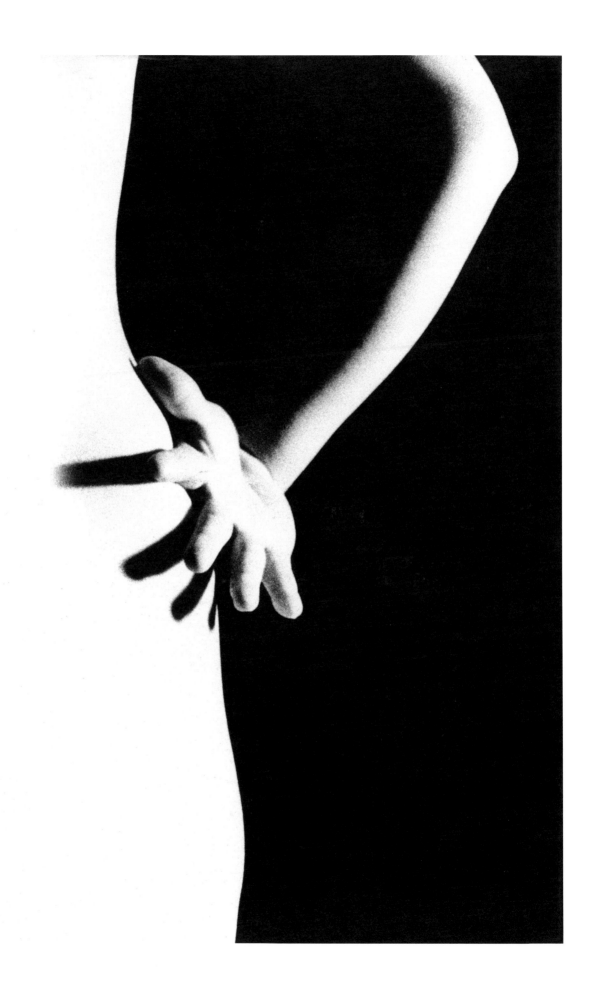

許淵富〈手〉
1979 │ 明膠銀鹽相紙 │ 58×44.5 公分 │ 國家攝影文化中心典藏
HSU Yuan-Fu │ *Hand*
1979 │ Gelatin silver print │ 58×44.5 cm
Collection of the National Center of Photography and Images

許淵富〈構成〉
1963 │ 明膠銀鹽相紙 │ 42.5×61 公分 │ 國家攝影文化中心典藏
HSU Yuan-Fu │ *Structure*
1963 │ Gelatin silver print │ 42.5×61 cm
Collection of the National Center of Photography and Images

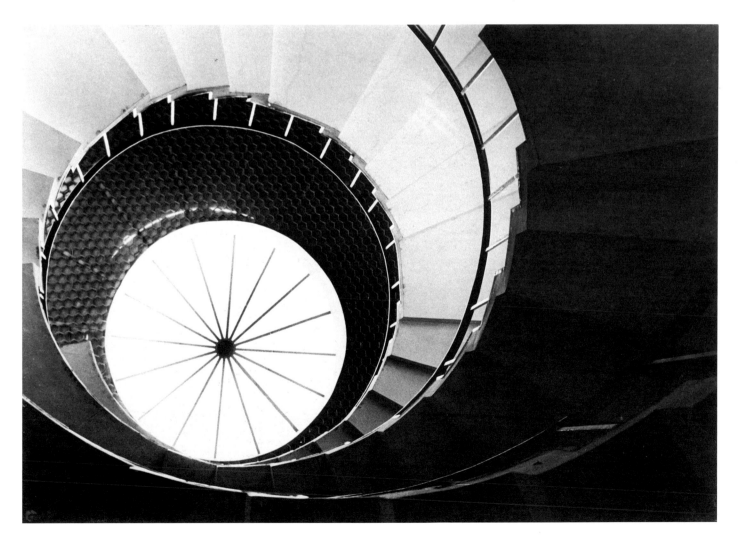

秦凱〈城市印象〉
1999 | 噴墨輸出 | 44.1×28 公分 | 國家攝影文化中心典藏

Dennis K. CHIN | *City Impression*
1999 | Inkjet print | 44.1×28 cm
Collection of the National Center of Photography and Images

秦凱〈歲月遺痕〉
2010 ｜ 噴墨列印 ｜ 29.5×44.1 公分
國家攝影文化中心典藏

Dennis K. CHIN ｜ *Remains of Time*
2010 ｜ Inkjet print ｜ 29.5×44.1 cm
Collection of the National Center of
Photography and Images

秦凱〈出水芙蓉〉
1995 ｜ 噴墨輸出 ｜ 90×60.5 公分 ｜ 國家攝影文化中心典藏

Dennis K. CHIN ｜ *Surfacing Lotus*
1995 ｜ Inkjet print ｜ 90×60.5 cm
Collection of the National Center of Photography and Images

秦凱〈聖山〉
2002 ｜ 噴墨輸出 ｜ 33×44.1 公分 ｜ 國家攝影文化中心典藏
Dennis K. CHIN ｜ *Holy Mountain*
2002 ｜ Inkjet print ｜ 33×44.1 cm ｜ Collection of the National Center of Photography and Images

林厚成〈逝者而逝〉
2013 │ 數位輸出 │ 60.5×80.5 公分，共 5 件 │ 藝術銀行典藏
LIN Hou-Cheng │ *Passed by Past*
2013 │ Digital print │ 60.5×80.5 cm (5 pieces) │ Collection of the Art Bank Taiwan

江思賢〈山 No.05〉
2018 ｜ 數位輸出、Awagami 阿波和紙 ｜ 65×100 公分 ｜ 藝術家提供
CHIANG Ssu-Hsien ｜ *Mountain No.05*
2018 ｜ Digital print on the Awagami paper ｜ 65×100 cm ｜ Courtesy of the artist

江思賢〈山 No.10〉
2018　｜　數位輸出、Awagami 阿波和紙　｜　40×60 公分　｜　藝術家提供
CHIANG Ssu-Hsien　｜　*Mountain No.10*
2018　｜　Digital print on the Awagami paper　｜　40×60 cm　｜　Courtesy of the artist

江思賢〈山 No.16〉
2018 │數位輸出、Awagami 阿波和紙│ 40×60 公分│藝術家提供

CHIANG Ssu-Hsien │ *Mountain No.16*
2018 │ Digital print on the Awagami paper │ 40×60 cm │ Courtesy of the artist

江思賢〈山 No.01〉
2018 ｜ 數位輸出、Awagami 阿波和紙 ｜ 40×60 公分 ｜ 藝術家提供
CHIANG Ssu-Hsien ｜ *Mountain No.01*
2018 ｜ Digital print on the Awagami paper ｜ 40×60 cm ｜ Courtesy of the artist

江思賢〈山 No.08〉
2018 │ 數位輸出、Awagami 阿波和紙 │ 40×60 公分
藝術家提供

CHIANG Ssu-Hsien │ *Mountain No.08*
2018 │ Digital print on the Awagami paper │ 40×60 cm
Courtesy of the artist

理性與感性

Sense and Sensibility

約翰・伯格（John Berger）說：「當一張照片記錄被看到的東西時，在本
質上總是會指涉到那些沒有被看到的東西。他是從連續的時刻裡孤立、
保留並呈現了某一瞬間。」，「繪畫詮釋世界，將世界轉譯成繪畫的語言，
但攝影卻沒有自身的語言，學習閱讀攝影就和學習閱讀腳印或心電圖一
樣。攝影處理的語言是事件的語言。它的所有參照都在自身外部，連續
性由此而來。」觀賞抽象攝影，我們在片斷的影像裡，從外部的參照得
到理性與感性的呼應。

John Berger said, "A photograph, whilst recording what has been seen, always and
by its nature refers to what is not seen. It isolates, preserves and presents a moment
taken from a continuum. The power of a painting depends upon its internal
references. Its reference to the natural world beyond the limits of the painted
surface is never direct; it deals in equivalents. Or, to put it another way: painting
interprets the world, translating it into its own language. But photography has no
language of its own. One learns to read photographs as one learns to read footprints
or cardiograms. The language in which photography deals is the language of
events. All its references are external to itself. Hence the continuum." Upon viewing
abstract photography, we respond to the fragmental images, rationally and sensibly.

林壽宇	Richard LIN
王攀元	WANG Pan-Yuan
羅平和	LO Pin-Ho
阮偉明	YUAN Wei-Ming
鄧博仁	TENG Po-Jen
牛俊強	NIU Jun-Qiang
蔡昌吉	TSAI Chang-Chi
江思賢	CHIANG Ssu-hsien
林添福	LIN Tian-Fu

林壽宇〈而它來去匆匆〉
1970 ｜ 複合媒材 ｜ 75.8×102 公分
國立臺灣美術館典藏

Richard LIN ｜ *And It Came to Pass*
1970 ｜ Mixed media ｜ 75.8×102 cm
Collection of the National Taiwan Museum of Fine Arts

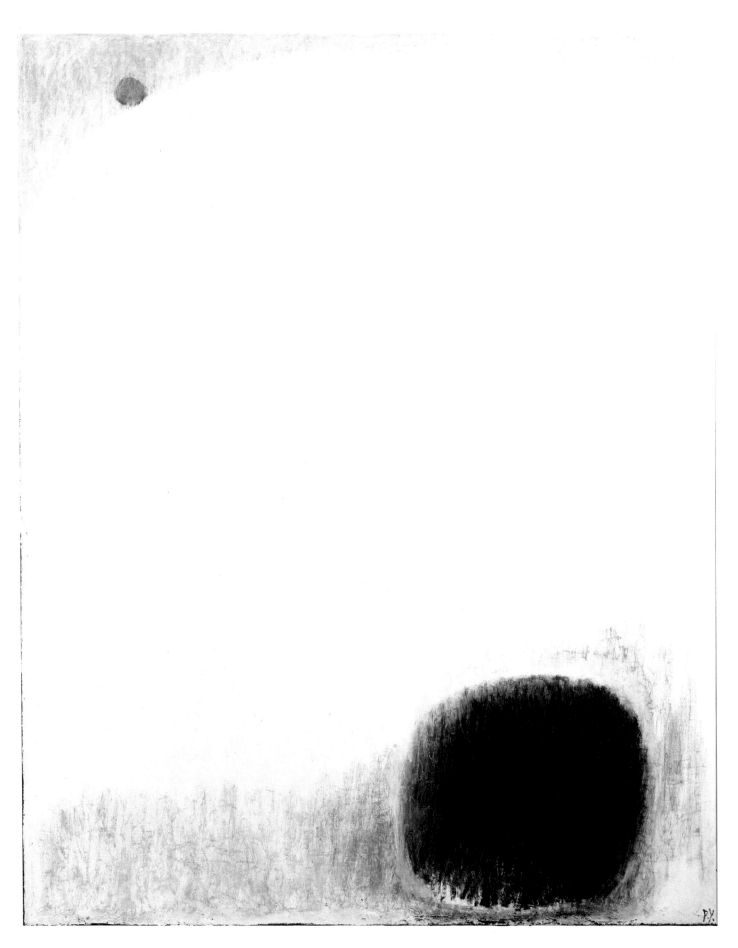

王攀元〈黑色的太陽〉
1963 │油畫│ 162×130 公分│國立臺灣美術館典藏
WANG Pan-Yuan │ *Black Sun*
1963 │ Oil painting │ 162×130 cm
Collection of the National Taiwan Museum of Fine Arts

羅平和〈香格里拉蘭花島〉
2010 │版畫│ 90.5×91.7 公分│國立臺灣美術館典藏
LO Pin-Ho │ *Shangri-La's Orchid Island*
2010 │ Print │ 90.5×91.7 cm
Collection of the National Taiwan Museum of Fine Arts

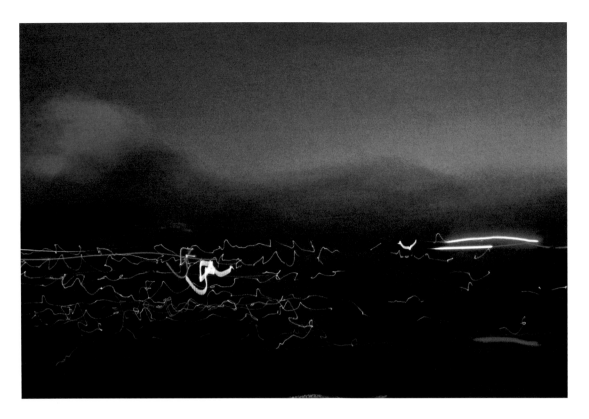

阮偉明〈夜航 J01〉
2018 ｜ 噴墨輸出 ｜ 40×60 公分 ｜ 藝術家授權
YUAN Wei-Ming ｜ *Night Flight J01*
2018 ｜ Inkjet print ｜ 40×60 cm ｜ Courtesy of the artist

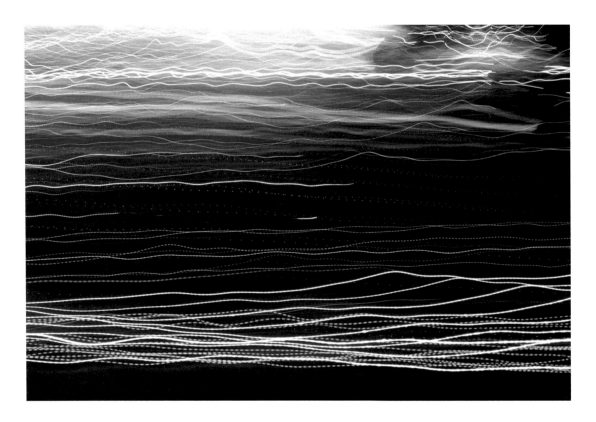

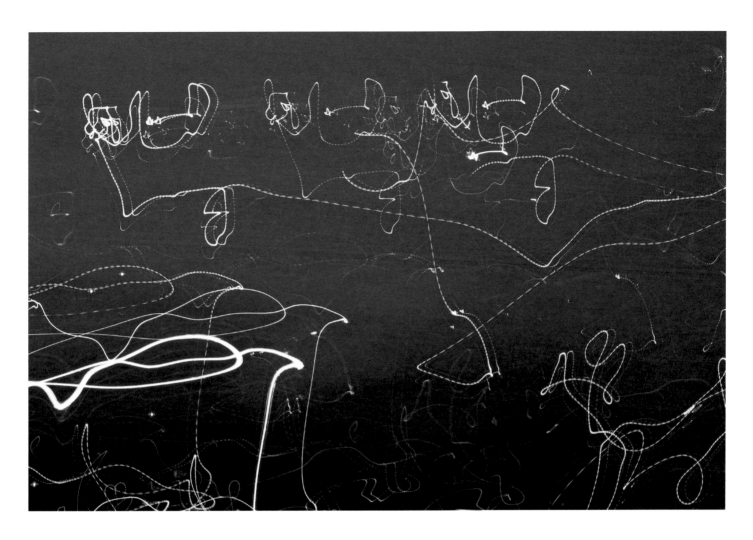

阮偉明〈夜航 J21〉
2019 ｜噴墨輸出｜ 40×60 公分｜藝術家授權
YUAN Wei- Ming ｜ *Night Flight J21*
2019 ｜ Inkjet print ｜ 40×60 cm ｜ Courtesy of the artist

阮偉明〈夜航 J04〉
2017 ｜噴墨輸出｜ 40×60 公分｜藝術家授權
YUAN Wei- Ming ｜ *Night Flight J04*
2017 ｜ Inkjet print ｜ 40×60 cm ｜ Courtesy of the artist

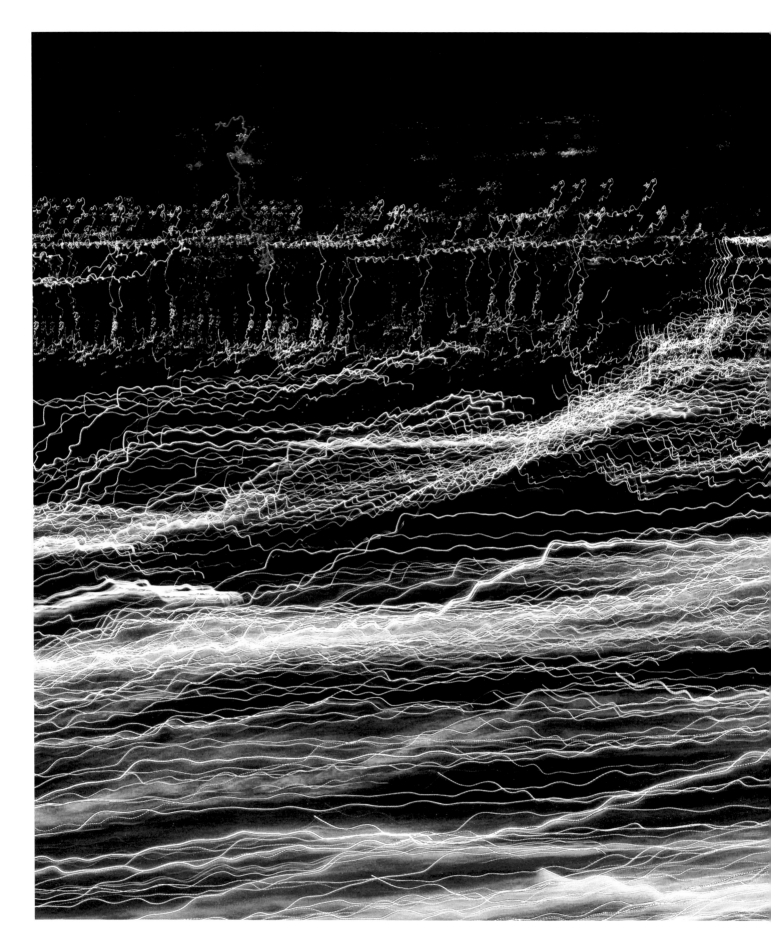

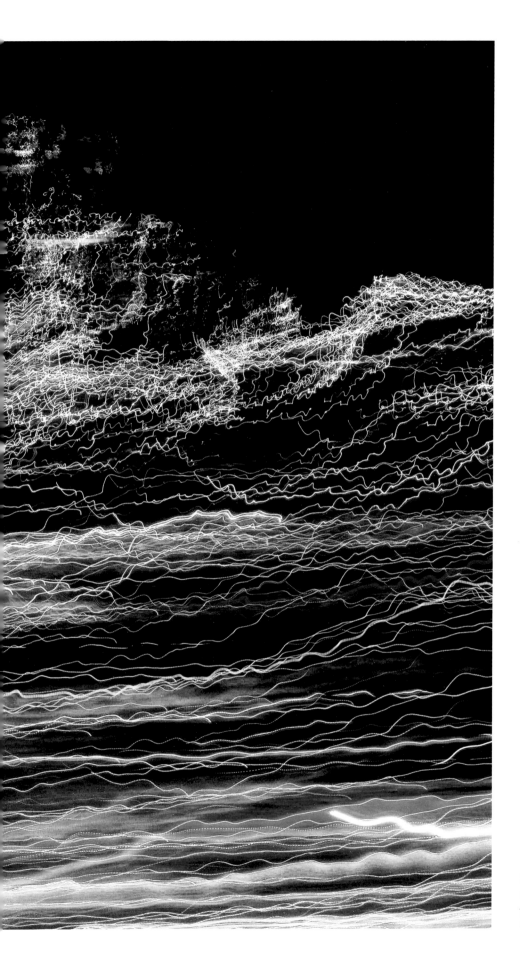

阮偉明〈夜航 J06〉
2017 ｜ 噴墨輸出 ｜ 40×60 公分 ｜ 藝術家授權
YUAN Wei-Ming ｜ *Night Flight J06*
2017 ｜ Inkjet print ｜ 40×60 cm ｜ Courtesy of the artist

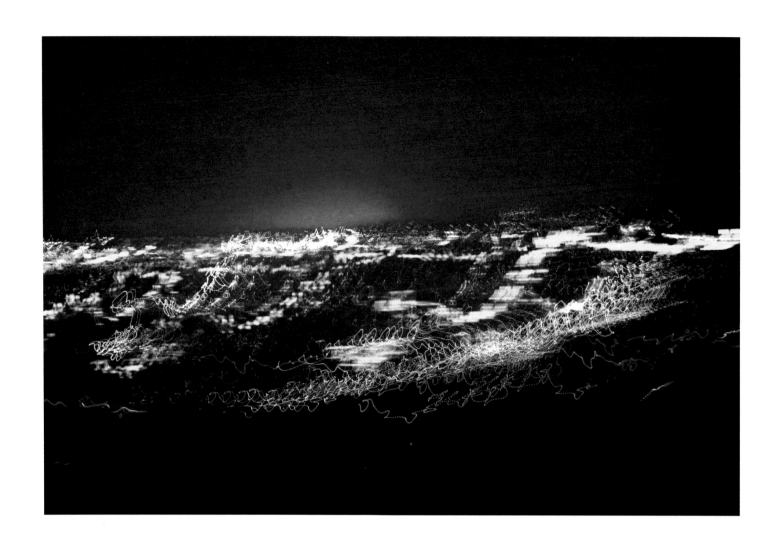

阮偉明〈夜航 J15〉
2018 ｜噴墨輸出｜40×60 公分｜藝術家授權

YUAN Wei-Ming ｜ *Night Flight J15*
2018 ｜ Inkjet print ｜ 40×60 cm ｜ Courtesy of the artist

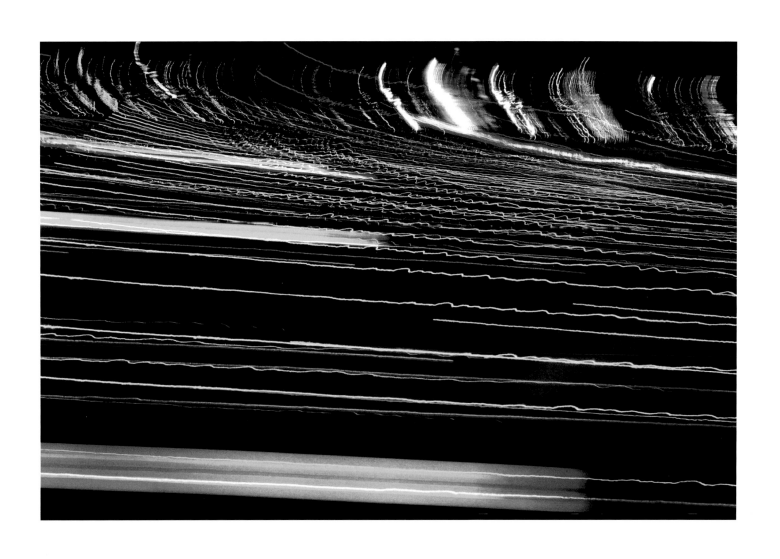

阮偉明〈夜航 J23〉
2019 ｜噴墨輸出 ｜ 40×60 公分 ｜藝術家授權

YUAN Wei- Ming ｜ *Night Flight J23*
2019 ｜ Inkjet print ｜ 40×60 cm ｜ Courtesy of the artist

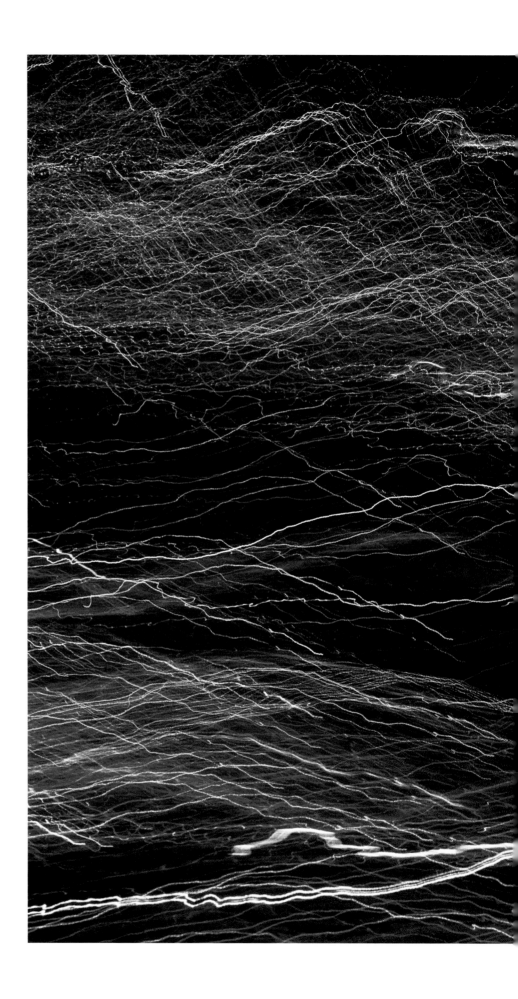

阮偉明〈夜航 J25〉
2019｜噴墨輸出｜40×60 公分｜藝術家授權
YUAN Wei-Ming｜*Night Flight J25*
2019｜Inkjet print｜40×60 cm
Courtesy of the artist

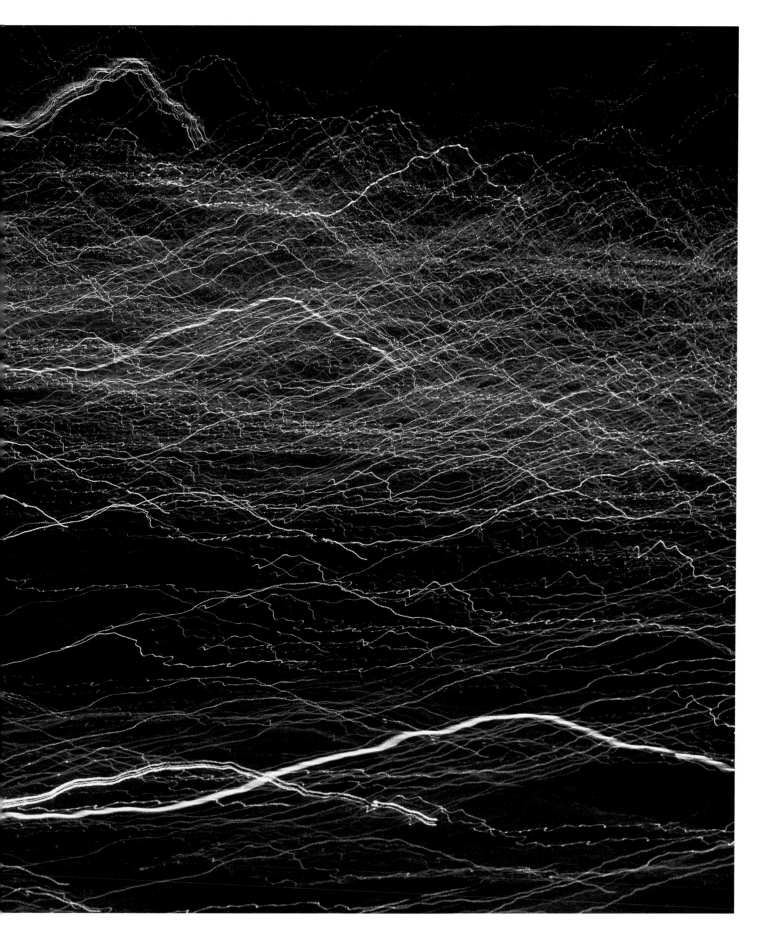

鄧博仁 〈輕呼吸〉
2000 ｜ 藝術微噴、德國純棉蝕刻藝術紙 ｜ 100×75 公分 ｜ 藝術家授權
TENG Po-Jen ｜ *Quiet Breathing*
2000 ｜ Giclée print on rag etching ｜ 100×75 cm ｜ Courtesy of the artist

鄧博仁〈輕呼吸〉
2000 ｜ 藝術微噴、德國純棉蝕刻藝術紙 ｜ 100×75 公分 ｜ 藝術家授權
TENG Po-Jen ｜ *Quiet Breathing*
2000 ｜ Giclée print on rag etching ｜ 100×75 cm ｜ Courtesy of the artist

鄧博仁〈輕呼吸〉
2000 │藝術微噴、德國純棉蝕刻藝術紙│ 37×50 公分│藝術家授權

TENG Po-Jen │ *Quiet Breathing*
2000 │ Giclée print on rag etching │ 37 × 50 cm │ Courtesy of the artist

鄧博仁〈輕呼吸〉
2000 ｜藝術微噴、德國純棉蝕刻藝術紙 ｜ 74×100 公分 ｜藝術家授權
TENG Po-Jen ｜ *Quiet Breathing*
2000 ｜ Giclée print on rag etching ｜ 74×100 cm ｜ Courtesy of the artist

牛俊強〈邊界 -2〉
2020｜攝影數位輸出、紙質｜88.5×58×3.5 公分
藝術銀行典藏

NIU Jun-Qiang｜*The Borderline-2*
2020｜Digital print on paper｜88.5×58×3.5 cm
Collection of the Art Bank Taiwan

牛俊強〈無題 -6〉
2019｜攝影數位輸出、紙質｜74.5×54.5×7 公分
藝術銀行典藏

NIU Jun-Qiang｜*Untitled-6*
2019｜Digital print on paper｜74.5×54.5×7 cm
Collection of the Art Bank Taiwan

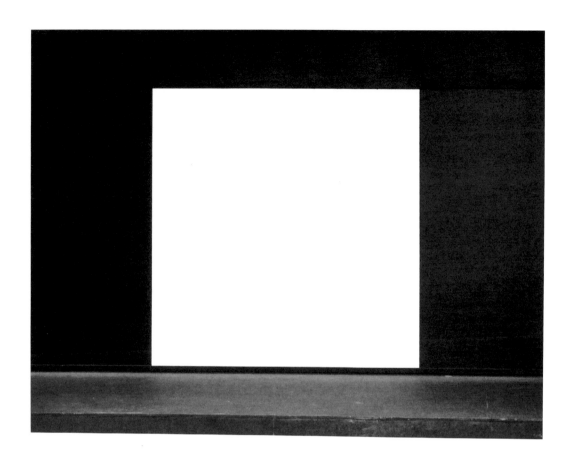

蔡昌吉〈牆〉
2014 │ 數位微噴 │ 70×90 公分，共 3 件 │ 藝術銀行典藏
TSAI Chang-Chi │ *The Wall*
2014 │ Giclée │ 70×90 cm (3 pieces) │ Collection of the Art Bank Taiwan

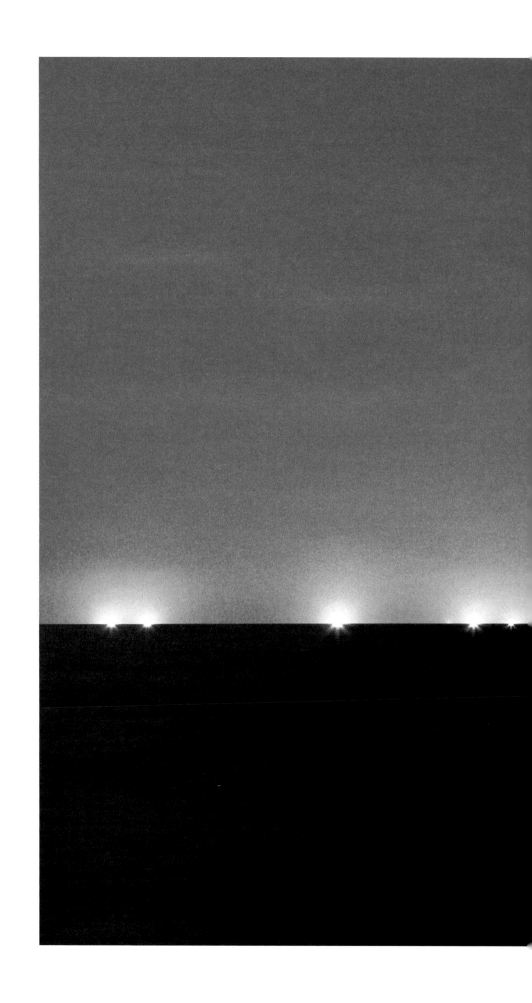

江思賢〈海上星光 No.10〉
2009 │噴墨輸出、MUSEO® 銀鹽紙基紙
60×90 公分│藝術家提供

CHIANG Ssu-Hsien │ *Starlight of the Sea No.10*
2009 │ Digital print on MUSEO® silver paper
60×90 cm │ Courtesy of the artist

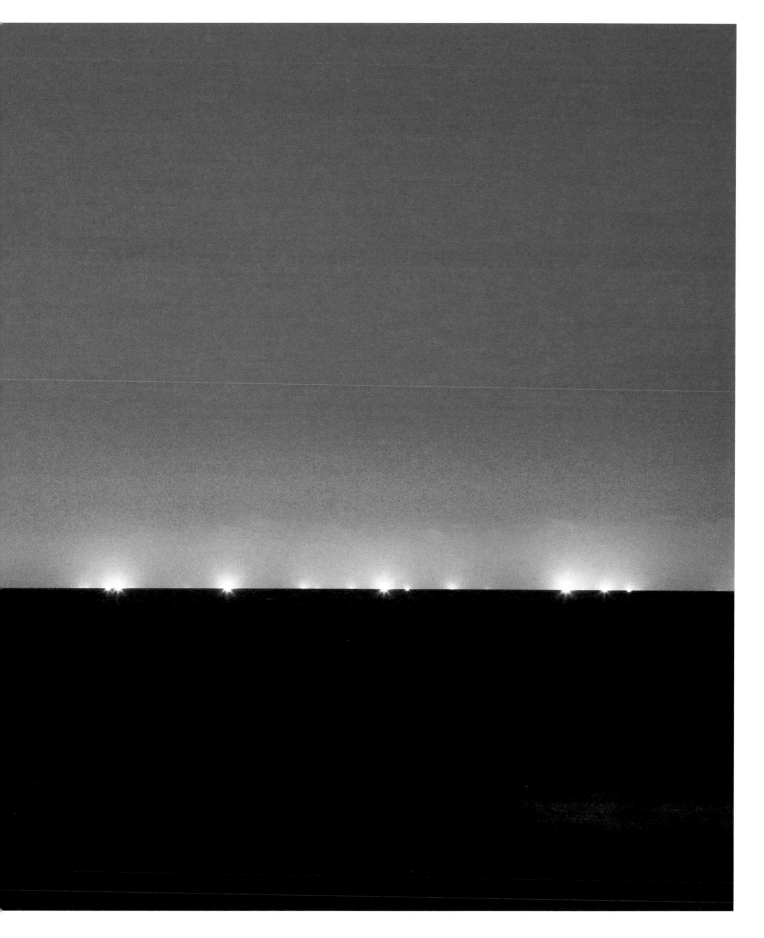

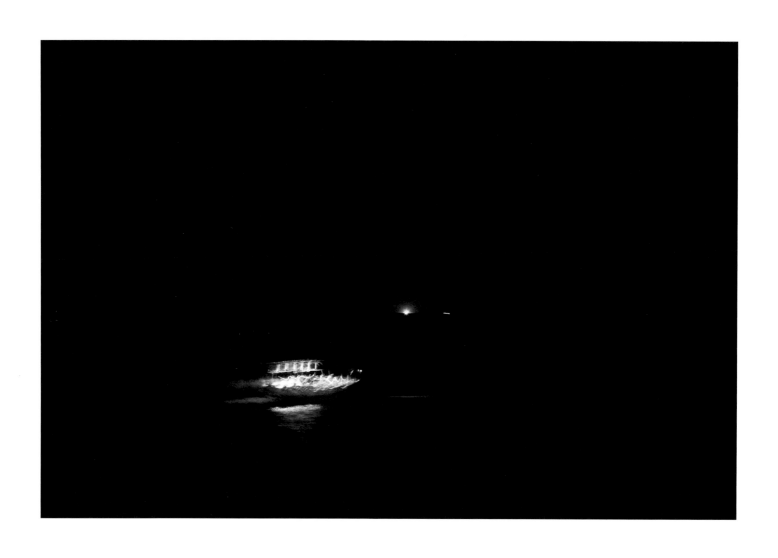

江思賢〈海上星光 No.01〉
2009 ｜噴墨輸出、MUSEO® 銀鹽紙基紙 ｜ 60×90 公分 ｜藝術家提供
CHIANG Ssu-Hsien ｜ *Starlight of the Sea No.01*
2009 ｜ Digital print on MUSEO® silver paper ｜ 60×90 cm ｜ Courtesy of the artist

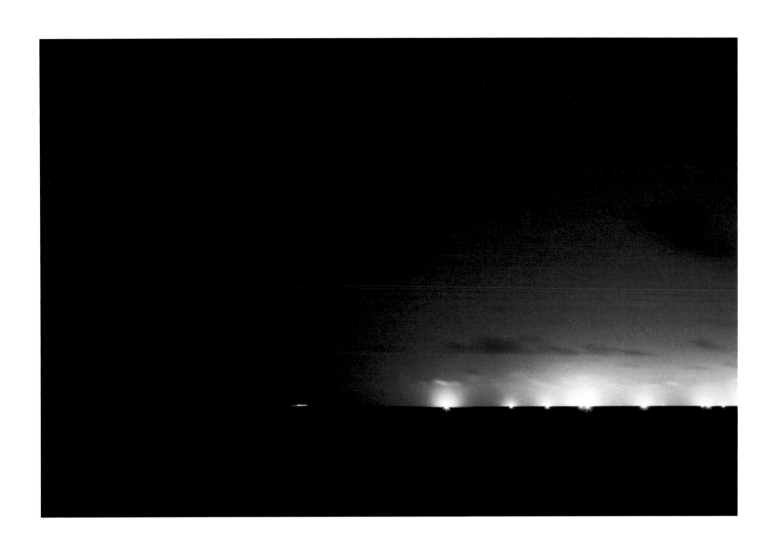

江思賢〈海上星光 No.03〉
2009 ｜ 噴墨輸出、MUSEO® 銀鹽紙基紙 ｜ 60×90 公分 ｜ 藝術家提供
CHIANG Ssu-Hsien ｜ *Starlight of the Sea No.03*
2009 ｜ Digital print on MUSEO® silver paper ｜ 60×90 cm ｜ Courtesy of the artist

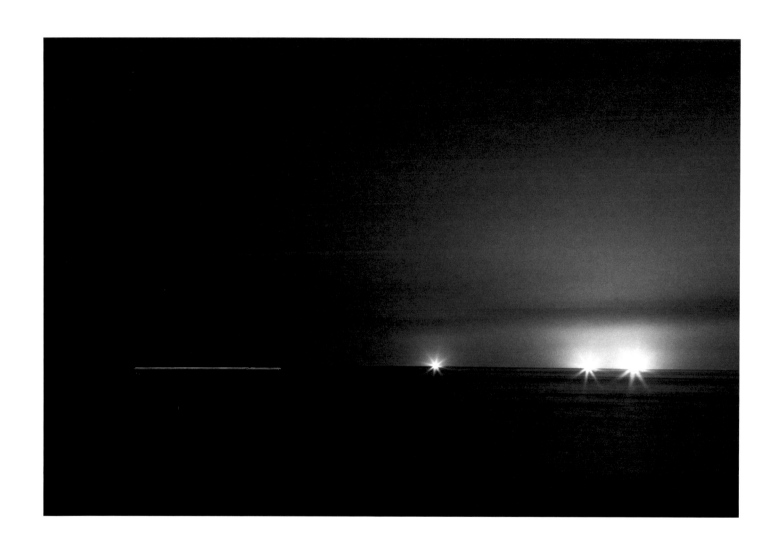

江思賢〈海上星光 No.13〉
2010｜噴墨輸出、MUSEO® 銀鹽紙基紙｜60×90 公分｜藝術家提供
CHIANG Ssu-Hsien｜ *Starlight of the Sea No.13*
2010｜Digital print on MUSEO® silver paper｜60×90 cm｜Courtesy of the artist

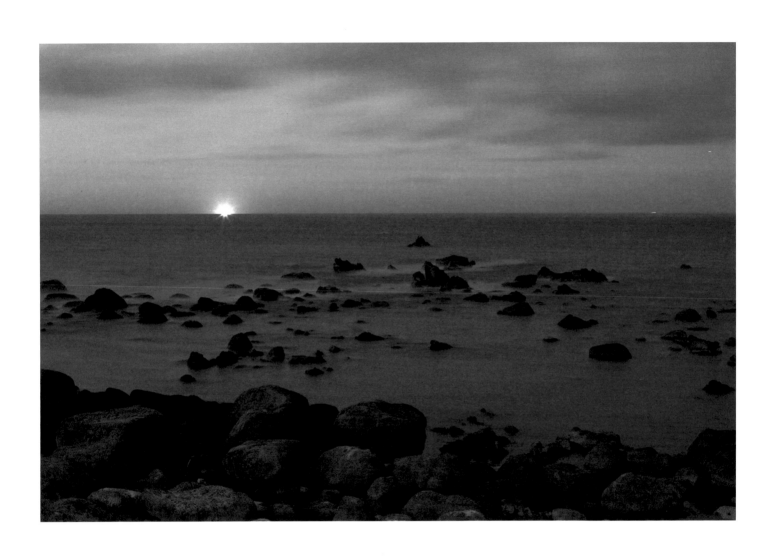

江思賢〈海上星光 No.16〉
2009 ｜噴墨輸出、MUSEO® 銀鹽紙基紙 ｜ 60×90 公分｜藝術家提供
CHIANG Ssu-Hsien ｜ *Starlight of the Sea No.16*
2009 ｜ Digital print on MUSEO® silver paper ｜ 60×90 cm ｜ Courtesy of the artist

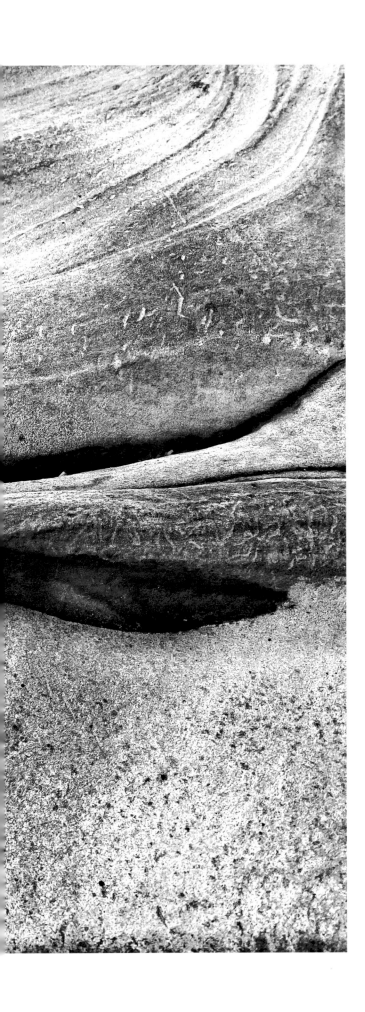

林添福〈煉石 (2)〉
2020 │ 噴墨輸出 │ 90×120 公分 │ 藝術家授權
LIN Tian-Fu │ *Alchemy 2*
2020 │ Inkjet print │ 90×120 cm │ Courtesy of the artist

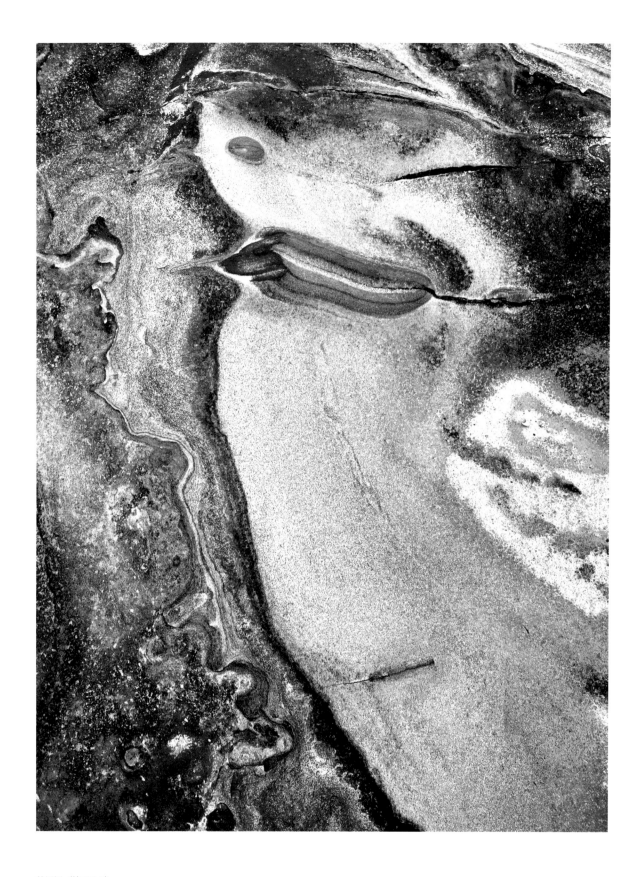

林添福〈煉石 (1)〉
2020｜噴墨輸出｜120×90 公分｜藝術家授權

LIN Tian-Fu｜*Alchemy 1*
2020｜Inkjet print｜120×90 cm｜Courtesy of the artist

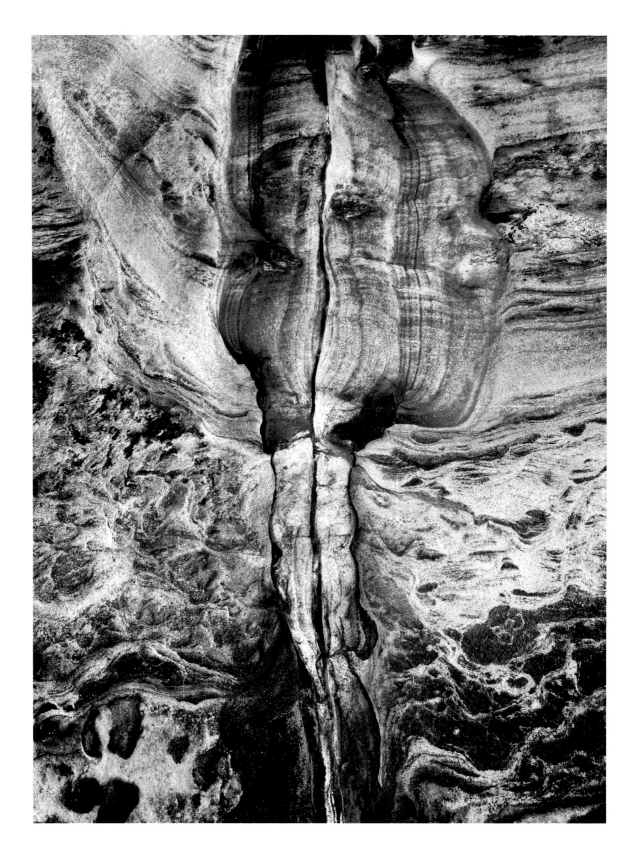

林添福〈煉石 (3)〉
2020｜噴墨輸出｜120×90 公分｜藝術家授權
LIN Tian-Fu｜*Alchemy 3*
2020｜Inkjet print｜120×90 cm｜Courtesy of the artist

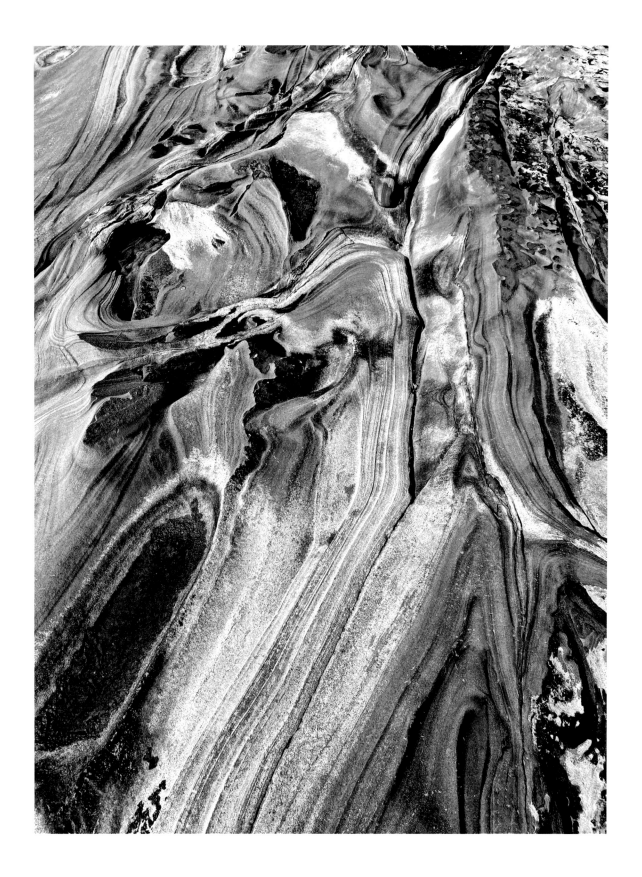

林添福〈煉石 (4)〉
2020 ｜噴墨輸出｜ 120×90 公分｜藝術家授權
LIN Tian-Fu ｜ *Alchemy 4*
2020 ｜ Inkjet print ｜ 120×90 cm ｜ Courtesy of the artist

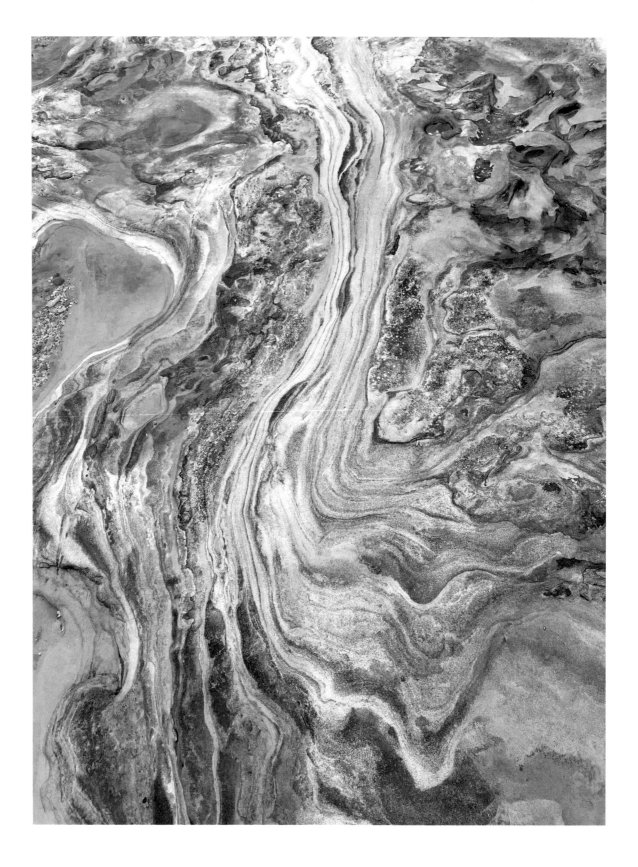

林添福〈煉石 (5)〉
2020 │ 噴墨輸出 │ 120×90 公分 │ 藝術家授權
LIN Tian-Fu │ *Alchemy 5*
2020 │ Inkjet print │ 120×90 cm │ Courtesy of the artist

完形

Gestalt

19 世紀物理學假設重力場、磁場內的元素因共鳴而凝聚在一起，完形心理學受到此一理論影響，也認為人們知覺世界裡也存在有一「視覺場」。其認為人類對於任何視覺圖像的認知，是一種經過知覺系統組織後的形態與輪廓，而並非所有各自獨立部份的集合。感知一朵玫瑰花除了單純的形狀、顏色之外，對於玫瑰花的經驗與印象也都會加進我們對於它的感知裡面，形成一個整體的「場」的概念。

Influenced by the discoveries of electromagnetism and the gravitational field in the 19th century, Gestalt Psychology assumed that in human perception there was a "visual field". It claimed that human's understanding of any visual figure, its form or profile, came from the organization of our cognitive system; they were not collections of individual parts. When we see a rose, we see its form and color, and together with what we have learned or experienced about roses previously, our feelings about it become a "field".

呂良遠　LU Liang-Yeavn

吳美琪　WU Mei-Chi

王艾斯　WANG IS

章光和　CHANG Kuang-Ho

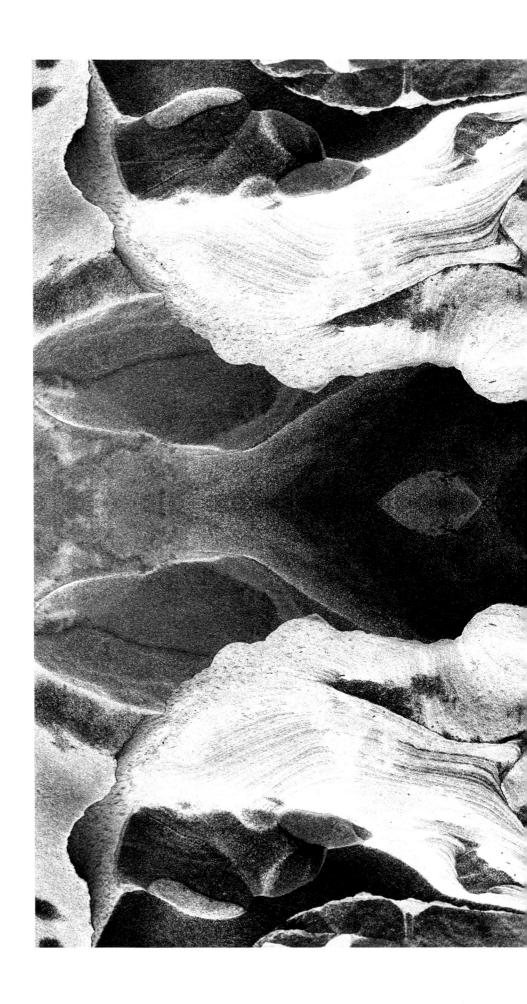

呂良遠〈磐古 3-01〉
1986 │ 顏料印刷、MUSEO® 銀鹽紙基紙
71.6×107.8 公分 │ 藝術家提供

LU Liang-Yeavn │ *Pan-Gu 3-01*
1986 │ Pigment print on MUSEO® silver paper
71.6×107.8 cm │ Courtesy of the artist

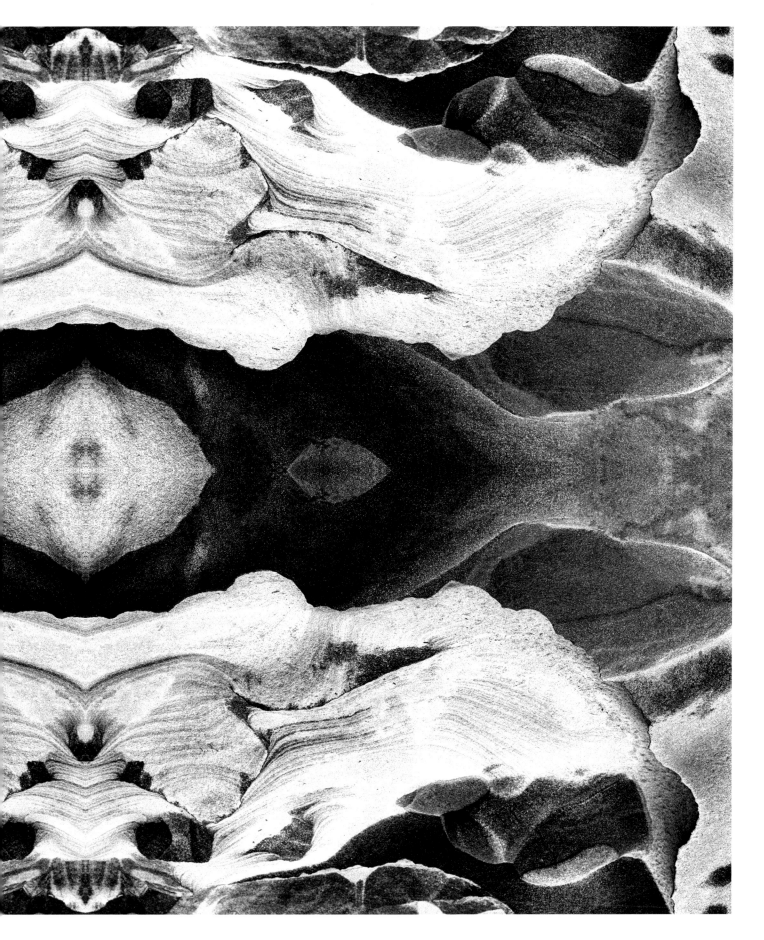

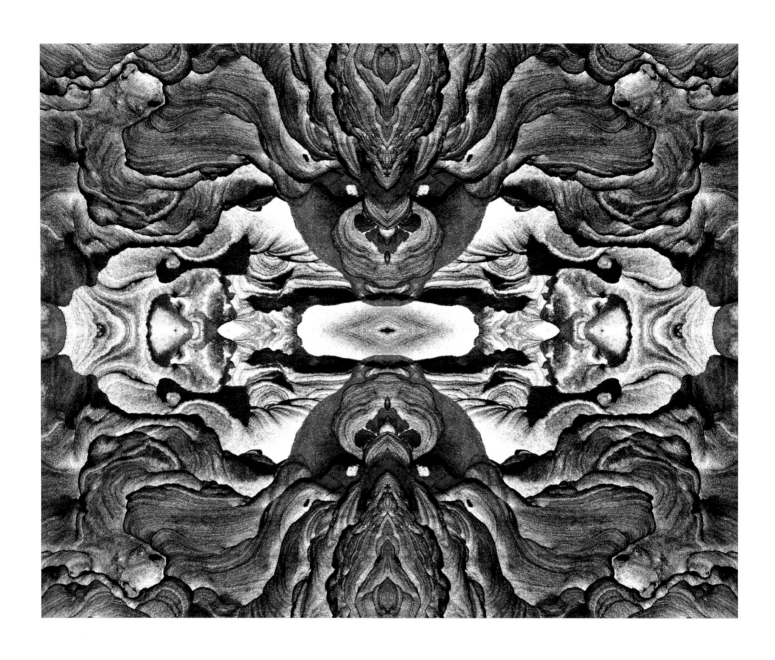

呂良遠〈磐古 1-05〉
1986 ｜顏料印刷、MUSEO® 銀鹽紙基紙 ｜ 107×133 公分｜藝術家提供

LU Liang-Yeavn ｜ *Pan-Gu 1-05*
1986 ｜ Pigment print on MUSEO® silver paper ｜ 107×133 cm ｜ Courtesy of the artist

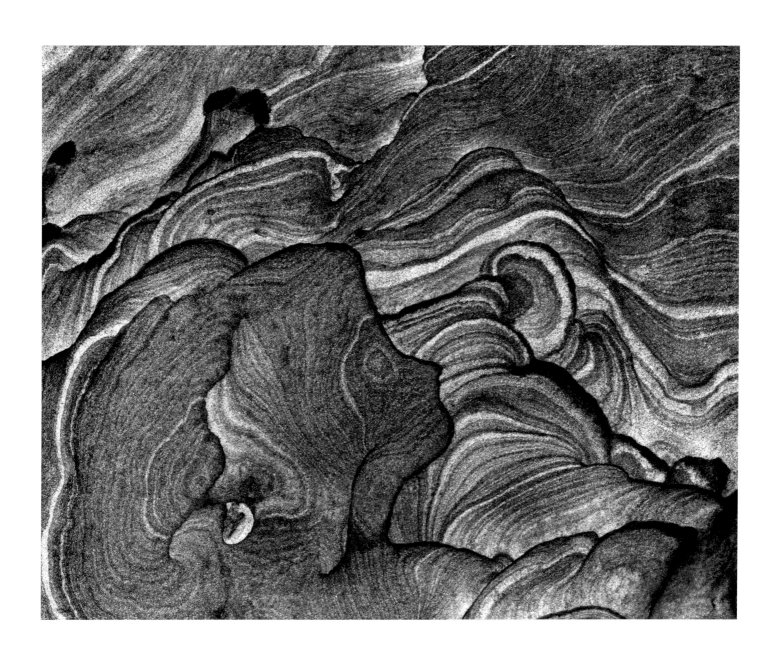

呂良遠〈磐古 I-15〉
1986｜顏料印刷、MUSEO® 銀鹽紙基紙｜86× 108 公分｜藝術家提供
LU Liang-Yeavn｜*Pan-Gu I-15*
1986｜Pigment print on MUSEO® silver paper｜86× 108 cm｜Courtesy of the artist

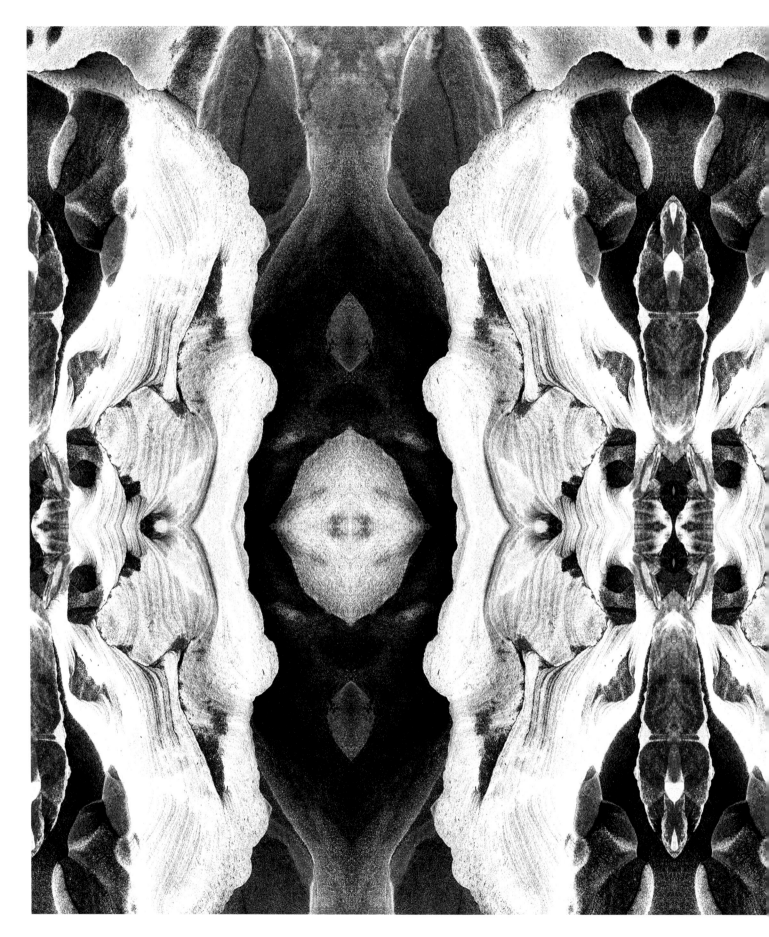

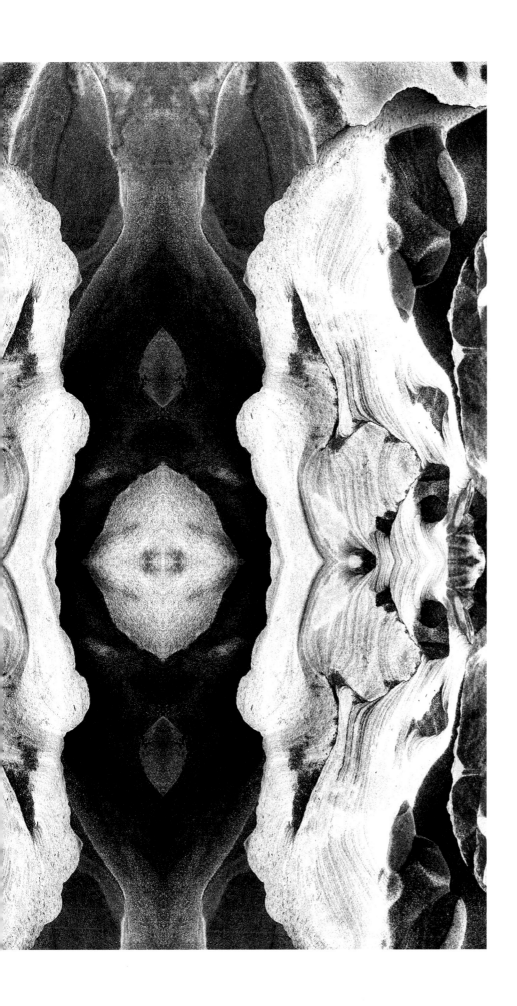

呂良遠〈磐古 3-02〉
1986 | 顏料印刷、MUSEO® 銀鹽紙基紙
72×95.6 公分 | 藝術家提供

LU Liang-Yeavn | *Pan-Gu 3-02*
1986 | Pigment print on MUSEO® silver paper
72×95.6 cm | Courtesy of the artist

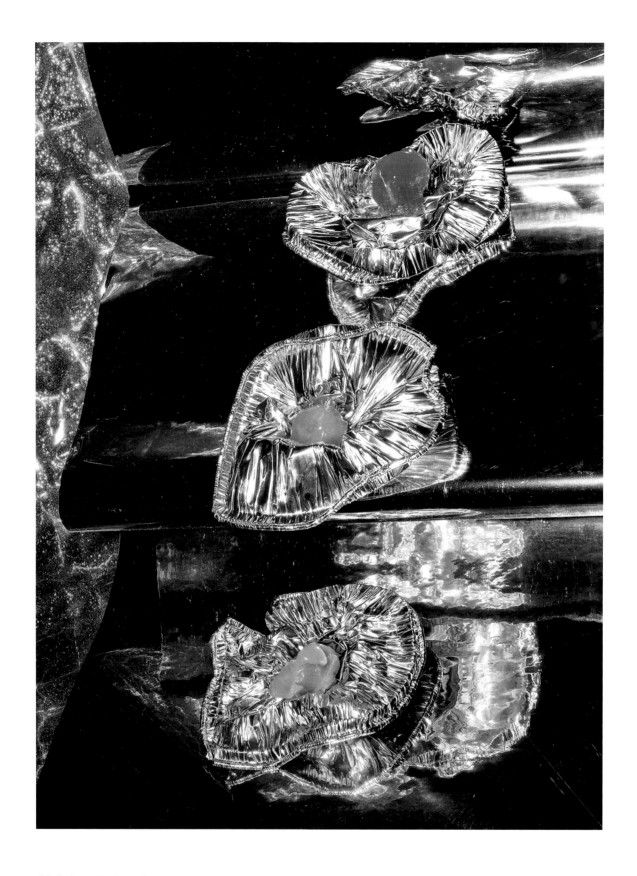

吳美琪〈YXX-The Flares #4〉
2019 ｜ 數位輸出、鋁板 ｜ 115×86 公分 ｜ 藝術銀行典藏

WU Mei-Chi ｜ *YXX-The Flares #4*
2019 ｜ Dye sublimation print on aluminum ｜ 115×86 cm ｜ Collection of the Art Bank Taiwan

吳美琪〈YXX-The Flares #10〉
2019 ｜ 數位輸出、鋁板 ｜ 103×69 公分 ｜ 藝術銀行典藏

WU Mei-Chi ｜ *YXX-The Flares #10*
2019 ｜ Dye sublimation print on aluminum ｜ 103×69 cm ｜ Collection of the Art Bank Taiwan

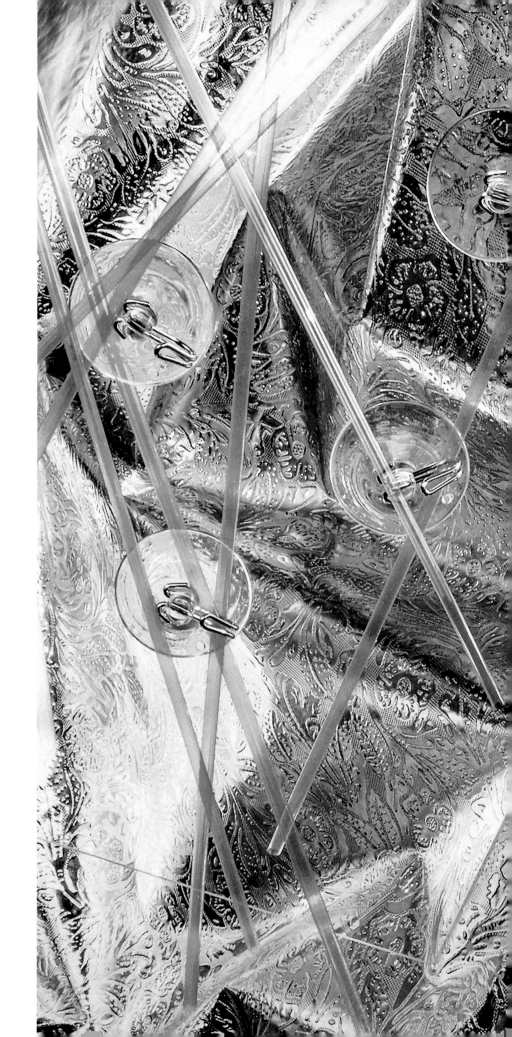

吳美琪〈YXX-The Flares #6〉
2019 │數位輸出、鋁板
105×140 公分│藝術銀行典藏

WU Mei-Chi │ *YXX-The Flares #6*
2019 │ Dye sublimation print on aluminum
105×140 cm │ Collection of the Art Bank Taiwan

王艾斯〈X-Y 建築立面 作品 2 之 1 號〉
2017 ｜攝影數位輸出、紙質｜119.8×53.7 公分｜藝術銀行典藏
WANG IS ｜ *X-Y Building Facade OP.2, NO.1*
2017 ｜ C-print ｜ 119.8×53.7 cm ｜ Collection of the Art Bank Taiwan

王艾斯〈X-Y 建築立面 作品 2 之 3 號〉
2018 ｜ 攝影數位輸出、相紙 ｜ 119.6×59.7 公分
藝術銀行典藏

WANG IS ｜ *X-Y Building Facade OP.2, NO.3*
2018 ｜ C-print ｜ 119.6×59.7 cm
Collection of the Art Bank Taiwan

王艾斯〈X-Y 建築立面 作品 3 之 1 號〉
2017 │ 攝影數位輸出、紙質 │ 212.5×102.5 公分 │ 藝術銀行典藏
WANG IS │ *X-Y Building Facade OP.3, NO.1*
2017 │ C-print │ 212.5×102.5 cm │ Collection of the Art Bank Taiwan

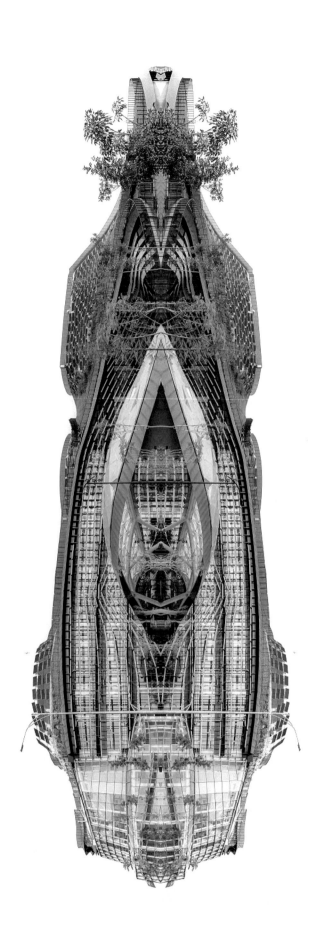

王艾斯〈X-Y 建築立面 作品 4 號之 1〉
2017 │ 攝影數位輸出、紙質 │ 212.5×87.5 公分 │ 藝術銀行典藏
WANG IS │ *X-Y Building Facade OP.4, NO.1*
2017 │ C-print │ 212.5×87.5 cm │ Collection of the Art Bank Taiwan

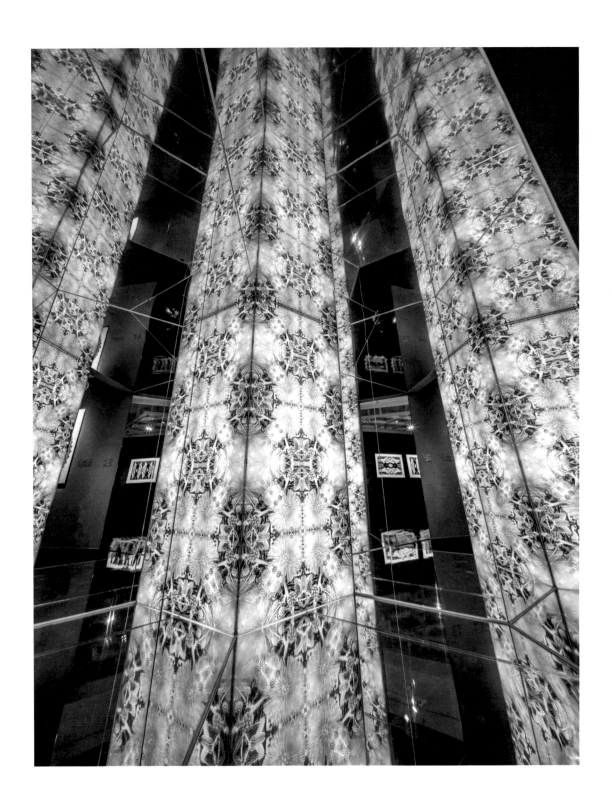

章光和〈莓果〉
2022｜裝置｜尺寸依現場而定｜藝術家授權
CHANG Kuang-Ho｜*Berry*
2022｜Installation｜Dimensions variable｜Courtesy of the artist

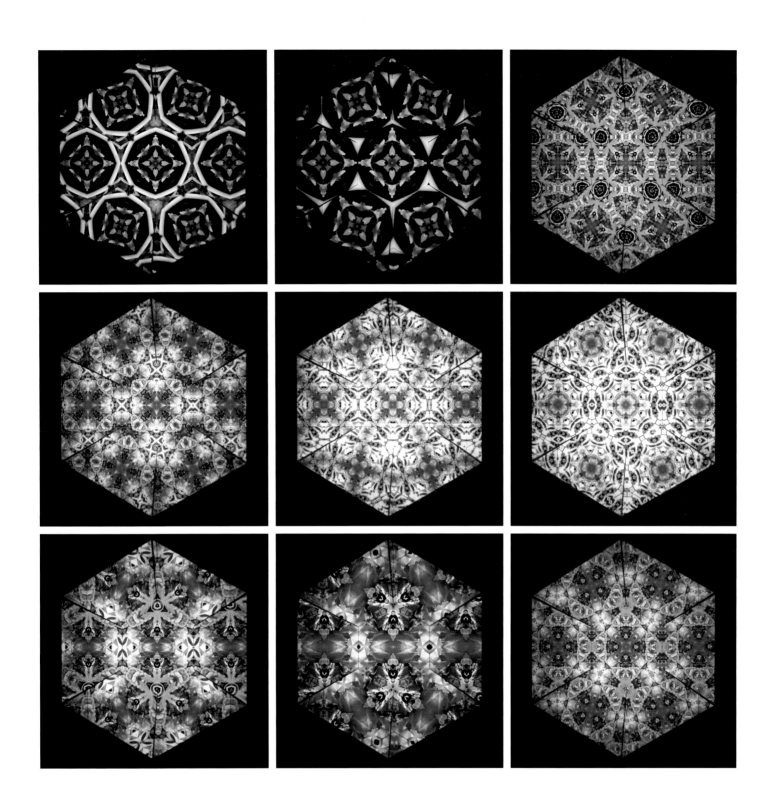

章光和〈小花蛙〉
2022｜裝置｜尺寸依現場而定｜藝術家授權
CHANG Kuang-Ho｜ *Flower Frog*
2022｜Installation｜Dimensions variable｜Courtesy of the artist

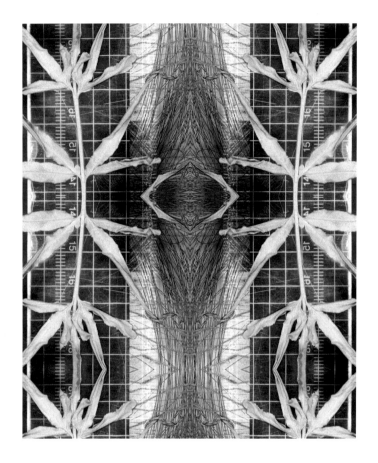

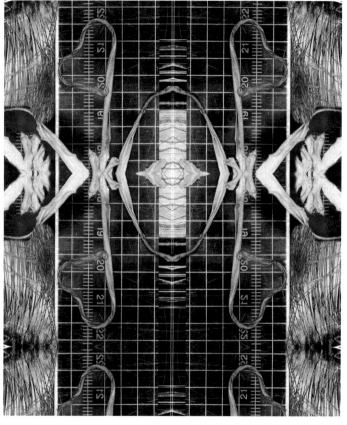

章光和〈鳳尾 1〉
2022 ｜噴墨輸出 ｜ 90×75 公分 ｜藝術家授權
CHANG Kuang-Ho ｜ *Pteris fern 1*
2022 ｜ Inkjet print ｜ 90×75 cm ｜ Courtesy of the artist

章光和〈鳳尾 3〉
2022 ｜噴墨輸出 ｜ 90×75 公分 ｜藝術家授權
CHANG Kuang-Ho ｜ *Pteris fern 3*
2022 ｜ Inkjet print ｜ 90×75 cm ｜ Courtesy of the artist

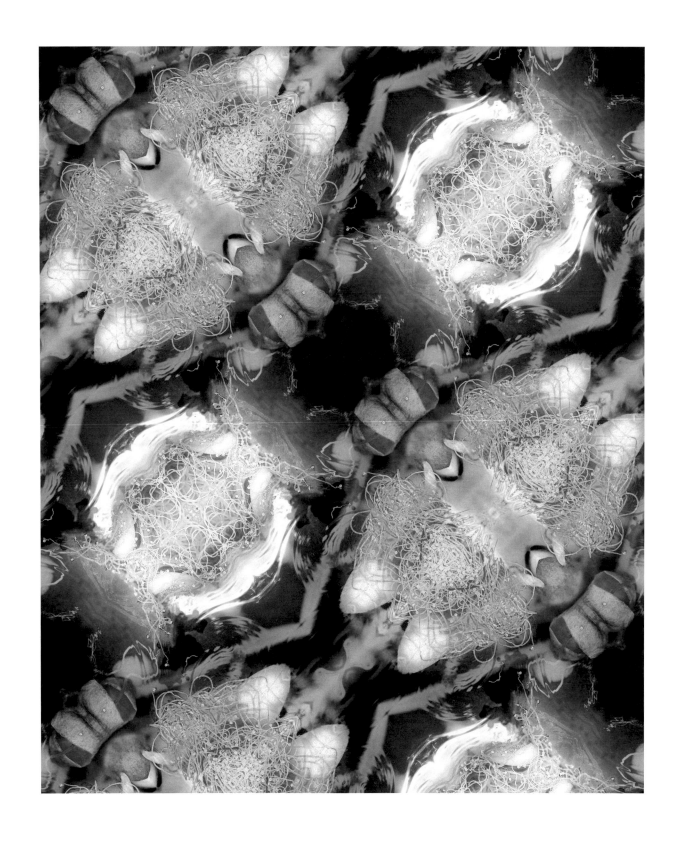

章光和〈穗花〉
2022｜噴墨輸出｜90×75 公分｜藝術家授權
CHANG Kuang-Ho｜*Spike flower 4*
2022｜Inkjet print｜90×75 cm｜Courtesy of the artist

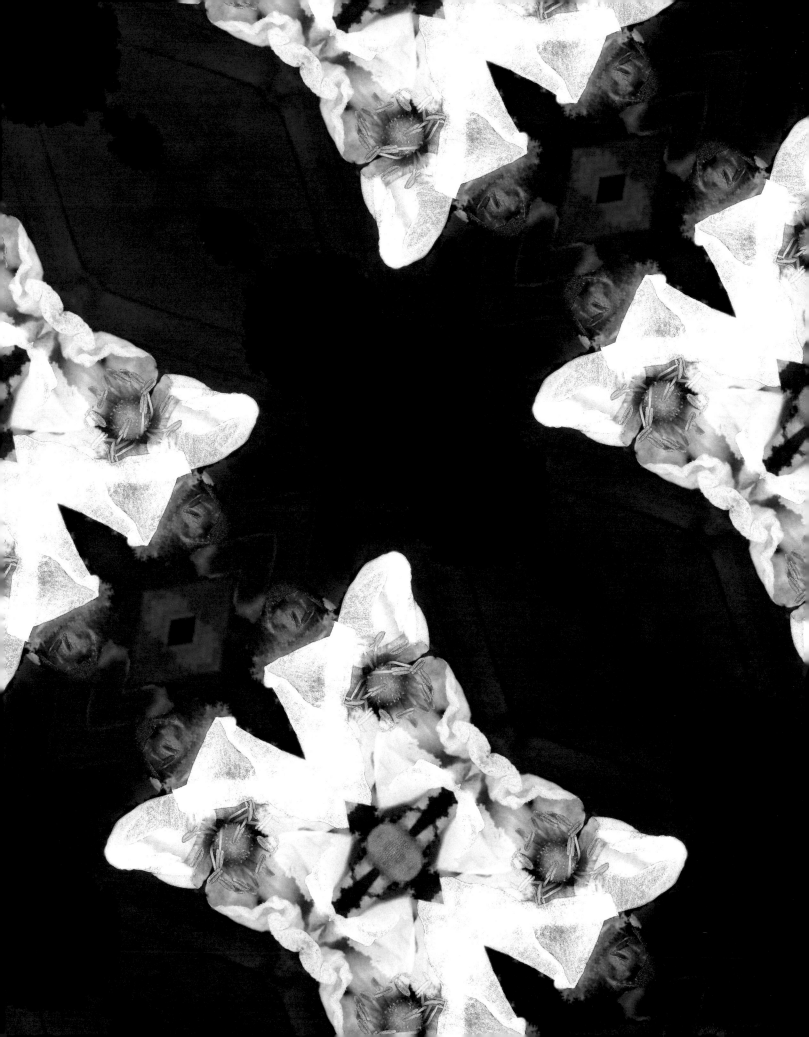

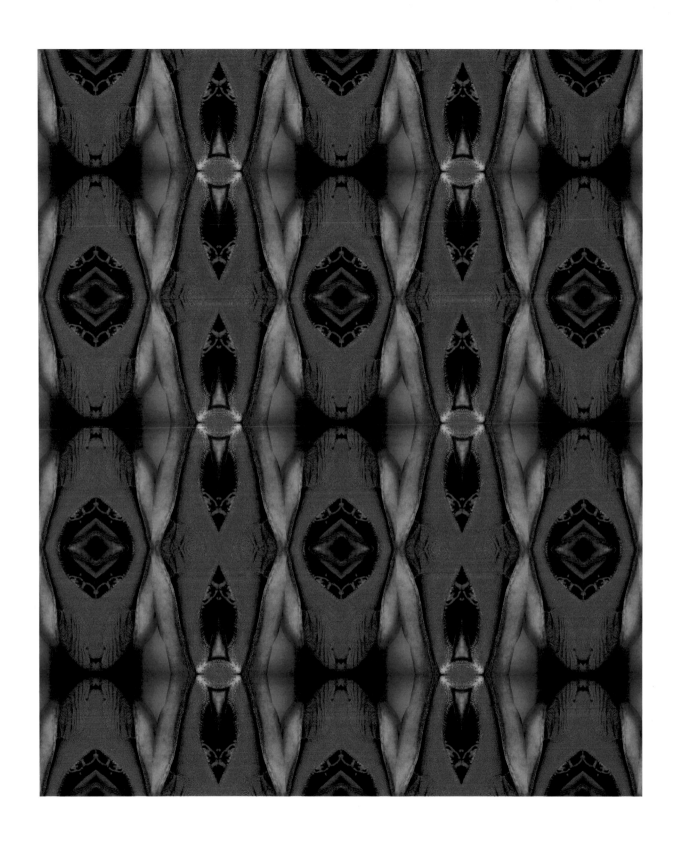

章光和〈墨色澤瀉 2〉
2022｜噴墨輸出｜90×75 公分｜藝術家授權

CHANG Kuang-Ho｜*Inky Alisma 2*
2022｜Inkjet print｜90×75 cm｜Courtesy of the artist

章光和〈項鍊眼〉
2022｜噴墨輸出｜90×75 公分｜藝術家授權

CHANG Kuang-Ho｜*Necklace*
2022｜Inkjet print｜90×75 cm｜Courtesy of the artist

物介質
Material Mediums

攝影的物體系隨著科技進化而改變。其體系分類從傳統銀鹽攝影與數位攝影再細分為黑白與彩色底片，黑白與彩色相紙，再加上黑白與彩色暗房的相洗技巧與藥水，交叉組合變化多端。進入數位攝影時代也依然可以因為螢幕呈現、網路傳輸、軟體應用、印表輸出等而產生各式稀奇古怪的視覺作品。攝影剛發明時就有實物投影的「光畫」(Photogram)。我們仔細思考廣義的攝影的原理，會發現影像是靠「成像物」與「成像源」合作而完成。例如底片或相紙是「成像物」，而實物或光是「成像源」，它是被表現出來的源頭。一個會感受光線的「成像物」接受「成像源」的訊號而形成影像。而這個概念已經將我們這個「物介質」的抽象攝影概念推進到最極致了。

Photography's system of objects changes as technology advances. It consists of traditional silver halide photography and digital photography. And in the category of traditional photography there are black-and-white or color films. The combinations of different developing skills or developers applied in the dark room produce all kinds of effects. And in the category of digital photography, the monitors presenting the images, network transmission, software, layouts, among other tools for various unusual visual works are also a part of the system. "Photograms" were created right after photography was invented. Carefully considering the principles of photography, we realize that images are produced by the substances of imaging and the sources of imaging. Film and photo paper are substances of imaging, and the objects to be projected and light are the sources of imaging. Photosensitive substances receive messages from the source and formulate images. These ideas have pushed the material mediums of abstract photography to the extreme.

李國民	LEE Kuo-Min
陳春祿	CHEN Chun-Lu
陳彥呈	CHEN Yan-Cheng
張博傑	CHANG Po-Chieh
宇中怡	YU Chung-I
許淵富	HSU Yuan-Fu
賴珮瑜	LAI Pei-Yu
洪譽豪	HUNG Yu-Hao
章光和	CHANG Kuang-Ho

李國民〈一痴三十年〉
1985-2015 │ 纖維相紙 │ 110×110 公分，共 5 件 │ 藝術家授權

LEE Kuo-Min │ *A Fool for Thirty Years*
1985-2015 │ Platine fibre rag │ 110×110 cm (5 pieces) │ Courtesy of the artist

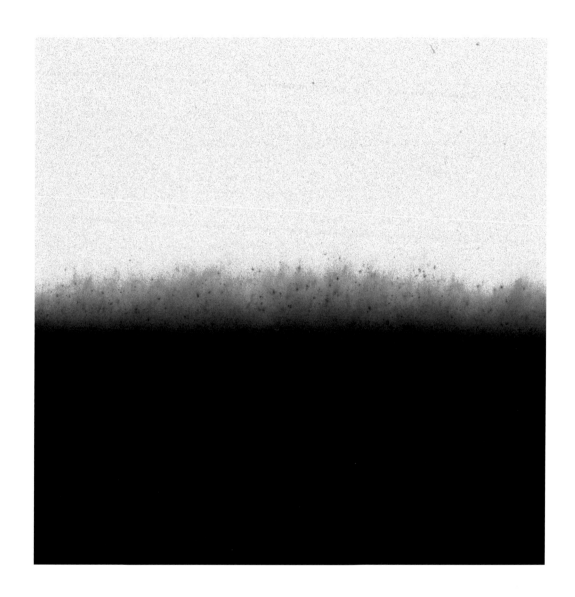

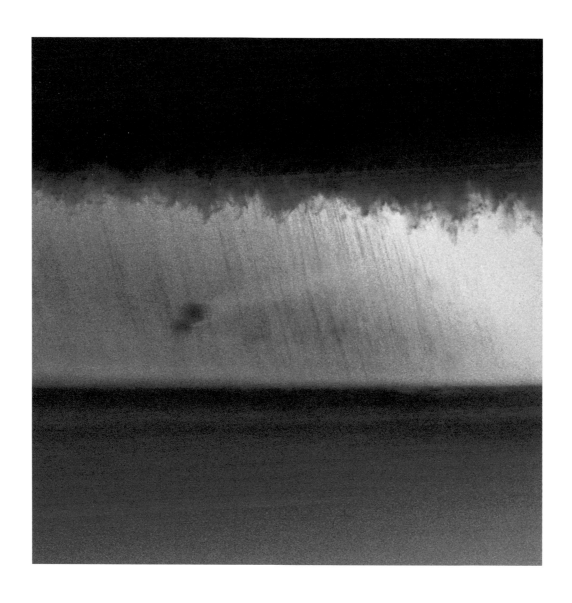

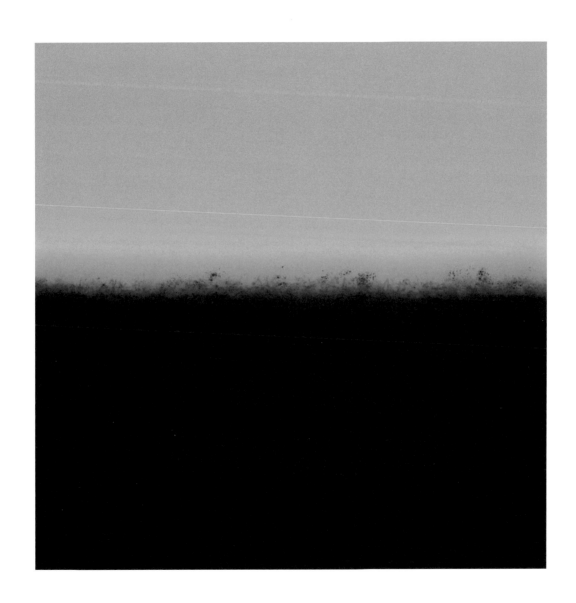

陳春祿〈開天系列 No.17〉
1999 ｜ 染料漂白 ｜ 56.5×49.5 公分 ｜ 國家攝影文化中心典藏

CHEN Chun-Lu ｜ *The Creation No.17*
1999 ｜ Cibachrome ｜ 56.5×49.5 cm ｜ Collection of the National Center of Photography and Images

陳春祿〈開天系列 No.37〉
1999｜染料漂白｜40.4×50.5 公分｜國家攝影文化中心典藏

CHEN Chun-Lu ｜ *The Creation No.37*
1999 ｜ Cibachrome ｜ 40.4 × 50.5 cm ｜ Collection of the National Center of Photography and Images

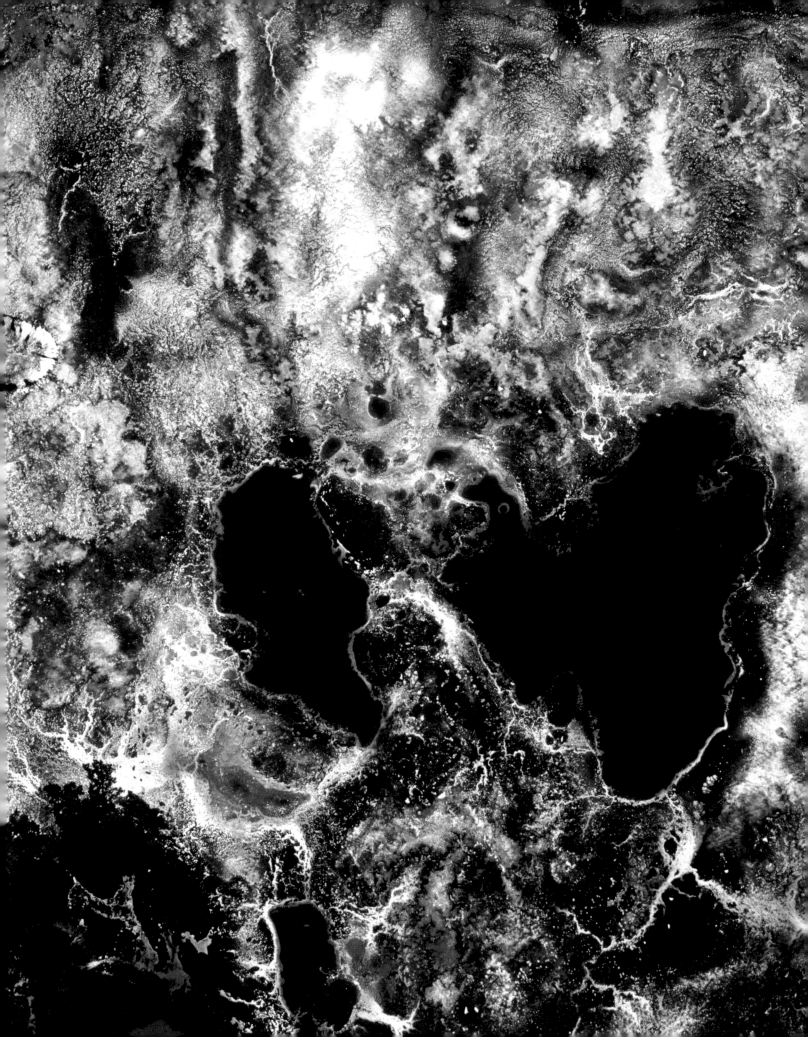

陳春祿〈開天系列 No.7〉
1999 ｜ 染料漂白 ｜ 52.7 × 48.7 公分 ｜ 國家攝影文化中心典藏

CHEN Chun-Lu ｜ *The Creation No.7*
1999 ｜ Cibachrome ｜ 52.7 × 48.7 cm ｜ Collection of the National Center of Photography and Images

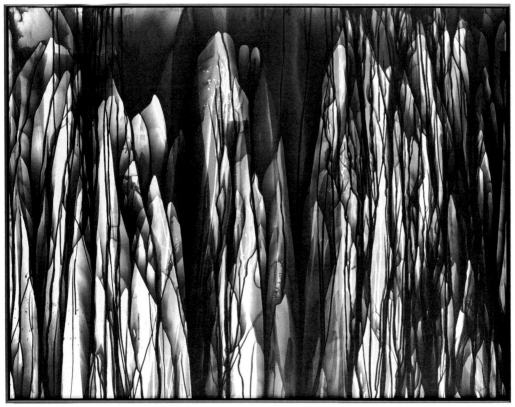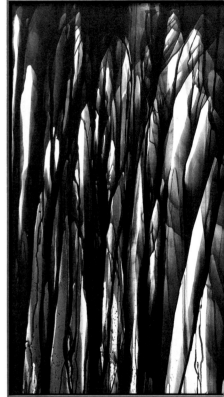

陳彥呈〈泉〉
2019 │ 明膠銀鹽相紙、顯影劑、定影劑 │ 91×361 公分 │ 藝術家提供

CHEN Yan-Cheng │ *Fountain*
2019 │ Gelatin silver paper, developer, fixer │ 91×361 cm │ Courtesy of the artist

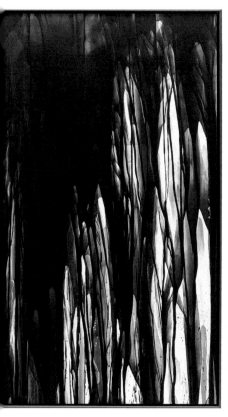

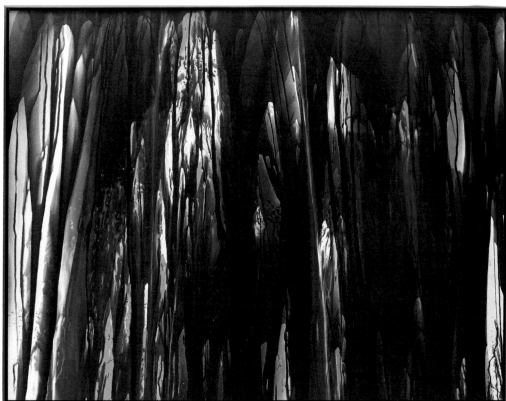

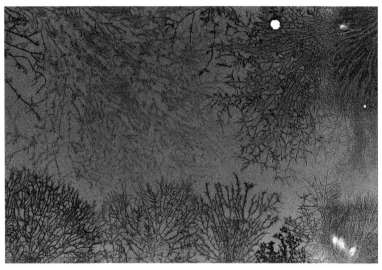 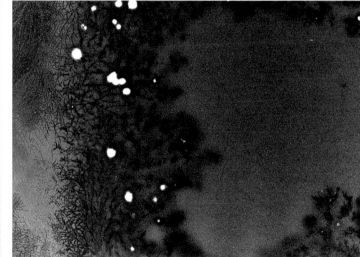

張博傑〈時間顯影〉
2017｜攝影數位輸出、相紙｜61.4×91.4 公分，共 4 件｜藝術銀行典藏
CHANG Po-Chieh｜*Contrast Medium of Time*
2017｜Digital print on photograph paper｜61.4×91.4 cm (4 pieces)｜Collection of the Art Bank Taiwan

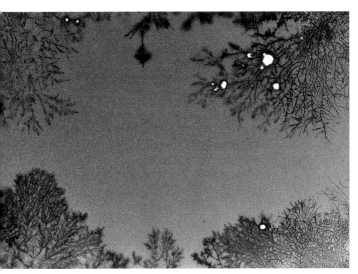

宇中怡〈當機時刻〉
2009｜攝影數位輸出、相紙｜22×30公分，共8件｜藝術銀行典藏

YU Chung-I｜*The Moment of the Crash*
2009｜Digital print on photograph paper｜22×30 cm (8 pieces)｜Collection of the Art Bank Taiwan

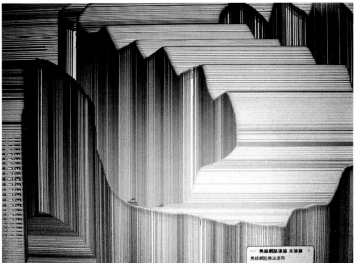

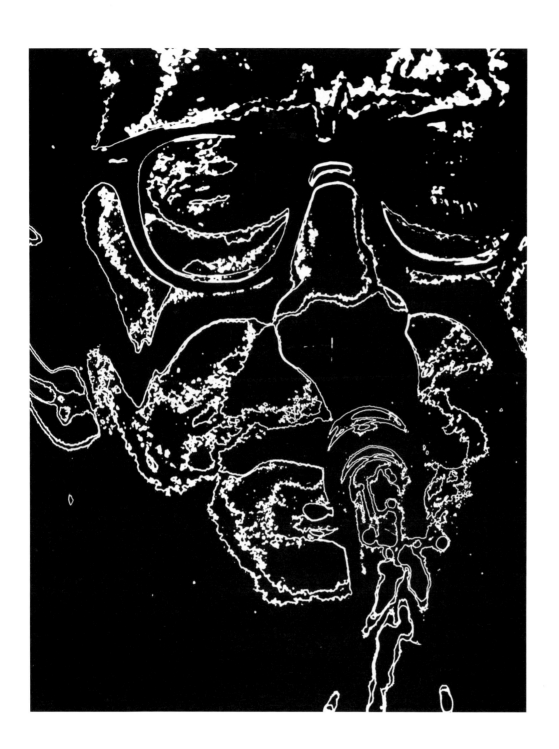

許淵富〈吹木笛者〉
1965 │ 明膠銀鹽相紙 │ 59.5×45 公分 │ 國家攝影文化中心典藏

HSU Yuan-Fu │ *Clarinet Player*
1965 │ Gelatin silver print │ 59.5×45 cm │ Collection of the National Center of Photography and Images

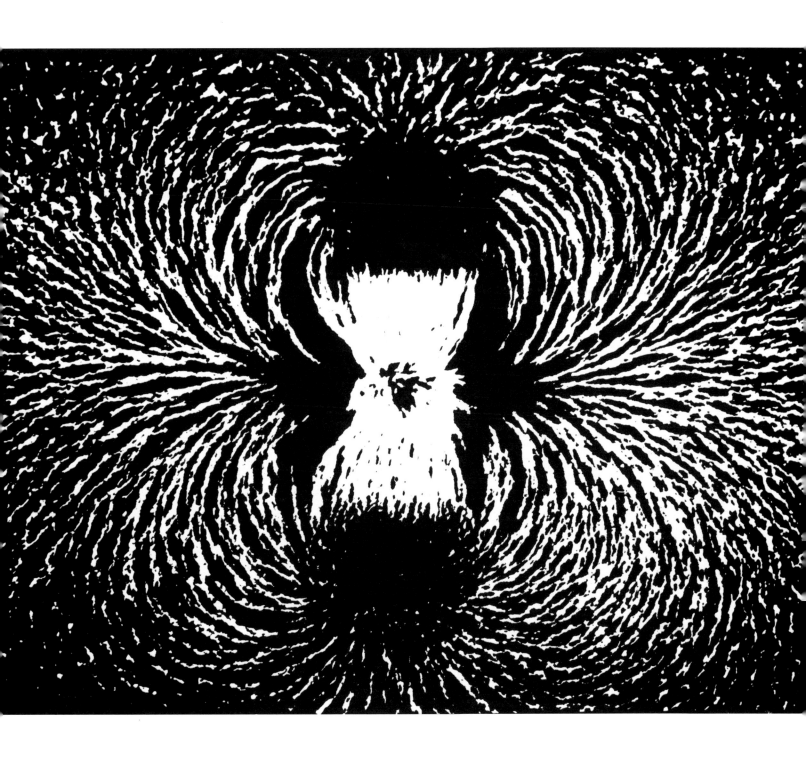

許淵富〈幻想樂〉
1966｜明膠銀鹽相紙｜47.6×61.5 公分｜國家攝影文化中心典藏

HSU Yuan-Fu｜*Fantasy*
1966｜Gelatin silver print｜47.6×61.5 cm｜Collection of the National Center of Photography and Images

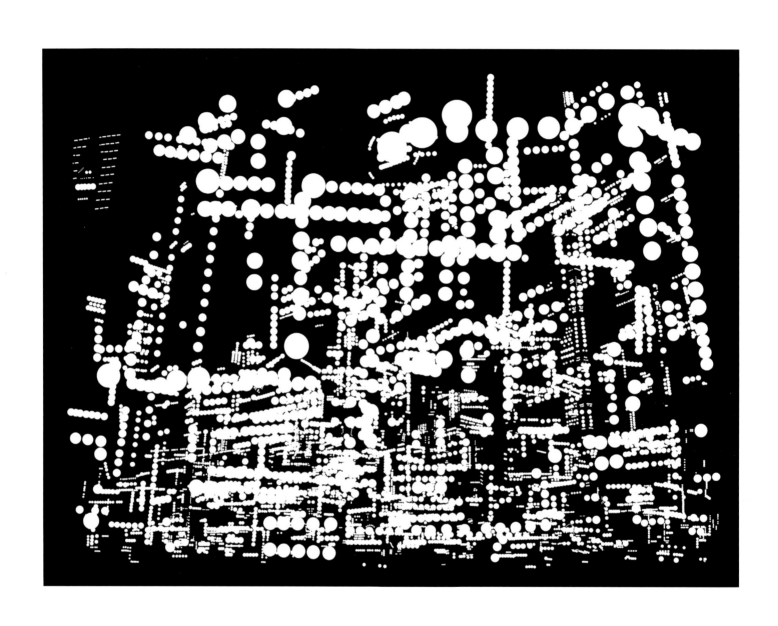

賴珮瑜〈● City-Taipei Tokyo〉
2008 ｜攝影數位輸出、相紙｜ 119.5×159.5 公分，共 2 件｜藝術銀行典藏

LAI Pei-Yu ｜ ● *City-Taipei Tokyo*
2008 ｜ Digital print on photograph paper ｜ 119.5×159.5 cm (2 pieces) ｜ Collection of the Art Bank Taiwan

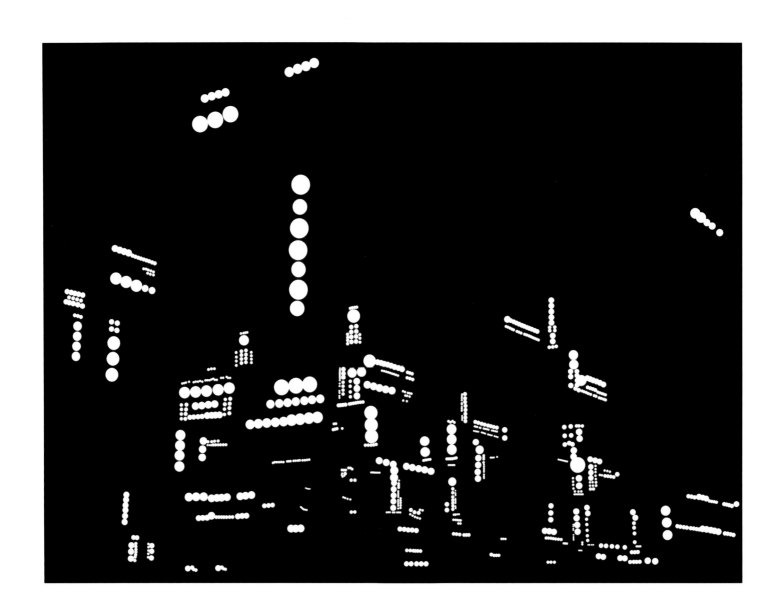

賴珮瑜 〈● City-Taipei〉
2006 ｜ 數位版畫 ｜ 87×115 公分，共 2 件 ｜ 藝術銀行典藏
LAI Pei-Yu ｜ ● *City-Taipei*
2006 ｜ Digital print ｜ 87×115 cm (2 pieces) ｜ Collection of the Art Bank Taiwan

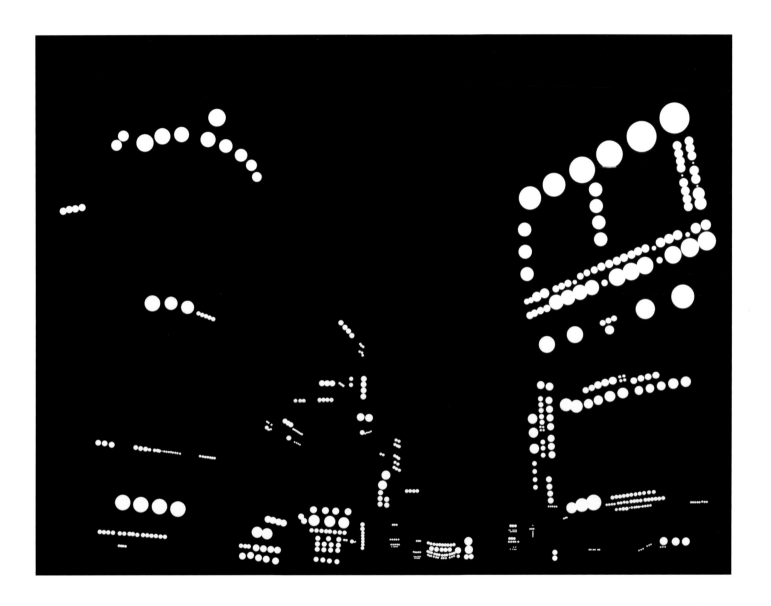

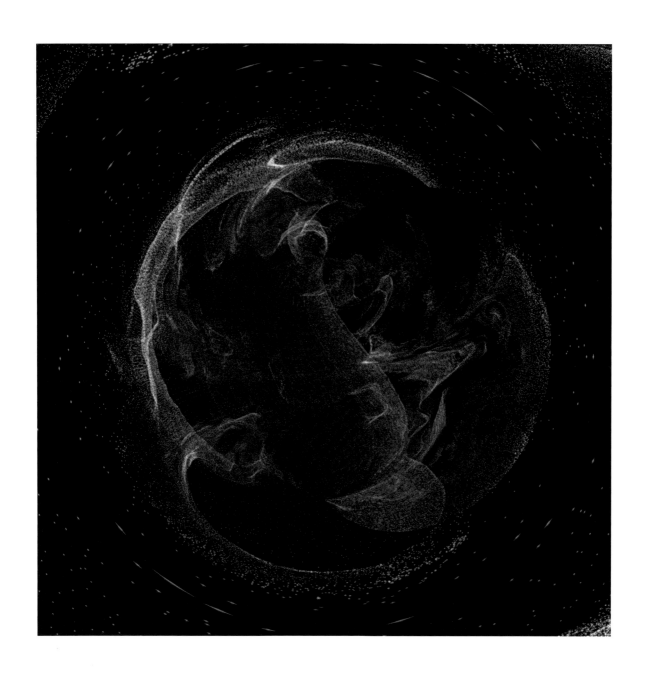

洪譽豪〈非虛構 -00〉
2022 ｜藝術微噴｜ 90×90 公分｜藝術家授權
HUNG Yu-Hao ｜ *Non-fiction Trace-00*
2022 ｜ Giclée ｜ 90×90 cm ｜ Courtesy of the artist

洪譽豪〈非虛構 -01〉
2022 ｜藝術微噴｜ 90×90 公分｜藝術家授權
HUNG Yu-Hao ｜ *Non-fiction Trace-01*
2022 ｜ Giclée ｜ 90×90 cm ｜ Courtesy of the artist

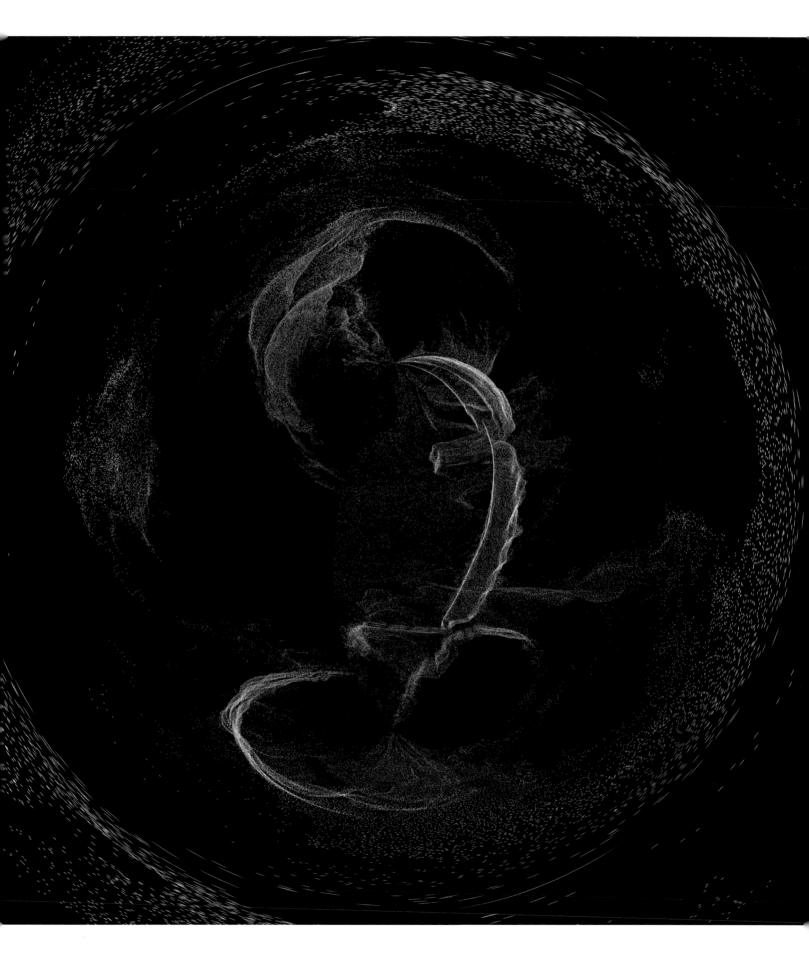

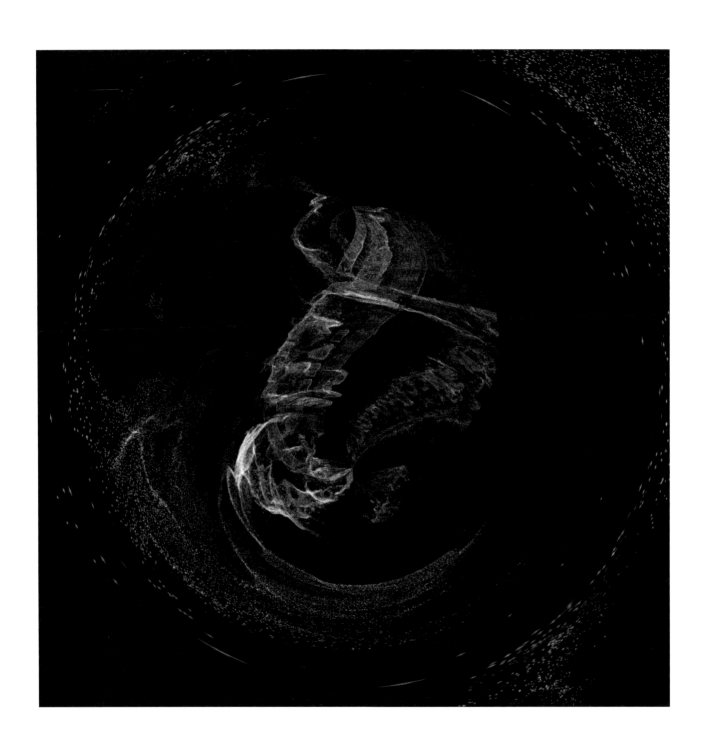

洪譽豪〈非虛構-02〉
2022｜藝術微噴｜90×90公分｜藝術家授權

HUNG Yu-Hao ｜ *Non-fiction Trace-01*
2022 ｜ Giclée ｜ 90×90 cm ｜ Courtesy of the artist

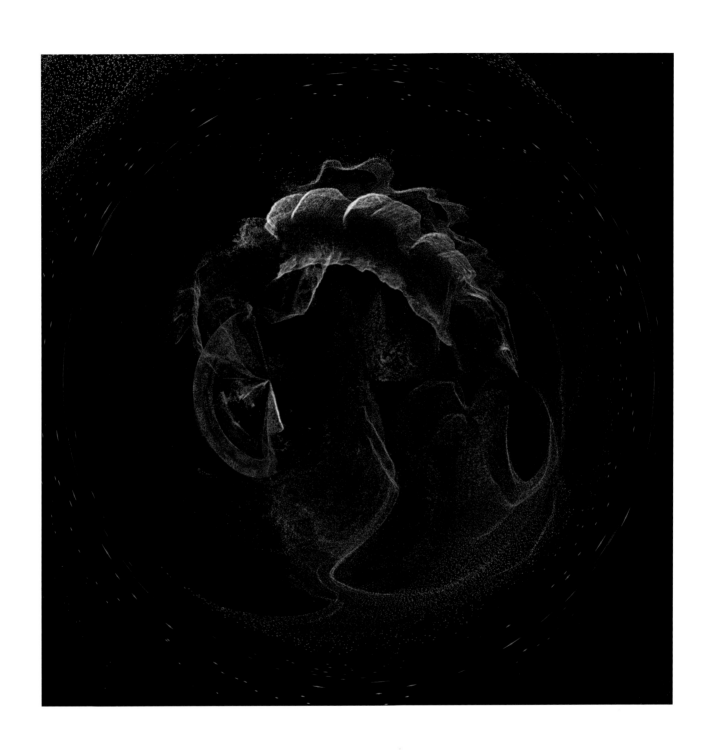

洪譽豪〈非虛構-03〉
2022 ｜藝術微噴｜ 90×90 公分｜藝術家授權

HUNG Yu-Hao ｜ *Non-fiction Trace-oo*
2022 ｜ Giclée ｜ 90×90 cm ｜ Courtesy of the artist

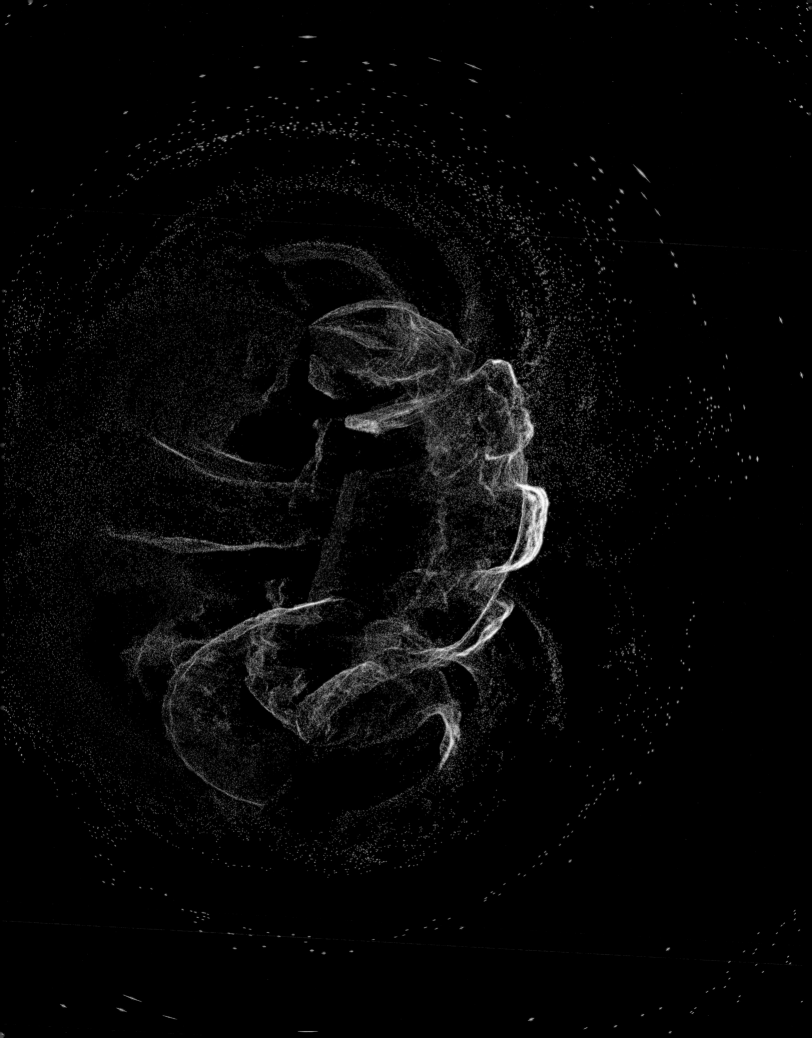

章光和〈博物館水墨二〉
2019 ｜ 明膠銀鹽相紙 ｜ 105×70 公分 ｜ 藝術家提供

CHANG Kuang-Ho ｜ *Museum Ink-2*
2019 ｜ Gelatin silver print ｜ 105×70 cm ｜ Courtesy of the artist

章光和〈博物館水墨三〉
2019 ｜ 明膠銀鹽相紙 ｜ 105×70 公分 ｜ 藝術家提供

CHANG Kuang-Ho ｜ *Museum Ink-3*
2019 ｜ Gelatin silver print ｜ 105×70 cm ｜ Courtesy of the artist

章光和〈博物館水墨四〉
2019 │ 明膠銀鹽相紙 │ 105×70 公分 │ 藝術家提供
CHANG Kuang-Ho │ *Museum Ink-4*
2019 │ Gelatin silver print │ 105×70 cm │ Courtesy of the artist

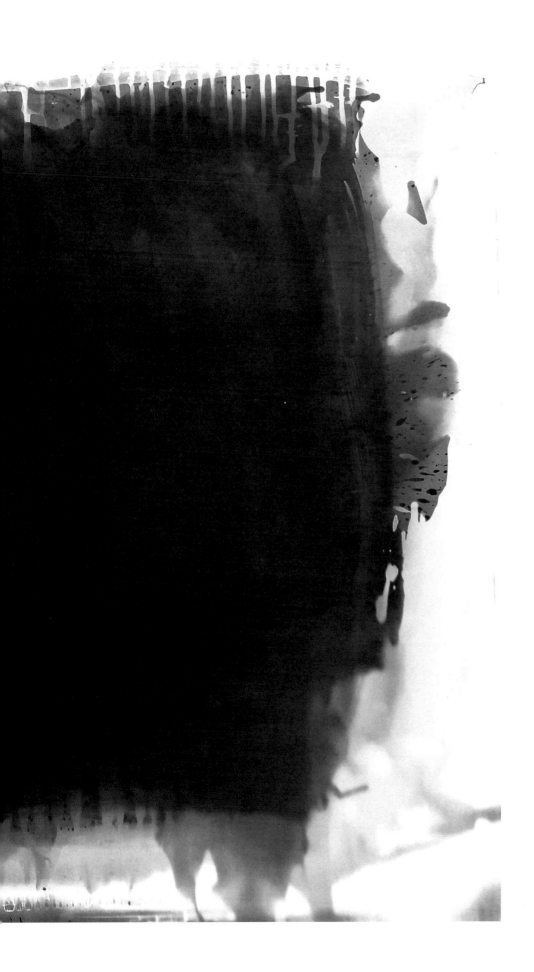

章光和〈博物館水墨一〉
2019 ｜ 明膠銀鹽相紙 ｜ 66×105 公分
藝術家提供

CHANG Kuang-Ho ｜ *Museum Ink-1*
2019 ｜ Gelatin silver print ｜ 66×105 cm
Courtesy of the artist

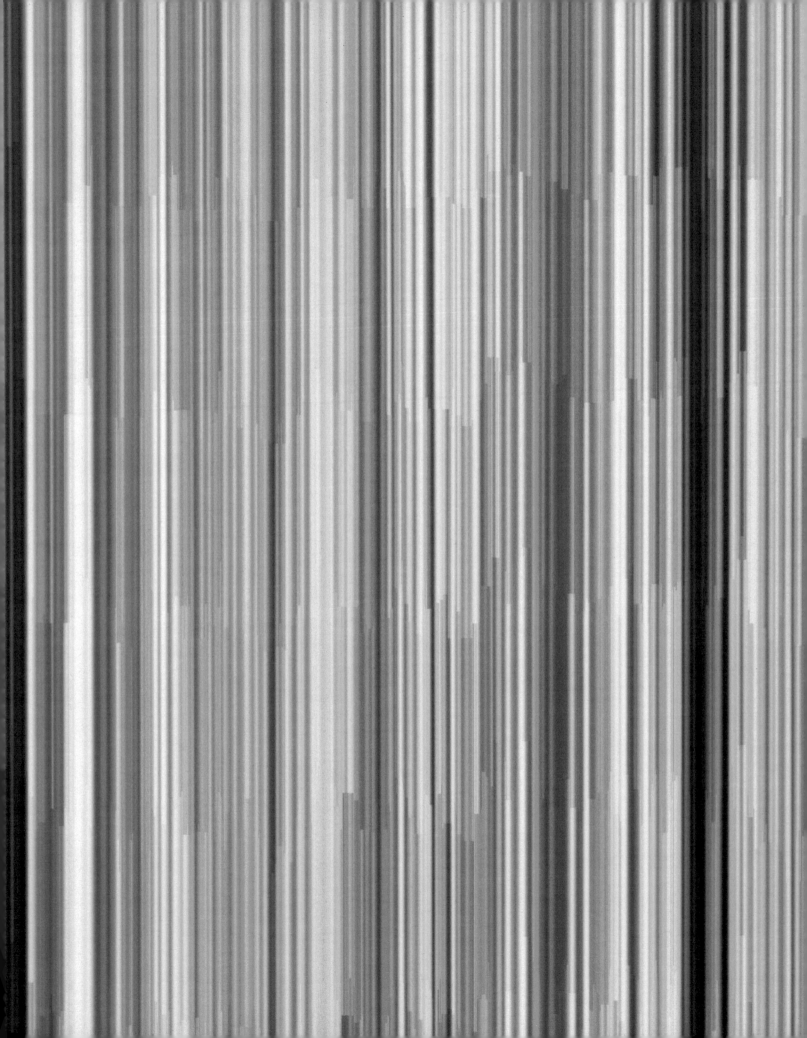

藝術家與作品介紹

Artists' Biographies and Introduction of Works

牛俊強

牛俊強擅長計畫型的錄像，結合空間裝置、攝影和複合媒材。目前工作於臺北，亦為實踐大學媒體傳達設計學系助理教授。

其作品以「視覺如何成為一種存在的形式？」出發，延伸至時空向度中，不可見的關係連結、個人至群體的意識，做細膩而宏觀的提問。

曾參與鹿特丹國際影展金虎獎短片競賽、FAFF 錄像藝術節、英國 Osmosis 錄像藝術節、美國 Pixilerations 新媒體藝術展、紐約 cutlog 藝術節、西班牙 Aguilar 影展、法國 Tours 亞洲影展、法國 ARTchSO 錄像藝術節、日本東京 Interdisciplinary 藝術節、韓國光州 ACC Asian Arts Space Network Show、「四不像」兩岸四地藝術交流計劃、臺北金馬影展、臺北美術獎、臺灣國際錄像雙年展、臺北電影節等國內外藝術節和影展展出。作品亦在柏林、伊斯坦堡、特拉維夫、俄羅斯、墨哥、首爾、北京、深圳等國際重要城市發表。曾獲頒第 53 屆美國休士頓國際影展最佳實驗電影，第 35 屆金穗獎最佳實驗片，及第 17 屆台新藝術獎入圍。

―― 藝術家提供

NIU Jun-Qiang

Born in 1983. He graduated with MFA in New Media Art from Taipei National University of the Arts. His artworks mainly focus on the video, film and mixed media installations. He is also the assistant professor of Communication of design in Shih Chien University.

During the creative process, Niu has investigated the incredible relations between materiality and spirituality and asks questions about the invisible relationships and consciousness from the individual to the group. He has worked with different sorts of participants to narrate their past experiences for the creation of a more united, joint experience.

Niu Jun Qiang's artworks have been featured in the short film competition at the Rotterdam International Film Festival in the Netherlands; Osmosis Audiovisual Media festival in the United Kingdom; Pixilerations Tech Art Exhibition in the United States; the Aguilar International Short Film Festival in Spain; Tours Asian Film Festival in France; ARTchSO Video Festival in Rennes, France; *It Takes Four Sorts*: Cross-Strait Four-region Artistic Exchange Project in Taiwan, Mainland China, Hong Kong, and Macau; Taipei Golden Horse Film Festival; Taipei Arts Awards in Taipei...etc. His works also had been showed in Paris, Berlin, Istanbul, Tel Aviv, Mexico, Seoul, Beijing, Shenzhen. He won the 53rd Worldfest-Houston International Film Festival; Best Experimental Film in the 35th Golden Harvest Award; and was selected for the 17th Taishin Art Award.

―― Provided by the artist

〈邊界 -2〉

藝術家牛俊強的創作計畫《邊界》，探索宗教信仰與身體疾病間所存在的相互關係，他認為疾病與死亡所帶來的恐懼是信仰的邊界，當人的生存處於邊緣狀態時，時常選擇投入信仰之中。〈邊界 -2〉是一件以神性經驗與心靈意識為出發的攝影，牛俊強在陽光下，將描圖紙覆蓋於耶穌像上，光線在紙張上暈染出純淨的色澤與柔美陰影變化，賦予神聖的美感。然而，紙張上耶穌像所折射的陰影，卻像是長了角的魔鬼，使得畫面融合了光與陰影、神聖與恐懼的對照。牛俊強以富有哲思的視覺辯證，表現出光明與黑暗的對比，以及兩者互為一體的狀態，展開對神性的探究。

―― 藝術銀行

The Borderline-2

The artist Niu Jun-Qiang's creative project, "*The Borderline*," explores the complex relationship between religious belief and disease. He believes that the fear that accompanies disease and death marks the boundary of belief: when someone's survival is on the edge, he or she often chooses to place their whole trust in belief. *The Borderline-2* is a photograph inspired by thoughts on divine experience and spiritual consciousness. Niu covered a statue of Jesus with tracing paper and placed it under sunlight, so that the light would blend pure colors and soft shadows on the paper, giving it a kind of divine beauty. However, the shadow cast by the statue of Jesus seems like a devil with horns, making the photograph a fusion of light and shadow, a contrast between divinity and terror. Niu uses such philosophical visual dialectics to show the contrast between light and darkness, as well as the state of the two combined into one, in an exploration of the divine nature.

―― Art Bank Taiwan

P.116

〈邊界 -2〉
The Borderline-2

〈無題 -6〉

藝術家牛俊強的創作，擅長以自己的生命經驗出發，運用各種視覺媒材的特性，創造細緻感受，開啟對關係、信仰與生命等主題的探討。〈無題 -6〉為一件攝影作品，牛俊強以光線表現出視覺的觸感，藉由抽象的感受，表達「神臨在的感受」，而其中神的概念不是特定信仰中的神明，而是指人與非物質世界的無形連結。他將交疊的描圖紙，加以凹折或覆蓋在幾何物件上，組合成抽象的曲線造型，在陽光下，半透明的描圖紙被光線暈染出溫和、純淨的色澤。柔和的陰影，呈現出寧靜、詳和的神秘感受，牛俊強運用光線與材質，創造出神聖的美感，探究神性的本質與意義。

―― 藝術銀行

Untitled-6

The artist Niu Jun-Qiang is very good at using the characteristics of various visual media to create delicate feelings and open up discussion on themes such as relationships, faith, and life, based on his own life experiences. In *Untitled-6*, a photographic work, Niu uses light to visually express palpability and abstract feelings that express "the feeling of the presence of God," with "God" not the kind found in a specific belief, but rather the invisible connection between people and the immaterial world. He folds tracing paper and covers various things with it in order to create abstract, curved forms. Under sunlight, the translucent tracing paper appears as if it is washed in gentle, pure colors. Soft shadows present a tranquil, mysterious mood. Niu Jun-Qiang uses light and materials to create a sense of sacred beauty and explore the essence and meaning of divinity.

―― Art Bank Taiwan

P.117

〈無題 -6〉 *Untitled-6*

王艾斯

王艾斯（本名王聖文），現居臺灣，擅長攝影人像、景觀及建築影像創作，並榮獲多項國內、外攝影比賽首獎及相關獎項。

基於本人對建築設計空間的熱愛，於 2016 年從商業攝影轉換到建築攝影，並以臺灣當代建築為創作主體，執行攝影影像創作計劃，2017 年誕生《X-Y 建築立面》系列作品，並二度獲得藝術銀行購藏。2017 年獲得巴黎 PX3 國際攝影比賽藝術特效類第一名、MIFA 莫斯科國際攝影比賽抽象類第一名及建築類第三名。

—— 藝術家提供

《X-Y 建築立面》系列

在拍攝作品《X-Y 建築立面》時，我會圍繞著建築本體，並採多種角度切換進行拍攝，讓作品呈現出更多建築的面貌，藉此探討當代建築影像的多變性與可能性。

欣賞《X-Y 建築立面》系列作品，均可旋轉 4 種 90 度角度觀看，來打破傳統影像擺放的框架，讓作品帶給人們全新的視覺感受，均因觀賞者而異。藉此隱喻每個人對於同一件人、事、物、時，切入點不同，最終所呈現的觀點也所不同。

—— 藝術家提供

WANG IS

Wang IS (Wang Sheng-Wen) currently resides in Taiwan, and specializes in portraiture, landscapes, and architecture photography, and has won numerous first prizes and related accolades in photography competitions domestically and abroad.

Based on his passion for architectural design spaces, in 2016 he moved from commercial photography to architectural photography, in particular taking Taiwanese contemporary architecture as his creative subject. Executing his creative photography project, in 2017, the *X-Y Building Facade* project was born, and have been collected by the Art Bank Taiwan for the second time. In 2017 he won the 1st Prize of Paris PX3 Professional Fine Art/Digitally Enhanced, the 1st Prize for Fine Art-Abstract and the 3rd Prize for Architecture-Building in 2017 Moscow International Foto Awards.

—— Provided by the artist

X-Y Building Facade Series

When capturing *X-Y Building Facade* series, I will circle the building itself, and capture images from multiple angles, allowing the work to present even more faces of the architecture. Through this, I explore the mutability and possibilities of contemporary architectural photography.

The *X-Y Building Facade* series can be viewed from four different 90-degree angles, breaking down the traditional display methods for photographs, and allowing the work to bring an all-new visual sensation to viewers, differing with every viewer. I take this to suggest that everyone's perspectives on the same person, event, or object are different, and thus will present different views.

—— Provided by the artist

P.144

P.145

P.146

P.147

〈X-Y 建築立面 作品 2 之 1 號〉
X-Y Building Facade OP.2, NO.1

〈X-Y 建築立面 作品 2 之 3 號〉
X-Y Building Facade OP.2, NO.3

〈X-Y 建築立面 作品 3 之 1 號〉
X-Y Building Facade OP.3, NO.1

〈X-Y 建築立面 作品 4 號之 1〉
X-Y Building Facade OP.4, NO.1

王攀元

1908 年生於中國江蘇，幼年早孤，早年際遇多遭離難。1933 年考上
復旦大學法律系，後因興趣於藝術創作而在隔年入上海美術專科學校
就讀。期間師承潘天壽、潘玉良、劉海粟等人，擅長水墨、水彩、油
畫等媒材，活用於中國傳統與西方現代風格間。畢業後，因中日戰爭
爆發而中斷了藝術學業，無法前往法國留學，並於 1949 年攜家眷隨
國民政府來臺。後定居宜蘭並擔任美術教師，並於 1961 年與友人共
組蘭陽畫會，爾後國內各類展覽邀約不斷，其創作漸受重視。2001
年獲頒第 5 屆國家文藝獎，自此奠定他在臺灣藝術史的地位。2017
年逝世於宜蘭，享嵩壽 109 歲。

—— 章光和

〈黑色的太陽〉

王攀元〈黑色的太陽〉顯得格外感性與風趣。兩個圓點一大一小在畫
布的對角相望，遠看似有水墨暈染的層次，其實整張畫充滿筆力觸力
道。圓具有圓融的感覺，造型上像是眼睛、太陽、星球，一道頂在上
緣的弧形像是山丘或是軌道。大小、明暗、黑白之間的引力互相牽引
活潑了繪畫的描繪。

—— 章光和

WANG Pan-Yuan

Wang Pan-Yuan was born in Jiangsu, China, in 1908. Orphaned at a young age, he
encountered many challenges in his early years. In 1933, he was accepted to the
Department of Law at Fudan University. Later, because of his interest in art creation,
he entered Shanghai University Fine Arts College the next year. During this period,
he studied under masters such as Pan Tian-Shou, Pan Yu-Liang, and Liu Hai-Su,
becoming proficient in media such as ink painting, watercolor, and oil painting,
bringing them to bear between Chinese traditional and Western modern styles. After
graduation, his art study was interrupted due to the Sino-Japanese War, preventing
him from studying in France. In 1949, he brought his family to Taiwan alongside the
KMT government. Later on, he settled in Yilan as an art teacher, forming the Lanyang
Painting Society with friends in 1961, which down the road was invited to many
domestic art exhibitions, gradually gaining recognition for their creation. In 2001, he
was awarded the 5th National Culture Award, cementing his position in Taiwanese art
history. In 2017, Wang passed away in Yilan at the ripe old age of 109 years old.

—— Chang Kuang-Ho

Black Sun

Wang Pan-Yuan's *Black Sun* comes off particularly emotional and witty. Two circles,
one large and one small, gaze at each other from two corners of the canvas. In
the distance there is the layering of an ink tint, but the entire image is filled with
brushstroke power. The circles have the feeling of integration. In their design, they
seem like eyes, the sun, planets. A curve on the upper half of the work resembles a
mountain or a path. The pull between large and small, bright and dark, black and
white, mutually draw and excite the descriptiveness of the work.

—— Chang Kuang-Ho

P.102

〈黑色的太陽〉 *Black Sun*

宇中怡

宇中怡為國立臺北藝術大學科技藝術研究所碩士，主修電子影音藝術。作品形式多以現場行為、靜態影像與行為錄像方式呈現，創作所關注核心思考多來自於自身生活經驗與周遭人事物知覺、連結與觀察感知所得，以及對於時間、空間、環境與記憶的關注，將個人內在知覺經驗向外投射，使之成為可被知覺的藝術表達方式，渴望觀者能帶著微笑並從中得到一塊思考的空地。

曾參與「淨土──國際行為藝術節」（2021，台灣）、「2020越過界──國際跨媒體藝術節」（2020，香港）、「複眼時代──第5屆機動眼國際動態媒體藝術節」的「臨場行為 Live Art」（2019，臺灣）、「UP-ON 向上國際現場藝術節」（2021，十二年現場檔率；2018，第6屆，四川成都）、阿川國際行為藝術節（2021、2020、2017、2014、2010，臺灣）、第4屆科隆國際錄像藝術節、瑞士巴塞爾 SCOPE Art Show 藝術博覽會，除臺灣外，作品曾於中國大陸、德國、冰島、法國、印度、委內瑞拉、瑞典、馬來西亞、瑞士等地發表。

—— 藝術家提供

〈當機時刻〉

當機應當是身處在數位文化時代中最不樂見的狀況，在快當機前令人感覺不安的操作，除了須面對應當是理性的電腦程式居然出現具「人性情緒化」的變化，還必須壓抑自我內在焦躁與強烈的無力感，這時唯一的樂趣、契機與渴望，或許就是等待復活或是把握當機前唯一可以生存的操作，利用「錯誤」來製造莫名產出的奇異影像。使用這剎那的「錯誤」為工具與媒介，將電腦視窗拖曳出殘像，彷彿作畫般無意識或有意識地暈染出另種空間，或許這錯誤間的美感是此時唯一能把握的快感。

—— 藝術家提供

YU Chung-I

Yu Chung-I holds a master's degree in Electronic Audiovisual Arts from the Graduate Institute of Technological Art, Taipei National University of the Arts. The format of her work mostly falls into live performance, still image and performance recording methods. The core philosophy of her creation mostly comes from her own life experience and from her cognitive, connective and observational senses of her daily life, as well as from her concern for time, space, the environment, and memory. She externalizes her internal cognitive experience, turning these into artistic methods of expression that can be sensed, hoping to make the viewer smile and give them some space to think.

Previously participated in *Pureland—International Performance Art Festival* (2021, Taiwan); *2020 Crossing Border Border Crossing International Intermedia Art Festival* (2020, Hong Kong); *Live Art* of *The Era of Compound Eyes—RANDOMIZE Intl. Unstable Media Art Festival 2019* (2019, Taiwan); *UP-ON International Live Art Festival* (12 Years of Live Archives, 2021; 6th Annual, 2018, Chengdu, Sichuan); ArTrend International Performance Art Festival (2021, 2020, 2017, 2014, 2010, Taiwan); 4th Cologne International Video Art Festival; SCOPE Art Show in Basel, Switzerland. Aside from in Taiwan, her works have been displayed in China, Germany, Iceland, France, India, Venezuela, Sweden, Malaysia, Switzerland, and other countries.

—— Provided by the artist

The Moment of the Crash

A system crash is probably the most undesirable situation that could happen in the age of digital culture. Before the crash, there's the system lag that makes one feel anxious. Aside from facing the unexpected "human emotional" changes that occur in what should be a completely rational computer system, one has to repress their internal anxiety and powerful helplessness. At this time, the only enjoyment, opportunity and desire, perhaps is to wait for a reboot or to take hold of the only command one can execute before the crash, which is to use "errors" to create unpredictable, strange images. Using this "error" as a tool and a medium, pulling the browser out of the wreckage, is akin to extracting a different space consciously or subconsciously as if painting. Perhaps this beauty between errors is the only pleasure that one can have at such a time.

—— Provided by the artist

P.170

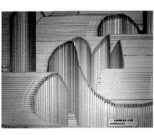
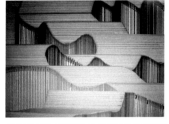

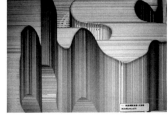
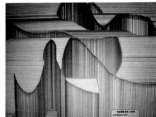

〈當機時刻〉 *The Moment of the Crash*

江思賢

目前從事攝影藝術創作與攝影教學，攝影影像創作至今 32 年。重要專題作品如《三更擺渡》、《流轉》、《唉嘛噢》、《真空妙有》、《Homeless》、《家非家》、《海上星光》、《行於寂靜》、《妙境》、《念念》、《山・非山》等系列。舉辦過 12 次個展，40 餘次聯展。

1996 年開始發表攝影系列作品《三更擺渡》於台北攝影藝廊，2005 年《Homeless》系列作品展於日本東京 Nikon Salon、2008 台灣美術雙年展、2011 年台灣新世代攝影展、2012 年臺北市立美術館「時代之眼——臺灣百年身影」、2012 年高雄市立美術館「出社會 1990 年代之後的台灣批判寫實攝影」展、與 2015 年「南方上岸— 2015 影像典藏展」聯展、臺北國際攝影節、大理國際影會、平遙國際攝影大展、北京國際攝影週、法國巴黎的「夢土」（Rêve la terr）展、「大台北藝術節」等展出。

試圖以作品探索生命的價值、時間與空間之相對應、人們對於安身之處的涵義；衝撞人們對於膚淺表像的理解，以促使觀者對於自身意義、生命與他人關懷的深刻反省。其細膩與富含人文氣息的視覺風格，使得影像多呈現一種沉思的辯證關係。

2011 年國立臺灣美術館典藏《家非家》系列作品、2013 年《家非家》作品高雄市立美術館典藏、2021 年國家攝影文化中心典藏《真空妙有》系列作品。

——藝術家提供

《山》系列

山遠，意窮，境虛，空⋯⋯。

山際即是雲邊，飄忽不定，深藏不露。空性自然，如如輕重！

看見了山水，不是真的青蒼山水；這意境，不是真的韶光山色，在影像的直觀上是虛情假意的，並非本意。

這一切都是假的也是真的，自然 由於潛意識作祟，在醞釀中發酵，反覆萃取而變現，造就了山脈雲嵐。四季融合交錯，天上的雲氣成形，就這麼弄假成真，將色彩抽離成黑白後，再從新上色調色，渾然天成！

心開微光，雲居清澄，山隱於明境一般，離一切相。

——藝術家提供

CHIANG Ssu-Hsien

Currently working in photographic art creation and education, with a career in video creation spanning 32 years.

Important subject works include series such as *Three Times Ferried*, *Cycling*, *Ai-Ma-O*, *Vacuum Existence*, *Homeless*, *A Home is Not a Home*, *Starlight of the sea*, *Lonely Passage*, *Wondrous Plane*, *Thoughts*, *Mountain / Not-Mountain*. Previously held over 12 solo exhibitions and 40-some joint exhibitions.

In 1996, he began to publish his series *Three Times Ferried* at the Taipei Photographic Art Gallery. His *Homeless* series was shown at the Nikon Salon in Tokyo, Japan in 2005; Taiwan Art Biennial in 2008; Taiwan's New Photography Generation in 2011; *Eyes of an Age—100 Years of Taiwan* at Taipei Fine Arts Museum in 2012; *Into Society—Taiwan Contemporary Photography Exhibition* at the Kaohsiung Museum of Fine Arts in 2012; *The South Ashore* Joint Exhibition at the Kaohsiung Museum of Fine Arts; *Taipei International Photography Festival*; *Dali International Festival*; *Pingyao International Photography Exhibition*; *Beijing International Photography Week*; *Rêve La Terre* in Paris, France; *Greater Taipei Arts Festival* and others.

Through his work, he aims to explore the value of life, the correspondence between time and space, the meaning of home, to impact people's understanding of surface-level existence, and to incite deep reflection in the viewer upon the meaning of the self, life, and care for others. His visual style, detailed and full of humanistic sensibilities, allows the image to further demonstrate a relationship of pensive dialectics.

In 2011, the National Taiwan Museum of Fine Arts collected his series *A Home is Not a Home*, the Kaohsiung Museum of Fine Arts following suit in 2013. In 2021, the National Center of Photography and Images collected *Vacuum Existence*.

—— Provided by the artist

Mountain Series

As the mountains grow distant, the intent fades, our surroundings dissolve, nothingness...

The crevasses of the mountains are the edges of clouds, drifting about, heavy with secrets. Their state is emptiness, wherefore are they light and heavy!

To see the mountains and the water, is not to see their fullness; this concept is not the fullness of their grandeur. The truth of the matter is that the image is insincere, never truthful.

All of this is false and it is true. The natural ferments in due process, or perhaps due to the machinations of the subconscious, it is repeatedly distilled and represented, making the mountains, the trails of the clouds. The four seasons meld together and intersect as the clouds in the sky form their shapes. This is how the false is made real. When the color is drained to leave black and white, and the color is reapplied and adjusted, nature's beauty abounds!

Light seeps out from the heart as the clear clouds abide. The mountains hide in plain sight, away from all artifice.

—— Provided by the artist

P.92

〈山 No.05〉 *Mountain No.05*

P.93

〈山 No.10〉 *Mountain No.10*

P.94

〈山 No.16〉 *Mountain No.16*

P.95

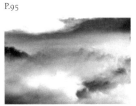

〈山 No.01〉 *Mountain No.01*

P.96

〈山 No.08〉 *Mountain No.08*

《海上星光》系列

日夜陰陽兩極；生命生活兩極；苦樂實虛兩極！

等待與觀望，好像深藏在每個人的心中；期盼未來的美好，好像越來越遙遠，又彷若眼前。於是，選擇了北海岸，開始了——我在都會城市與北海岸之間的夢遊。去尋找，在等候，如孤獨，若發現，彷怡悅、那麼再生而凝靜，無解。

《海上星光》這系列作品，試圖在實景裡抽離元素，演繹出半夢半醒之幻影。藉由海岸搜尋標的與等待時機，或是介入畫面，利用海景天色、雲層風高、夜晚黎明、天際線的漁火，來營造出不同於一般視覺印象的影像。海上景象轉化光影幻境，畫面裏賦予隱藏著「我在」現場；時間動線融入空間，而讓「我」融入大海的浪聲風聲之中。

光，明光，靈光！

我，時時日日在人世間與心識間轉換，分離即融合⋯⋯若有念、若無念。

—— 藝術家提供

Starlight of the Sea Series

The extremes of yin and yang in day and night; in life and love; in sorrow, in joy, in true and false!

Waiting and watching seems embedded in the depths of each heart; we anticipate the goodness of the future as it seems more and more distant, even as it appears right before us. So, I chose the northern coast, beginning my dream walk between the city and the north coast. Searching, waiting, as if alone, rejoicing in discoveries, rebirth, settlement, enigma once again.

This series, *Starlight of the sea*, aims to extricate the elements from the scene, enacting the phantasms between dreaming and consciousness. Through the waiting and searching for a subject on the seashore, or the scenes of involvement, I use the scenes of the sea and sky, where the clouds are thick and the winds are high, at dusk or at dawn, or the lights of the fishing boats, to cultivate an image different from most visual impressions. The scenes on the ocean transform the fantasies of light and shadow; the image holds the hidden gift of "myself" present in the scene. The passage of time flows into the space, allowing "myself" to become one with the sea, the waves and the wind.

Light, the bright light, the light of the spirits!

I shift hourly, daily, between the physical and the spiritual life. Separation is integration... as if present, as if not.

—— Provided by the artist

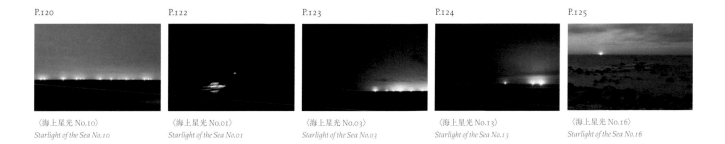

P.120

〈海上星光 No.10〉
Starlight of the Sea No.10

P.122

〈海上星光 No.01〉
Starlight of the Sea No.01

P.123

〈海上星光 No.03〉
Starlight of the Sea No.03

P.124

〈海上星光 No.13〉
Starlight of the Sea No.13

P.125

〈海上星光 No.16〉
Starlight of the Sea No.16

吳美琪

臺南人，2012 年畢業於國立高雄大學傳統工藝與創意設計學系。曾拍攝有關眷村的作品，編製《老時光，好時光：左營眷村影像書》，為將走入歷史的崇實、自助、復興三個新村留下最後身影。現任 NEPO Gallery 的藝術總監，從事策展及編輯設計攝影出版品。曾舉辦個展「XXY–The Space of Things 物事的場所」、「XYX–A Moveable Feast 流動的饗宴」，「YXX –The Flares」並參與多項國際攝影聯展。吳美琪喜愛薩爾瓦多‧達利（Salvador Dali）、馬克‧夏卡爾（Marc Chagall）、雷內‧馬格利特（René Magritte）等超現實主義大師的作品，以及《2001 太空漫遊》、《星際效應》、《全面啟動》、《異星入境》科幻太空電影，透過探討太空重力與時間空間的複雜性的三部曲作品，企圖達到宇宙科幻連結的境界。

—— 藝術家提供

〈YXX-The Flares #4〉

藝術家吳美琪過去幾年持續進行著靜物影像的科學實驗，利用攝影這個媒材去探索不同材質的物件在空間裡的可能性。解構眼前的作品圖像，可以看出黑色背景前，主要有被鋁箔容器包裹的三個橘色物件，散發有如鑽石般璀璨的光芒。空間中經排列的物件，無可避免地有著前後遠近的關係。在數學裡我們習慣將三維空間定義為 XYZ 三個軸向座標，使得畫面中每個物件都能精準轉化為數字座標。這也是吳美琪為藝術作品命名的由來，X 代表著真實物件本身，以及被鏡子反射的鏡像。Y 是介質，代表著光影的變化。在吳美琪所塑造的虛實交錯的空間裡，她專注地記錄著光影移動的軌跡。

—— 藝術銀行

〈YXX-The Flares #10〉

將意外的物件混搭出和諧的空間調性，需要的是一雙孩子般好奇的眼睛。藝術家吳美琪每個系列的作品，展的是她當下對某種材質的偏執，《YXX-The Flares》這個系列最顯眼的就是包含髮夾、塑膠管子在內的低成本塑料，她通常在跳蚤市場或是公益二手店尋找素材。創作時她需要先搭場景，再拼貼複合媒材，進行靜物的拍攝。沿著空間軸線她為平面攝影創造了能無限延展的空間，運用大量光線的折射與反射，以及鏡像的原理，她像造物主般主宰著空間的鋪陳，被扭曲的光線也記錄了時間的可塑性。她以另類的手法印證了愛因斯坦的相對論，空間其實很弔詭，像果凍一樣可能被壓縮與扭曲。

—— 藝術銀行

WU Mei-Chi

Wu Mei-Chi is from Tainan, and graduated from the Department of Traditional Art and Creative Design at National Kaohsiung University. She previously photographed a work about military villages, editing *Old Times, Good Times: A Photobook of Zuoying Military Villages*, leaving a final record for the Chongshih, Tzuchu, and Fuhsing villages imminently facing historical destruction. As the artistic director for NEPO Gallery, she was involved in the curation and design of photo publications. She also previously held the solo exhibitions, *XXY—The Space of Things*, *XYX—A Moveable Feast*, *YXX—The Flares*, as well as participating in many international joint photography exhibitions. Wu loves works by surrealist masters such as Salvador Dali, Marc Chagall, and René Magritte, as well as space fantasies such as *2001: A Space Odyssey*, *Interstellar*, *Inception*, and *Arrival*. Through a trilogy that investigates gravitational pull and the complexities of temporal space, she aims to reach a state of connection to cosmological fantasy.

—— Provided by the artist

YXX-The Flares #4

The artist Wu Mei-Chi has been running scientific experiments on still life images in the past few years, using photography as a medium for exploring the various spatial possibilities of different materials. Deconstructing the image of the work in front of you, you can see that in front of the black background, there are three mainly orange objects wrapped in aluminum foil containers, which glitter with a brilliant, diamond-like light. The objects arranged in the space inevitably have a front-back relationship. In mathematics, we are used to defining three-dimensional space with the three axes X, Y, and Z, so that every object in the picture can be accurately converted into digital coordinates. This also explains the origin of Wu's titles for her artworks. "X" represents the real object itself as well as its mirror image. "Y" is the medium, which represents the changes of light and shadow. In the kinds of space she creates, where reality and fantasy mix, she focuses on recording the movements of light and shadow.

—— Art Bank Taiwan

YXX-The Flares #10

Mixing a bunch of unrelated objects into a harmonious work requires a pair of curious, childlike eyes. Each series of the artist Wu Mei-Chi's works show her obsession with certain materials. In her *YXX—The Flares* series, the most conspicuous thing is cheap plastic articles, such as hairpins and plastic tubes. She often visits flea markets or second-hand charity stores looking for materials. When creating, she needs to set up the scene first, then collage the Mixed media, and photograph the still life. Along an axial line, she created an infinitely stretched-out space before the camera. Using the refraction and reflection of a large amount of light, as well as the principles of mirroring, she controlled how the space spread, and the distorted light rays record the malleability of time. She confirmed Einstein's theory of relativity with an alternate technique: space is full of paradoxes, and may be compressed and distorted like jelly.

—— Art Bank Taiwan

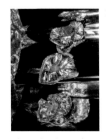

P.140

〈YXX-The Flares #4〉
YXX-The Flares #4

P.141

〈YXX-The Flares #10〉
YXX-The Flares #10

P.142

〈YXX-The Flares #6〉
YXX-The Flares #6

〈YXX-The Flares #6〉

有一次吳美琪搭電梯時發現牆面被黏上吸盤，原來是警衛為了方便簽名，用吸盤來固定原子筆。她快速在腦中分析吸盤加上光影的效果，這就是藝術家吳美琪對素材心動的日常瞬間。從吸盤的通透性與花玻璃的光影，到交錯的長吸管線條所產生的透視感，物件被抽離原本的實用性剩下純粹的形式美感，透過光線的掌控，更進一步把物件的形狀也解構了，物質的型態在各種扭曲與變形下，流露科幻與超現實感。當我們把吳美琪的作品放在黑暗中，只要一點微微的光，會意外的發現，每件作品好像獨自在發光。她採用「熱轉染金屬成像」的技術，最大化色彩的飽和度，讓光影成像更加鮮艷銳利的呈現在觀者眼前。

—— 藝術銀行

YXX-The Flares #6

Once when Wu Mei-Chi was riding an elevator, she found a suction cup stuck on its wall. It turned out that the security guard was using it to hold his ballpoint pen for signing his name during his round. In her mind, Wu quickly analyzed the light effects of the suction cup, and this became the initial impulse that led to her selection of this material. From the transparency of the suction cups and the light-and-shadow effects on the patterned glass, to the perspective produced by the long, staggered lines between the suction cups, the objects are drawn away from their original practical purpose, leaving only the pure beauty of their forms. By controlling the light effects, the shape of the objects are further transformed. When deconstructed, distorted, and deformed in this way, ordinary material objects take on the surreal aspect of something in science fiction. When we place Wu's work in the darkness, only a little light is needed, and unexpectedly we find that every work seems to glow on its own. Wu uses "dye sublimation printing" technology to maximize the color saturation and make the imagery sharper and more vivid.

—— Art Bank Taiwan

呂良遠

1991 年發起台北攝影節並擔任首屆副總幹事。1992 年起至 2003 年間無償提供台北攝影節新人獎獎金。曾任教於中國文化大學、國立臺灣大學、世新大學，並曾任國立臺灣美術館展品審查委員、中華攝影教育學會常務理事、中華攝影藝術交流學會諮詢委員、台灣攝影博物館文化學會常務理事。其所撰攝影收藏系列文章被《中華攝影周刊》連載成集，並收錄於 2007 年北京華辰影像拍賣圖錄。

—— 藝術家提供

LU Liang-Yeavn

Founded Taipei Photography Festival in 1991 as its first Vice Director. From 1992 to 2003, provided out of his own pocket the Taipei Photography Festival Newcomer Scholarship. Previously taught at Chinese Culture University, National Taiwan University, Shih Hsin University, and was the Jury Member for Exhibitions, National Taiwan Museum of Fine Arts; Executive Director, Chinese Photography Education Association; Consultative Committee Member, Chinese Photography Art Exchange Association; Executive Director, Taiwan Association for Photography Museums and Culture. His serial writings on photography collections have been assembled by *Chinese Photography Weekly*, and were published together in the 2007 Beijing Huachen Image Auction Catalogue.

—— Provided by the artist

《磐古》系列

千岩萬壑消耗的殘跡，形成簡約的山水意象，虛無飄渺的詩意動人心弦。此次展出《磐古》系列部分是攝取千岩萬壑的磐石消耗殘跡，運用點、線、面來分割出層次交疊的視覺構圖，其形成簡約的束方山水意象，藉影像姿態引起欣賞者的情趣交感共鳴，寂靜無聲中含蘊著豐沛的生命力，抽象化的自然影像，延伸具有宋畫及宇宙本體的哲學探索，呂良遠刻意連結人與自然的融合，賦予影像豐沛細緻的想像，在創作中把作品影像本質深度藝術化，傳達當代觀點及物我關係的關鍵鏈結，作品一股透力隱約中直逼而來，令人渾然感染了脫離一切現象世界的情緒與美感，詩意般的動人心弦。

—— 藝術家提供

Pan-Gu Series

The traces of mountain ranges, ebbing and flowing to form simple mountains and rivers: their diffuse poetry plucks the heartstrings. The portion of the *Pan-Gu* series that will be exhibited this time, is drawn from the traces of shifting rocks in mountain ranges, using points, lines, faces to draw out an intersecting visual structure. This forms simple Eastern landscapes of mountains and water, inviting the appreciator's resonance of interest, a rich life force nurtured in silence and solitude. The abstracted natural images, extend to a philosophical exploration of Song paintings and cosmological ontology. Lu intentionally connected the integration of humans and the natural, giving the image rich and minute imagination. In his creation, he deepens the artistry of the image of the work itself, conveying contemporary viewpoints and critical linkages of the relation between self and object. The penetrative power of the work reveals itself forcefully, infecting people with feelings and aesthetics that depart from the phenomenal world, tugging at the heartstrings poetically.

—— Provided by the artist

P.134

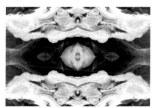

〈磐古 3-01〉 *Pan-Gu 3-01*

P.136

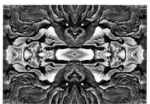

〈磐古 1-05〉 *Pan-Gu 1-05*

P.137

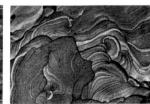

〈磐古 1-15〉 *Pan-Gu 1-15*

P.138

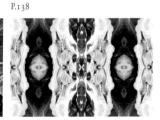

〈磐古 3-02〉 *Pan-Gu 3-02*

阮偉明

廣東省台山縣人，1948 年誕生於廣州市，後定居於臺南市。1970 年畢業於東海大學建築系。1974 年到美國聖路易市華盛頓大學研究，獲得建築碩士學位，並在該校的藝術學院選修以攝影為主題的獨立研究。畢業後在聖路易市職場工作，繼續從事攝影創作。1983 年起，任教於東海大學建築系三十年，以副教授身份退休。2014 年於臺中市與臺北市舉辦「捕捉空間的靈光」攝影個展，並出版同名專輯。2016 年獲得新光三越國際攝影大賽首獎。2017 年起，投入專業藝術攝影活動。曾參加在舊金山、巴黎、阿爾勒、紐約等地舉辦的攝影藝術博覽會。並在京都、東京、維也納、上海、臺北等各大城市舉辦攝影個展。

—— 藝術家提供

《光之幽谷》系列

美國亞歷桑那州，位於鮑威爾湖 (Lake Powell) 區的羚羊峽谷 (Antelope Canyon) 是一條長長的岩洞。正午左右，一線天光照射進來，打到如浪濤凝固的砂岩上，造成令人驚嘆的絢麗景象，我稱之為「光之幽谷」，前後參訪了 3 次。除了紀錄光，我企圖展現畫面抽象的美。我先觀察取景框內線條組成的構圖，然後審視形成的空間，包含二度和三度的。岩石有時候展現為實體，有時候圍閉為虛。雖在洞窟內，我卻想展現無窮延伸的空間性，同時呈現豐富的岩石層次感和質感。光是最終勾勒空間的畫筆，也是統合整個畫面的主宰。我用最大的景深以達到畫面的抽象效果。彩色照片多用高解析度正片拍攝。

—— 藝術家提供

YUAN Wei-Ming

From Taishan, Guangdong Province. Born 1948 in Guangzhou, later settling in Tainan. Graduated in 1970 from Tunghai University's Architecture department. In 1974, studied at Washington University at St. Louis, earning a Master's in Architecture and embarked on independent research in the art school, focusing on photography. After graduation, he worked in St. Louis, continuing his photographic craft. From 1983, he taught for 30 years in the architecture department at Tunghai University, retiring as associate professor. In 2014, he held his solo exhibition *Capturing the Aura of Spaces*, and published an eponymous album. In 2016, he won the first prize in the Shin Kong Mitsukoshi International Photography Competition. From 2017, he devoted himself to professional artistic photography work. He has participated in photographic art expos in San Francisco, Paris, Arles, and New York, and has held solo photographic exhibitions in cities such as Kyoto, Tokyo, Vienna, Shanghai, and Taipei.

—— Provided by the artist

Cave Light Series

Antelope Canyon, situated in Lake Powell, Arizona, is a serpentine cave. At about midday, a ray of light shines in, striking upon the stone as sturdy as the waves, creating a breathtaking and marvelous phenomenon I call "cave light". I visited 3 times in total. Aside from documenting the light, I aim to present the abstract beauty of the image. I first observed the composition formed by lines within the frame, after which I examined the space it formed, both 2D and 3D. At times the stone would present as tangible, at times closing itself off intangibly. Though within the cave, I rather wanted to present a spatiality that extended onward endlessly, the unifying feature of the image. I used the largest possible depth of field so as to attain the abstract quality of the image. The color pictures were mainly taken using high-resolution positive film.

—— Provided by the artist

P.64

〈光之幽谷 A04〉
Cave Light A04

P.65
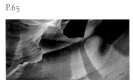
〈光之幽谷 A11〉
Cave Light A11

P.66

〈光之幽谷 A02〉
Cave Light A02

P.67

〈光之幽谷 A07〉
Cave Light A07

P.67

〈光之幽谷 A03〉
Cave Light A03

P.68

〈光之幽谷 A10〉
Cave Light A10

P.70
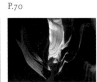
〈光之幽谷 A15〉
Cave Light A15

《夜航》系列

每當我搭飛機在傍晚起飛時，我都會以長時間曝光紀錄外面的光的軌跡。這些光包含跑道上的燈光，建築和設施物的照明，還有遠處都市的夜景。通常我將相機鏡頭緊貼著窗戶，曝光約 20 餘秒。我特別喜歡飛機從跑道上快速奔馳，然後升入天空的這段航程，因為會有一些優美的弧線。飛機在將降落時我也會拍攝。這些攝影的美妙之處是我永遠無法預測結果，而往往令我驚喜連連。這系列是多次旅行拍攝的結果，影像完成後我會做一些畫面裁切，以符合我的美感判斷。

—— 藝術家提供

Night Flight Series

Every time I take a flight that takes off in the evening, I use a long-exposure to document the trails of light outside. This light includes the lighting on the runway, the illumination on buildings and structures, as well as the evening cityscape from afar. Usually I keep the camera lens right up against the window, with a 20-plus-second exposure. I particularly like when the plane moves quickly along the runway, and then lifts off into the air, because there will be some beautiful curves. When the plane lands, I will also take pictures. These wondrous moments in photography are where I can never predict the outcome, and they continually excite me. This series is the result of many travel photography sessions. Once the image is complete I will do some image cropping, to account for my aesthetic judgment.

—— Provided by the artist

李國民

自由攝影師。目前生活居住臺北八里。1992 年開始攝影師生涯。1996 獲「台南美展」攝影入選。1996 年任《雅砌》雜誌空間攝影。1999 年開始於展覽中發表作品，2002 年於「慕尼黑年輕華人藝術家展」中展出。2006 年於臺北寶藏巖駐村。2007 年擔任「第 52 屆威尼斯藝術雙年展」臺灣館藝術家。2014 年出版書籍《與：李國民空間攝影作品集》，田園出版社。2016〈一痴三十年〉作品獲臺北市立美術館永久典藏。2018 參與高雄市立美術館「為無為——謝英俊建築實踐展」。2022 參與上海當代藝術博物館「直行與迂迴——臺灣現代建築的路徑」，亦參與邱文傑建築師事務所「基隆塔」項目攝影。

—— 藝術家提供

〈一痴三十年〉

李國民收集底片片頭成痴，〈一痴三十年〉就是以彩色正片材料製造的效果來回應這一種關係。李國民在底片沖洗後剩下無用的片頭裡看到「美」。有如美國抽象表現主義大師馬克・羅斯科（Mark Rothko）上下分段的抽象構圖，他將底片片頭的美呈現出來。雖說片頭是攝影材料的一小部分，但是透過他攝影英雄式的觀看，卻是看到藝術世界抽象表現的極致之美，一種沒有攝影「在」的存在美。這裡完全沒有鏡頭、對焦、景物，有的是底片過度曝光的邊際領域。片頭是一捲底片被拖出開拍的開場白，它完全無關緊要，有時為了保險還必須多浪費一些片頭。但是因為不同廠牌、型號、漏光情況、藥水等因素，每一次片頭產生的「美」就都會不一樣。太有意思了，但這也必須癡狂三十年才做得到吧！

——章光和

LEE Kuo-Min

Lee Kuo-Min is a freelance photographer currently residing in Bali, Taipei. He began his photographic career in 1992. In 1996, he was selected for the *Tainan Photographic Exhibition*, and selected as the interior photographer for *Arch* magazine. In 1999, he began to present his works at exhibitions. In 2002, he presented his work at the *Young Chinese Artists Exhibition* in Munich, and in 2006, at Treasure Hill Artist Village, Taipei. In 2007 he was selected as an artist for the Taiwan Pavilion at the 52nd *Venice Biennale*. In 2004, he published his book, *AND: Lee Kuo-Min Interior Photography Collection* with Tianyuan Publishing. In 2016, *A Fool for Thirty Year* was collected into the permanent collection of the Taipei Fine Arts Museum. In 2018 he participated in *Acts Without Effort—The Societal Architecture of Hsieh Ying-Chu*n, by the Kaohsiung Fine Arts Museum. In 2022, he participated in *Action and Recovery—A Trace of Modern Architecture in Taiwan* at the Power Station of Art in Shanghai, and the "Keelung Tower" photography project with AxB Architecture Studio.

— – Provided by the artist

A Fool for Thirty Years

Lee Kuo-Min crazily collects film leaders, his *A Fool for Thirty Years* is produced by leaders of color reversal films. In the useless film leaders, he sees incomparable beauty. Reminiscent to American expressionist painter Mark Rothko's abstract compositions of divided upper and lower parts, Lee found the beauty from film leaders. Although the leader is a very small part of a roll of film, the artist sees the unparalleled aesthetics of abstract art through his heroism of vision. It is the beauty of existence without "being" photography, no lens, no focal point, no scene but the horizon made by over exposed films. The leader of a roll of a film is pulled out to kick off the shooting, it matters little, sometime more of the part will be wasted in case the operation goes wrong. But in his creation, different effects of the works unfold because of the leaders from different brands or batches of films, different degrees of light leaks, or different chemicals applied. Such excitement won't happen without thirty years of infatuation.

—— Chang Kuang-Ho

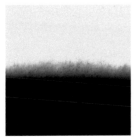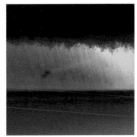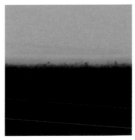

〈一痴三十年〉 *A Fool for Thirty Years*

林厚成

1981 年生於臺北。
持續按著快門渴望捕捉消逝的那一刻，晃眼間，已是斜槓中年，同時身兼影視從業人員、假日藝術家與失聯的家人，去年因緣際會參與了一些成人動作片的拍攝，完成了一項人生清單，但按快門的衝動，不曾停止。

—— 藝術家提供

〈逝者即逝〉

遙想著他方，再一次踏上旅途，遠方總伴隨著神祕、未知及不安，卻也帶給身體一種小小的刺激與興奮，在那裡也許會有種截然不同的面貌被期待著，讓人想到無限組合的可能，存取著收拾不完的快門聲，我心雀躍不已，那股動力持續湧入，朝著內心的深處，來面對人類群體日漸凋零與轉化的惡劣環境。唯有此刻，透過心跳的節奏，傳遞給指尖的快門，閃神一瞥。異鄉，我們素未謀面，短暫的停留只有旁觀者的狀態存在，保持著距離的添附關係，對於周遭急遽變化的現實感到相當的違合感，但又不允許自己轉身逃走，這種盡力保持不遠不近，不斷調整，貼近及拉遠與被攝者的關係，保持透明人的中間性存在，這是一種日日，從未間斷的鍛鍊。不在場的證明，在快門上留下的指紋，鏡子反射到了瞳孔，陌生的雙眼彼此注視，凝視著觀景窗，過程中令人頭皮發麻，無法塗抹的存取遠方記憶。

—— 藝術家提供

LIN Hou-Cheng

Born in Taipei, 1981.
He presses the shutter hoping to capture that fleeting moment. In the blink of an eye, he's a veteran jack-of-all-trades, at once film and television worker, weekend artist and disconnected family member. Last year through happenstance he participated in some adult film work, adding another check to his bucket list. His impulse to press the shutter has never once faded.

—— Provided by the artist

Passed by Past

I embark on a journey while thinking about someplace else. The distant is always accompanied by mystery, the unknown, and uncertainty, but still brings the body a dash of stimulation and excitement. Perhaps a completely different self awaits, making one think of endless possible combinations. I save disheveled shutter sounds as my heart leaps for joy. That impulse continues to wash over me, towards the depths of my heart, to help me face a harsh environment where the human race is daily wilting, changing. Only in this moment, through the rhythm of my heartbeat and the snap it sends to my finger, do I seem to see through it, in that instant. Estranged land, we have never once met. A short stay only allows me to be here as an observer, maintaining the added relationship of distance, the considerable dissonance I feel at the rapid changes to reality happening around me. But I don't allow myself to turn around and flee. I try to maintain a reasonable distance, I'm constantly adjusting, keeping close to, pulling away from the subject, maintaining my invisible, intermediary existence. This is a daily training that has never once been interrupted. My alibi, the fingerprints left on the shutter. The mirror reflects my pupil as the eyes of strangers look at each other, focusing on the viewfinder. The process is scalp-numbing, distant, stored memories that cannot be wiped away.

—— Provided by the artist

P.88-91

〈逝者而逝〉 *Passed by Past*

林添福

林添福早年曾以人像攝影著稱，曾任時尚雜誌《VOGUE》及《ELLE》國際中文版、《People》國際中文版攝影師，時尚人像作品也曾獲邀至臺北市立美術館展出。1987 年前往中國拍攝專題，30 年來一直以少數民族及地區為拍攝主題，是相當了解中國的臺灣攝影人。代表作品包括《獨龍族的冬天》、《馬幫》、《半個世紀的愛》、《彝族阿哲祭龍》。最為人所知的，莫過於耗費二十餘年時間進行創作的《半個世紀的愛》，從中國各民族中尋找結婚超過五十年的夫妻，記載他們的故事。近年他改以手機拍攝，更創立用手機拍攝為主的「一日一圖」的攝影團體。「大部分的人把手機當備用機來用，我是用專業的心態來對待手機攝影」。林添福大力倡導手機攝影的方便性與即時性。

—— 鄧博仁，把攝影當繪畫《煉石》色彩豐富如童話，1 IMAGE ART
—影像，瀏覽日期：2022 年 11 月 9 號，
https://www.1imageart.com/post/mom02020042301

LIN Tian-Fu

Lin Tian-Fu made his name early on in portraiture, having previously worked as the photographer for the Chinese editions of fashion magazines *Vogue and Elle* as well as *People* magazine. His fashion portraiture has previously been invited for display in North America. In 1987, he travelled to China for a photography project, and for the past 30 years has centered on ethnic minorities and areas as his subject. This makes him a Taiwanese photographer who understands China rather well. His representative works include *The Winter of the Tvrung vrvng, Caravan, A Half-Century of Love*, and *The Dragon Dance of A-Zhe of the Yi People*. His most well-known work may perhaps be *A Half-Century of Love*, which he spent over two decades creating. He searched for couples among China's various peoples who had been married for over 50 years, recording their stories. Recently, he has switched to smartphone photography, further establishing a photography group that takes "A Picture a Day" using their smartphones. "Most people use their smartphones as a backup device, but I take a professional stance on smartphone photography". Lin is highly involved in advocating for the convenience and instantaneity of smartphone photography.

—— Teng Po-Jen, "Taking Photography as Illustration, The Colors of *Alchemy* are Rich as a Fairy Tale", 1 IMAGE ART, browsed on Nov. 9, 2022, https://www.1imageart.com/post/mom02020042301

《煉石》系列

臺灣作為一個島嶼四面環海，海岸景觀自然極其豐富多樣，而且東西南北各海岸每一處都各具特色。

尤其是北海岸，除了地質本身區別於其他海岸，加之長年累月的海蝕、風蝕，在海水與強烈冬北季風的多重作用下，幻化成千奇百怪的神奇景觀，其中最具代表性的便是野柳，野柳也是北海岸景觀最為集中的地方。野柳的景觀中最吸引人的便是奇形怪狀的岩石，一直以來都是觀光客和攝影師趨之若鶩的焦點，在眾人驚嘆於野柳岩石的千姿百態時，我卻被另一個特殊景觀所吸引，那便是野柳的海岸紋理！相信任何藝術家都難以創造這般瑰麗與變化莫測的紋理來，簡直就像上帝的魔術手一般，令人嘆為觀止！

為了最完美的詮釋北海岸的景觀特色，我曾經嘗試過各種各樣的影像表現手法，但都不盡如人意，偶然一次徘徊於野柳海岸，發現沿岸岩石在極至特寫下，竟能還原肉眼所不及的豐富層次與色彩，尤其是繽紛的色彩，變幻莫測的紋理線條，組合成形象詭異的圖像，飛禽走獸、花鳥蟲魚、亦人亦物無所不像，而這種種，成了我鏡頭下《煉石》作畫的筆觸，我用鏡頭去描摹它們的筆鋒走勢，追隨自然的腳步。

取名為《煉石》，有女媧煉石補天的意涵，把上帝的魔術巨匠的手，用攝影者的眼光再次的發現、挖掘，錘煉點石成金！看似大自然隨意的塑造，經攝影人豐富的想像力與精心錘煉打造，賦於石頭新的令人驚嘆的詮釋。

—— 藝術家提供

Alchemy Series

As an island, Taiwan is surrounded by sea on four sides. Naturally, this makes its ocean views rich and diverse, a special view on every corner, north to south, east to west.

Especially on the northern coast, aside from its terrain, which differs from the other coasts, and the long-term erosion from the sea and winds, under the multiple pressures of the seawater and northeastern winds, it has produced a variety of miraculous views, the stuff of fantasy. In particular, Yehliu stands out as the most representative, the most concentrated spot for views on the northern coast. Among these, the most attractive are its oddly-shaped stones, focal points for tourist and photographer alike. As the masses fawned over the many faces of the Yehliu rocks, I was attracted by another interesting view—the patterning of the Yehliu shore! I believe that any artist would have a hard time creating such a beautiful, unpredictable pattern. Just like the magic hands of God, they drew a sigh from my lips!

In order to most perfectly capture the qualities of the northern coast view, I previously tried many methods of video presentation, but none of them satisfied me. However, once as I wandered the Yehliu shores, I discovered that the shoreline rocks, under an extreme close-up, restored rich texture and color invisible to the naked eye. In particular, the vibrant colors, the unpredictable patterns, formed themselves into images of strange shape — birds and beasts, flowers, insects, and fish, like human and like object. This variety became the brushstrokes of *Alchemy* under my lens. I used the lens to illustrate their lines, following in their natural footsteps.

Naming this piece *Alchemy* refers to Nüwa (goddess in Chinese mythology) forging the stone to patch the sky. I take the magic hands of God, and use the eyes of the photographer to rediscover, dig up, and forge these stones into gold! What seem like casual creations of nature, through the imagination, care, and forging of the photographer, give the stones a new and breathtaking explanation.

—— Provided by the artist

P.128

〈煉石（1）〉 *Alchemy 1*

P.126

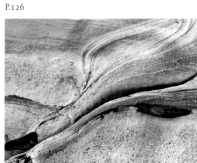

〈煉石（2）〉 *Alchemy 2*

P.129

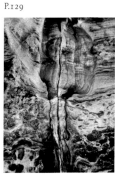

〈煉石（3）〉 *Alchemy 3*

P.130

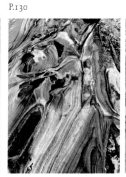

〈煉石（4）〉 *Alchemy 4*

P.131

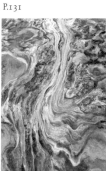

〈煉石（5）〉 *Alchemy 5*

林壽宇

1933 年生於日治台中霧峰林家宮保第。1954 至 1958 年就讀於倫敦綜合工藝學院研究建築與美術。1958 年林壽宇專心以繪畫為業,由倫敦金貝爾 斐斯畫廊經紀。1964 年獲選參展德國第 3 屆卡塞爾文獻展。1967 年與朱德群、莊喆、丁雄泉、趙無極,共同入選美國匹茲堡第 44 屆卡內基國際美術展。1983 年國立故宮博物院通過故宮管理委員會審查,收藏林壽宇畫作〈繪畫浮雕雙聯作〉,成為故宮第一件在世藝術家入藏故宮之作品,亦成為該院的第一件現代藝術藏品。2011 年逝世於台中。

—— 章光和

〈而它來去匆匆〉

林壽宇說:「白色是最平凡的顏色,也是最偉大的顏色;是最無的顏色,也是最有的顏色;是最崇高的顏色,也是最通俗的顏色;是最平靜的顏色,也是最哀傷的顏色。」馬列維奇從未來派(Futurism)追求前衛科技與速度的抽象視覺,建立絕對主義最高精神性的幾何繪畫,而林壽宇似乎略有探討幾何圖形間光影的問題。作品〈而它來去匆匆〉白色畫布上多層次的水平色帶表現出極簡的想法,繪畫可以探討的不再是生活的描述,而是白色條帶之間的空間感與光影的效果。

—— 章光和

Richard LIN

Richard Lin was born in the Wufeng Lin Family Gardens, Taichung, in 1933 during the Japanese colonial era. From 1954 to 1958, he studied architecture and art at Regent Street Polytechnic, London, managed by Gimpel Fils Gallery, London. In 1964, he was invited to participate in the 3rd Documenta, Kassel, Germany. In 1967, he was jointly invited to the 44th Annual Carnegie International Exhibition alongside Chu Te-chun, Chuang Che, Walasse Ting, and Zao Wou-Ki. In 1983, the National Palace Museum collected his work *Modern Painting Relief Diptych* via the decision of the National Palace Museum Management Association, making him the first living artist to have his work collected by the National Palace Museum, and making his work the first work of modern art collected by the museum. He passed away in 2011 in Taichung.

—— Chang Kuang-Ho

And It Came to Pass

Richard Lin says, "White is the most common shade, the great colorlessness with great hue. White is sublime, and white is popular; white is peaceful, and white is sorrowful." From the pursuit of advanced technology and speed in Futurism, Malevich established the highest spirituality in geometric suprematism. Richard Lin seemed to have indirectly addressed the light and shadows in his geometric abstract paintings. The layered horizontal shades on the white canvas of *And It Came to Pass* has a taste of minimalism. Thus painting as an art genre no longer focuses on depicting lives in reality. It could be about the sense of space or the effects of light and shadows.

—— Chang Kuang-Ho

P.100

〈而它來去匆匆〉 *And It Came to Pass*

洪譽豪

1989 年生於臺北，國立臺灣藝術大學新媒體藝術研究所碩士。創作主題專注於新媒體情境中之虛擬與現實表現於地理誌圖像，緣自自身住所的生命經驗，藉長期觀察臺北市萬華區的各種市井映像，在常民空間投注社會認知與群體流動的凝視經驗，進而以空拍攝影錄像、3D 掃描及虛擬實境 VR 製作，使個人在時間上的探知，感受在地社群網絡不同維度的場所感。

展覽經歷包括：國立臺灣美術館「流動的街區」個展、於德國慕尼黑「苦中作樂」個展；參展「2020 臺北白晝之夜」、「穿孔城市」、烏蘭巴托國際媒體藝術節、2018 波蘭波茲南調解雙年展等；榮獲英國流明獎入選、拉古納藝術獎入選、2018 全國美術展新媒體藝術類金牌獎等；作品典藏於文化部藝術銀行、有章藝術博物館。

—— 藝術家提供

《非虛構》系列

若攝影作為紀錄時間的一種可能，攝影測量法則將可能性延伸到了空間上，此形式除了將空間資訊擷取下，亦紀錄著身體在真實維度中的軌跡。《非虛構》彰顯著城市在紀錄與記憶間蓄差的資訊，因建築在街區中不斷更迭，卻也同時不斷在住民的記憶中迭代，於此每次由身體探測空間的初始印象，都會勾勒出曾經的記憶輪廓，並疊加在當下的時間景觀上。《非虛構》以身體視角投射出的數位資訊，記錄著城市中真實與記憶的一種可能性。

—— 藝術家提供

HUNG Yu-Hao

Hung Yu-Hao was born in Taipei in 1989, and graduated from the Graduate Institute of New Media Art, National Taiwan University of Arts. His creative focus centers on the expression of virtual and real in atlas images in new media environments, stemming from his life experiences at his own residence. Through his long-term observation of urban life in Wanhua, Taipei, he invests his experience of observing societal consciousness and group fluidity in plebeian spaces, further moving into drone photography, 3D scanning and VR environment production. This opens one's cognition of time to different dimensions of place in local societal networks.

His exhibition experience includes: *Liquid Streets* solo exhibition in the National Taiwan Museum of Fine Arts; *Joy in Pain* solo exhibition in Munich, Germany. Participating in *2020 Taipei Nuit Blanche*; *Perforated City*; Ulaanbaatar International Media Art Festival; 2018 Meditation Biennale in Poznań, Poland, and others. He has been nominated for The Lumen Prize; the Arte Laguna Prize; the Gold Prize in New Media Art Category of 2018 National Art Exhibition, and others. His work has been collected by the Art Bank Taiwan, as well as the OUR MUSEUM, National Taiwan University of Arts.

—— Provided by the artist

Non-fiction Series

If photography contains the possibility of recording time, photogrammetry perhaps could be applied to space. Aside from accessing spatial information, this also records the path of the body moving in real dimensions. *Non-fiction* emphasizes the discrepancies of the city between record and memory, as structures continually change within cities, while continually being passed down in the memories of residents. In each first impression the body receives of space, the shape of past memories will be drawn out and layered upon the temporal landscapes of contemporary time. *Non-fiction* takes the digital information projected from the perspective of the body, recording the possibilities of reality and memory in the city.

—— Provided by the artist

P.178

P.179

P.180

P.181

P.182

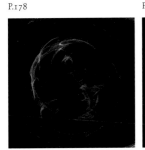
〈非虛構 -00〉 *Non-fiction Trace-00*

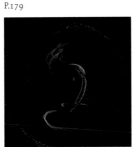
〈非虛構 -01〉 *Non-fiction Trace-01*

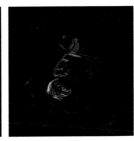
〈非虛構 -02〉 *Non-fiction Trace-02*

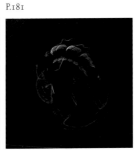
〈非虛構 -03〉 *Non-fiction Trace-03*

〈非虛構 -04〉 *Non-fiction Trace-04*

秦凱

出生於江蘇，11 歲時初次接觸攝影，之後隨著叔叔四處拍攝，開啟與攝影的深厚因緣。秦凱早年任職於上海銀行，同事們欣賞他的攝影作品，而代其投件《良友畫報》攝影比賽；機緣偶合下，受到評審之一的攝影家郎靜山賞識而獲獎。其後，秦凱毅然轉職為《良友畫報》的特約攝影記者，正式踏入攝影之路。秦凱的攝影生涯與新聞產業關係密切，他除了早年擔任國軍第十九軍團少校新聞官，1945 年起擔任中央通訊社攝影記者，更於 1952 年成為哥倫比亞廣播公司（CBS）首位駐臺新聞特派員，數十年的新聞攝影工作，培養出其捕捉關鍵瞬間的拍攝能力。

退休後的秦凱對於攝影的熱情絲毫未減，更積極嘗試不同的攝影風格與題材。秦凱足跡遍及世界三十多個國家，透過相機捕捉異國的人文風土景觀，一生累計拍攝超過十萬張照片。他對於世界充盈豐沛的好奇心與活力，晚年時期攝影友人口中的「攝影老頑童」。

秦凱的攝影題材風格跨度極廣，囊括新聞時事、畫意地景、抽象攝影與人文景觀。記者的身分使他能於許多重要的政治、社會事件中親身「在場」，包含花蓮地震賑災、臺鐵支線通車典禮等，記錄並保存時代變遷。秦凱捕捉事件「決定性瞬間」的新聞攝影技巧，在晚年轉化成他多元風格的攝影創作養分，他以敏銳細膩的影像主題結合饒富趣味的視覺構圖，展現廣袤的自然景致、異國的文化意蘊、寫意的抽象靜物等令人驚豔的攝影創作，呈現其寬闊豐富的創作視界。

—— 國家攝影文化中心

〈城市印象〉、〈歲月痕跡〉、〈出水芙蓉〉與〈聖山〉

秦凱的〈城市印象〉、〈歲月痕跡〉、〈出水芙蓉〉與〈聖山〉也是典型的攝影手法，運用局部放大、裁切超乎一般肉眼習慣性的觀看，在細節裡製造細節，讓我們在重複同樣中迷失方向。以一個具象創作出另一個具象，具象非像。這樣的趣味永遠吸引著觀者與拍攝者的參與。

—— 章光和

Dennis K. CHIN

Born in Jianasu, China. He came across photography for the first time as a child of ten. Then, he followed his uncle Chin Yuan-Hua to take pictures in many places, beginning his lifelong engagement with photography. In his early years, Chin worked in the Shanghai Bank. Amazed by the pictures he had taken, his colleagues encouraged him to sign up for the photography competition of *The Young Companion*. Appreciated by Long Chin-San, a jury member, Chin was awarded with a prize. This induced Chin's firm decision to switch job and work as a photojournalist for *The Young Companion*, marking the start of his career in photography. Chin's career was closely related to journalism. Aside from his military service in the Nineteenth Army as an information officer at the rank of major, he joined the Central News Agency as a photojournalist since 1945. In 1953, he became the first Taiwan-based representative of the Columbia Broadcasting System. Decades of career in photojournalism fostered his expertise in capturing key moments.

After retirement from the advertising business, Chin's passion for photography did not subside; on the contrary, he became keen on trying out different styles and subject matters. Having travelled in over thirty countries in the world, he used his camera to take in scenes of foreign cultures and landscapes. The corpus of pictures accumulated through his lifetime exceeds a hundred thousand. Inspired by his strong curiosity and energy, his friends in the circle of photography dubbed him as the "old gamin of photography" in his late years.

Chin's photography deals with a variety of subject matters, ranging from photojournalism, pictorial landscape, abstract figures to cultural scenes. In the capacity of a photojournalist, he recorded many important political and social events "on the spot", including the disaster relief of Hualien earthquake and the launching ceremony of a branch line of Taiwan Railways. Those pictures possess documentary value to mark the development of history. His photojournalistic aptitude for catching the "decisive moment," as well as his creative viewpoints on images cultivated by his career in advertisement business, fused in his late years to nurture his artistic productivity, allowing him to diversify his style.

Resplendent in details, his subject matter is framed in a visually compelling composition. His unbound and rich vision is embodied in engrossing works that represent vast natural landscape, foreign cultures, poetic still life and so on.

—— National Center of Photography and Images

City Impression, Remains of Time, Surfacing Lotus and *Holy Mountain*

Dennis K. Chin's *City Impression, Remains of Time, Surfacing Lotus* and *Holy Mountain* apply typical photographic techniques, such as partial enlargement or cropping to present images beyond the habitual seeing of naked eyes. They create details in detail, and the audience gets lost in the maze of repeating patterns. A figure is created by another figure, which is no longer figurative. Such maneuvers always intrigue photographers to apply and audience to watch.

—— Chang Kuang-Ho

P.82

P.86

P.84

P.87

〈城市印象〉 *City Impression*

〈出水芙蓉〉 *Surfacing Lotus*

〈歲月遺痕〉 *Remains of Time*

〈聖山〉 *Holy Mountain*

張博傑

1986 年生，2012 年獲實踐大學建築系學士學位，2016 獲國立臺北
藝術大學新媒體藝術系碩士學位，目前生活、工作於臺北。張博傑的
作品多以數位生活工具使用經驗為發想，與參與者共寫敘事日常。在
這樣創作過程中，他探討人與人之間微妙的牽連、不可見的交會、個
人到群體的生命經驗。他善於提及數位生活所控制的身體，如作品
《地圖詩歌》系列描述重度遵守數位導航路線的徒步玩家，冒險於城
市之中，和誤用數位搜尋工具所創造出來的藝術語言，如作品《眾人
詩》，蒐集上百句熱門關鍵字，重組成大眾共同書寫的紙本詩選。

——參考資料：CV，張博傑，瀏覽日期：2022 年 11 月 9 號，
www.pochiehchang.com/cv.html

〈時間顯影〉

藝術家張博傑經常以生活中的科技工具，作為創作的發想，探索人與
人之間，生命的交會經驗。作品〈時間顯影〉，把攝影底片交給遠行
的友人，拍攝來自遠方的影像供他留念，他把收到後的底片埋入土
中，經過一年的時間，再將底片取出，並進行沖洗、顯影，最後顯現
出底片膠捲被黴菌吞食後的影像。黴菌顯影後呈現的樹狀影像，好似
四張連續記錄著黑夜中的樹梢的照片。張博傑封存底片讓時間顯影，
試圖探討人與人之間，不可見卻相互牽連的微妙關係。

——藝術銀行

CHANG Po-Chieh

Born in 1986, and graduated from the Department of Architecture, Shih-Chien
University 2012, MFA in New Media arts, Taipei National University of the Arts
Master's degree,2016, Currently lives and works in Taipei. Chang's works are
inspired by the experience of utilizing digital tools, drafting everyday narratives
with participants. Through this process he explores the subtle, unforeseen
connections between people, from the individual to the community. The body
disciplined by technology is emphasized in his *Map Poetry* series which portrays
a player depending heavily on navigation technology to explore the city.
Miscommunications triggered by search engines form its own artistic language in
Our Poetry which is a collection of trending phrases coming together to construct
poetry of the people.

—— Source: "CV", Po Chieh Chang, browsed on Sep. 9, 2022,
www.pochiehchang.com/cv.html

Contrast Medium of Time

Chang Po-Chieh often uses technological tools in life as a creative idea to explore
the experiences between people. In the work, *Contrast Medium of Time*, the
photographic film is handed over to a traveling friend so the friend can take photos
to be remembered. He buries the film he received from friends and takes it out after
a year, with the final film showing signs of molding. The tree-like image presented
by the mold looks like four record photos of treetops in the dark. Chang seals
the film to let time make its own mark, trying to explore the subtle relationship
between people, one that is intertwined and yet cannot be seen.

—— Art Bank Taiwan

P.168

〈時間顯影〉 *Contrast Medium of Time*

莊明景

臺北人，臺灣大學哲學系畢業。1971 年至紐約從事商業攝影，1990
年返回國。曾舉辦多次個展，1984 年榮獲中山學術獎攝影獎，1986
年《黃山之美》攝影專輯獲金鼎獎，1981 至 1996 年間於臺北美國文
化中心、國立歷史博物館國家畫廊、臺北春之藝廊、原亦藝術空間舉
行攝影個展，其作品於 1992 年獲臺北市立美術館典藏，2004 年獲國
立臺灣美術館典藏。莊明景曾出版《黃山天下奇》（1985）、《天山風
雲》（1995）、《無盡的影像》（1997）、《青藏高原》（2000）、《甲子
風景》（2006）等攝影集，並曾任全國美術展、南瀛美展、郎靜山紀
念攝影獎等多個攝影獎項評審。

——莊明景，《聚焦臺灣——唯美與寫真》
（臺中：國立臺灣美術館，2003），189

《老梅》系列

莊明景《老梅》系列作品利用水灘的反光映向紅潤天色，產生一種東
方水墨情趣。尤其逆向天色，地面的沙石產生水墨畫厚重渲染的黑色
氣質，與大畫家朱德群的抽象畫有異曲同工之妙。應用地形地物天光
雲影，再結合生活文化情感創作出一種視覺認同趣味實屬不易。繪畫
與攝影融為一體在這裡看到明亮的曙光。

——章光和

Mike CHUANG

A native of Taipei, Mike Chuang graduated from the Department of Philosophy,
National Taiwan University. In 1971, Chuang went to New York, where he engaged
in commercial photography, and returned to Taiwan in 1990. Chuang has organized
many solo exhibitions, and won the Sun Yat-Sen Academic Award in Photography
in 1984, and his *Beauty of Huangshan* photo album won the Golden Tripod Award
in 1986. From 1981 to 1996, Chuang held solo exhibitions at the American Cultural
Center in Taipei, National Gallery of National Museum of History, Spring Gallery in
Taipei, and Yuanyi Art Space. His works were collected by Taipei Fine Arts Museum
in 1992, and National Taiwan Museum of Fine Arts in 2004. Chuang has published
photo albums *The Mount of Great Wonder—Huangshan* (1985), *Legends of Jade
Mountain* (1995), *Endless Images* (1997), *Qinghai-Tibet Plateau* (2000), and *Sceneries
of Six Decades* (2006); Chuang has also served as juror of National Arts Exhibition,
Nanying Art Exhibition, and Long Chin-San Memorial Award of Photography.

—— Chuang Ming-Ching (Mike Chuang), *Focus on Taiwan: Idealism vs. Realism*
(Taichung: National Taiwan Museum of Fine Arts, 2003), 189

Lao-Mei Series

Mike Chuang's series work *Lao-Mei* presents a taste of eastern ink painting by
the reflection of pinky sky on the watershore. The reversed light draws black ink
painting on the sand beach, reminiscent of the abstract painting by acclaimed artist
Chu Teh-Chun. Both artists have successfully transformed daylight and shadows
created by changing clouds into landscape that the audience can relate to their
daily activities. Such an extraordinary maneuver gives us some ideas of the perfect
mixture of painting and photography.

—— Chang Kuang-Ho

P.72

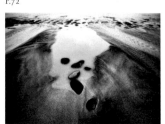

〈老梅〉 *Lao-Mei*

P.73

〈老梅〉 *Lao-Mei*

P.74

〈老梅〉 *Lao-Mei*

P.75

〈老梅〉 *Lao-Mei*

許淵富

出生於臺南，小學四年級初次接觸相片沖洗，就讀臺南師範學校時下定決心鑽攝影。畢業後展開教職生涯，於 1955 年購買了第一臺相機。1958 年參與成立鳳凰寫真俱樂部，1959 年與友人合組無名攝影俱樂部，並自該年起多次獲得攝影比賽獎項。無論黑白照片還是彩色幻燈片，他總能憑藉作品的情感，讓評審眼睛為之一亮。1969 年後，許淵富專心投入推展地方攝影藝術，並於 1972 年成立點點攝影俱樂部，聚集不少攝影同好，對推廣南部攝影風氣極有貢獻。許淵富擅長捕捉市井生活中瞬間的深切情感，或用鏡頭解構物體的造型，利用光影創造虛實抽象的畫面，更常以顛覆常理的視角觀察一般人未曾注意到的角落，創新的實驗精神十足。1993 年，許淵富策劃並參與《攝影家眼中的府城吉蹟》專輯拍攝及編輯出版工作，亦於 2008 年出版的《1860—2006 聚焦府城—臺南市攝影發展史及史料》擔任主編，記錄近半個世紀的臺南攝影發展史。2018 年，臺南國際攝影節以許淵富為第一位展出的焦點攝影家。

—— 參考資料：孫曉彤，《臺灣攝影家：許淵富》
（臺北：國立臺灣博物館，2018）

〈峰〉、〈羞〉、〈祖〉、〈手〉、〈構成〉、〈吹木笛者〉與〈幻想樂〉

許淵富一系列 1960、1970 年代早期作品，其抽象的趣味其實隱藏在底片拍攝製作中，所產生高反差所引起的抽象趣味。傳統黑白攝影講究階調富變化，如此可以真實的複製現實情境，但是如果運用技巧去除中間豐富的階調，加大黑白的反差，視覺上就會抽象許多。因為黑白對比很大、非黑即白，所以產生一種消去雜質去蕪存菁的抽象視覺。黑與白在畫面上成為一種「圖」與「地」的競爭關係，誰是「圖」是主角，誰是「地」是背景，於是我們的視覺在「圖」與「地」，「黑」與「白」，「實」與「虛」之間看見一個抽象的形塑，但是也試圖將抽象的圖形還原為現實的影像。而這個能力在視覺心理學裡就是完形心理學（Gestalt psychology）裡的「圖地反轉」（Figure-ground organization）。一般觀者其實已經習慣可以解讀這般嫻熟手法的創意。但許淵富這一系列作品還是不愧為抽象攝影創作的一個經典。

—— 章光和

HSU Yuan-Fu

Born in Tainan. He developed film for the first time in the fourth grade. He decided to study photography when he was studying in Tainan Normal School. He became a teacher after graduation, and purchased his first camera in 1955. In 1958 he co-founded the Phoenix Photographic Club, and in 1959, he co-founded the Anonymous Photographic Club with his friends. Starting from 1959, He won numerous awards at photography competitions. Regardless of black-and-white photos or color slides, Hsu could always catch the jury's eyes with the emotions of his photographs. After 1969, He focused on promoting photography locally, and founded the Dots Photographic Club in 1972, gathering many fellow photography lovers and making significant contributions to the promotion of photography in southern Taiwan. He specialized in capturing profound instantaneous emotions in daily life, or deconstructing through his lens the forms of objects, and creating abstract pictures through light and shadow; he most frequently observed corners overlooked by people through unconventional perspectives, making his works innovative and highly-experimental. In 1993, he planned and participated in the photographing, editing, and publishing of the photo album *Historic Sites of Tainan in the Eyes of Photographers*, and served as editor-in-chief of *Focus on Tainan 1860-2006—History and Records of the Development of Photography in Tainan*, published in 2008, which chronicled the history of photography in Tainan over nearly half a century. The 2018 Tainan International Foto Festival featured Hsu Yuan-Fu as the first Keynote Photographer.

—— Reference: Sun Xiao-Tong, *Photographers of Taiwan: Hsu Yuan-Fu*
(Taipei: National Taiwan Museum, 2018)

Peaks, Shyness, Nude, Hand, Structure, Clarinet Player and *Fantasy*

Hsu Yuan-Fu's works in the 1960s and 1970s contain abstract elements through the contrasts captured in the films. Conventional black-and-white photography focuses on the delicate changes of grayscale, and once the contrast is accentuated, the visual effects of abstraction are evident. Black-and-white photographs give an atmosphere of visual purity with the composition of the figures at the foreground and the place in the background. Between figure and place, black and white, or solid and void is the formulation of abstraction, and the attempt of restoring reality from abstract images. It is the "Figure-ground organization" in Gestalt psychology whose maneuvers are quite familiar to the audience, and the series work of Hsu Yuan-Fu is undoubtedly classics of abstract photography.

—— Chang Kuang-Ho

P.172

P.173

〈吹木笛者〉 *Clarinet Player*　　　〈幻想樂〉 *Fantasy*

P.76 　　P.78 　　P.79 　　P.80 　　P.81

〈峰〉 *Peaks*　　　〈羞〉 *Shyness*　　　〈祖〉 *Nude*　　　〈手〉 *Hand*　　　〈構成〉 *Structure*

陳彥呈

陳彥呈，臺灣人，喜歡探索時間的性質，並不斷地讓攝影與自身進行撞擊，以產生的火光為樂。自 2016 年成為專職奶爸後，遊走於育兒、烹飪、家事等領域，也進行影像創作與策展。近期開始進行著以新生命為題，討論關於家、關於愛、關於時間的創作計劃。作品曾至國立臺灣美術館，臺北市立美術館、日本、新加坡、紐西蘭、中國等地展出。

—— 藝術家提供

〈泉〉

「CYUAN」是中文裡「fountain」（泉）的念法，「泉」同時也是作者父親的名字，作者以曝曬於日光下的感光材料為底，將顯影劑快速流過感光紙張，將潛藏在紙內的黑逐步的顯現出來，同時也讓定影劑流過紙張，保留住些許紙張的顏色。在顯影與定影短暫的時間內，顯現了液體順流而留下的痕跡，流動象徵著系譜上的傳承分支，同時已顯現的黑色線條見證了生命不可佇足的狀態與家族的繁衍。

—— 藝術家提供

CHEN Yan-Chen

Chen Yan-Cheng, Taiwanese, enjoys exploring the nature of time, continually allowing photography to impact himself, and relishing in the sparks that are generated. Since becoming a full-time caregiver in 2016, he moves between raising his child, cooking, chores, and other fields, also creating video art and curating. Recently, he has begun a creative project discussing family, love, and time, taking new life as its subject. His work has been displayed at the National Taiwan Museum of Fine Arts, Taipei Fine Arts Museum, and in countries such as Japan, Singapore, New Zealand, and China.

—— Provided by the artist

Fountain

"CYUAN" (泉) is the Mandarin word for "fountain", and coincidentally is the name of the artist's father. The artist takes photosensitive material exposed to sunlight as his material, quickly running developer over the photosensitive paper, gradually exposing the black hidden in the paper. At the same time, the fixer is also run over the paper, keeping some of the paper's color. In the short time between developer and fixer, the traces of liquid running over the paper are made apparent. Flow signifies the transmission and branching off of genealogy; at the same time, the black streaks that have become visible attest to the inimitability of life and the proliferation of family.

—— Provided by the artist

P.166

〈泉〉 *Fountain*

陳春祿

1956 年 2 月 20 日生於臺南市。1977 年畢業於世界新聞專科學校公共關係科（現為世新大學），1985 年畢業於日本東京寫真商業攝影科。曾任職於日本堀內專業現像所技術部，並參與創辦台北攝影藝廊，及於文化建設委員會、新聞局金鼎獎、各地文化中心評審與審議。現職為第五階專業沖印公司負責人。曾於臺北市立美術館舉辦多次個展，於日本東京、大阪、福岡與義大利米蘭等地亦有展出。

—— 參考資料：陳春祿，《開天》（臺北：陳春祿，2000）

《開天》系列

陳春祿《開天》系列作品視覺上有如宇宙星雲華麗變幻。取名「開天」應是其效果有如盤古開天一般混沌初開幻化形成宇宙。作品中偶有出現佛像隱約成形於抽象彩色迷濛之間，那是因為作者將拍攝的佛像彩色正片浸泡於藥水之中，不正常的酸鹼侵蝕造就了藥膜面起化學變化，脫落位移，因此正常的成像受到破壞而有如此不尋常的抽象效果。這種巧合相當有趣，攝影本身無從拍攝到這種效果，而在數位時代之前，這種「類比」效果的控制確是成為一種另類的攝影技巧延伸。有志之士奮力開發各種底片塗抹藥水，破壞藥膜的技巧，可以局部控制，局部刮擦效果更是神奇，為的就是要改變顏色造型等因素，創造一種神奇畫面。

—— 章光和

CHEN Chun-Lu

Chen Chun-Lu was born in Tainan on February 20, 1956. In 1977, he graduated from the Department of Public Relations at Shih Hsin School of Journalism (now known as Shih Hsin University), and in 1985 from the Commercial Photography Department in Tokyo College of Photography, Japan. He has previously worked in the technical department at Horiuchi Professional Image Studio, participated in the founding of Taipei Photography Art Gallery, and served as a jury member for the Council for Cultural Affairs (now known as Ministry of Culture), the Golden Tripod Awards, and various cultural centers. He currently is the president of Zone 5 Professional Printing. He has previously held many solo exhibitions at Taipei Fine Arts Museum, as well as displaying his work in places such as Tokyo, Osaka, Fukuoka and Milan.

—— Reference: Chen Chun-Lu, *The Creation* (Taipei: Chen Chun-Lu, 2000)

The Creation Series

Chen Chun-Lu's *The Creation* series presents magnificent views of nebulae, and the title *The Creation* suggests the murky universe before Pan-Gu separated the heaven and the earth. Figures of Buddha vaguely emerge from the abstract images, which are created by soaking the color reversal films in chemicals. The coated sides were eroded by acid or alkali, resulting in peeling or displacement of the coats. The abstraction comes from the unusual process of damage. Photography can't have such effects by taking photos, and before digital techniques, such alternative maneuvers were deemed as the extension of photography. Many interested people tried to invent chemicals that could partially break or scratch the coats to create amazing effects in colors or in styles.

—— Chang Kuang-Ho

P.162

〈開天系列 No.17〉 *The Creation No.17*

P.163

〈開天系列 No.37〉 *The Creation No.37*

P.164

〈開天系列 No.7〉 *The Creation No.7*

章光和

1988 年在紐約大學學習攝影，以澄墨山水東方繪畫技法，融合西方暗房技巧創作《博物館》系列作品。顛覆攝影為真的觀念，挑戰攝影時間性，因為作品一直在變暗（沒有完全定影）。1994 年寫作台灣第一本 Photoshop 電腦影像書《暗房終結者》，創作《植物誌》影像合成，預告暗房的終結。18 年後柯達公司破產，數位影像興起。2004 年創作《數位人體美學》以 3D 繪圖虛擬實境創作影像，揭示著我們生活在一種沒有來源或真相的真實，即是一種超真實（hyperreal）。如今 AR 擴增實境、VR 虛擬實境充斥在我們身邊。2010 年重新創作《植物誌貳》提高影像解析度，增加人工的痕跡，例如指紋、刮傷、髒污、灰塵，以一種繪畫的手法企圖找回攝影初發明時雖然簡陋，但是有一種人性的靈光。2022 年重新創作《植物誌 0.5》為《植物誌》前傳，是一種四方連續的萬花筒圖案。結合裝置藝術效果讓觀眾欣賞時進入夢幻情境。

—— 藝術家提供

《博物館水墨》系列

在暗房裡，相紙曝光之後在相紙上就會有一個潛像（肉眼看不見），潛像碰到顯影液就會顯影成像，之後必須定影才能成形，如果沒有定影在光線下，終將變成一團黑。如果打亂了這些材料與步驟，那就會有很多超乎潛像的影像會產生。章光和 1987 年開始創作《博物館》系列作品，以大型壁畫相紙曝光紐約自然歷史博物館拍攝的標本影像，進行繪畫般的顯影效果。以海綿沾著顯影液在大相紙上刷出影像，如繪畫一般也可以加多一點水份做渲染效果。不想要潛像顯現就先施加定影。每一張作品都是獨版，因為每一次在漆黑的暗房如繪畫般的不確定施作，作品都會不同，但是很多作品都是同一張底片做不同的洗相而成。當時留存了一捲 40 英吋乘 30 英尺的捲筒壁畫相紙，2020 年想進入一個了結的時間點，好奇相紙不知有無過期，這就是《博物館水墨》系列的由來。老靈魂、老相紙、老底片、老手法。暗房進行中，一切的期待都因時間而改變，30 年的老相紙無法感應投影機照射過來的底片內容，潛像若有似無，博物館裡櫥櫃的遠古生物隱匿無蹤，隱約意識到的是時間的歷史痕跡，自己對於這 30 年來叛逆洗相手法的回憶。而就在這一刻心想何不讓藥水與相紙回歸自我，展現材料物本質的原始趣味。在盡情的揮灑顯影液當中，依然看到藥水、相紙、中途曝光之間妙趣橫生的一面。其實原本《博物館》系列作品裡面所大量應用的藥水塗抹、洗刷、渲染的筆觸，就是在對美國抽象表現主義繪畫致敬。這裡更是拿掉了影像而純粹的留下抽象表現的想法。

—— 藝術家提供

CHANG Kuang-Ho

Chang Kuang-Ho studied photography at New York University in 1988. He brings Western darkroom techniques together with traditional Eastern ink painting techniques for the *Museum* series. Overturning the concept of photography as reality, he challenges the temporality of photography, because the work is continually darkening (not completely fixed). In 1994, he wrote Taiwan's first Photoshop digital image book *Darkroom Terminator*, creating the image composite *Botany*, signaling the termination of the darkroom. 18 years later, Kodak declared bankruptcy, and digital images came to prominence. In 2004, he created *Digital Aesthetics of the Body*, creating virtual environments using 3D illustration, revealing our existence in a reality without source or truth, a "hyperreal". At present, augmented reality and virtual reality saturate our lives. In 2010, he re-created *Botany 2.0*, raising the image resolution and increasing artificial augmentation, such as fingerprints, scratches, blemishes, and dust, using an illustrative method to return to the bare, but humanistic aura that existed at the dawn of photography. In 2022, he re-created *Botany 0.5* as a prelude to *Botany*. It is a kaleidoscopic image that continues on four sides. Employing effects from installation art, viewers can enter into a dreamlike environment.

—— Provided by the artist

Museum Ink Series

Chang Kuang-Ho began his *Museum* series in 1987, using wall mural-sized photo papers to expose images taken of the specimens from the American Museum of Natural History in New York. The imaging effects were similar to that of painting by spreading the developer over the photo papers with sponges. With more water, the sponges could be applied for the effects of ink wash. The author didn't fix the images when the latent images emerged. Each work was a solo version because of the uncertainty of making them in the darkroom. Several different works were created by different ways of developing the same film. In 2020, the artist wished to make a conclusion with a leftover roll of 40×30 feet photo paper; whether it was still good to use or not was not clear. Thus the *Museum Ink* series was born from an old soul, with expired photo papers and films, and old techniques. In the darkroom, what had been expected was changed in time, for the thirty-year old photo papers did not fully respond to the projection. The latent images appeared indistinctly, and the ancient creatures from the cabinets in the museum did not show at all. Vaguely, the artist became aware of the historical traces in time, and recalled his thirty years of experience of developing films with alternative methods. At this moment, Chang Kuang-Ho thought, why not let the photo paper and chemicals play the roles they used to be and represent their original nature. There was a lot of fun discovered in the photo papers during the process of exposure through the artist's free application of the developer. In fact, the inking, brushing, and washing in the *Museum* series is the artist's homage to American abstract expressionism by radically extracting images from the planes and leaving the expressing style alone.

—— Provided by the artist

P.184　　　P.184　　　P.185

P.186

《博物館水墨二》 *Museum Ink-2*　　《博物館水墨三》 *Museum Ink-3*　　《博物館水墨四》 *Museum Ink-4*　　《博物館水墨一》 *Museum Ink-1*

《植物誌 0.5》系列

章光和 1994 年作品《植物誌一》,就以電腦影像處理方式產生一種四方連續圖案當成《植物誌一》作品的背景。這種對稱又連續的圖樣像花布壁紙一般,具有一種機械重複性,產生一種大量生產且單調庸俗的視覺趣味。它呼應了工業現代化之後電腦時代進一步產製了沒有「靈光」的虛擬視覺。高科技的電腦處理技術如萬花筒一般將影像切碎,然後上下左右對稱拼接出千變萬化的圖樣,他稱之為《植物誌 0.5》系列。其作品的解析度非常高,細節質感清晰可見,我們好奇這是什麼東西的「在」的存在,但是最後我們依然被完形心理學的視覺趣味所吸引。對稱的垂直中軸顯得莊嚴肅穆,而傾斜的對稱軸打破了機械的重複性而活潑起來。每一作品的個別細節也都因為對稱性而產生相似性的物件,而它們的造型顏色大小相似又產生另一愉悅的解讀。另外《植物誌 0.5》系列也有裝置作品。以鏡面將四方連續的影像做上下左右的無限延伸,反射影像的反射而形成一種無底無極限的視覺重複。觀者可以進入此裝置作品中,在此鏡射影像的鏡射空間裡一切的數學運算答案都是無限的,它超越了我們的身體感知,而有一種迷幻的效果。

—— 藝術家提供

Botany 0.5 Series

Chang Kuang Ho's *Botany* in 1994 has rows of square images generated by computer as its background. The wallpaper of continuous and symmetric flowery patterns has a taste of monotone and mediocrity from the mechanic repetition. It is about the auraless virtual images in the modern industrial and digital era. Advanced computer programs process images into kaleidoscopic patterns through left-right and up-down symmetric collages. The work the artist calls *Botany 0.5* demonstrates clear details from very high resolution images. It inspires our curiosity about what is "being" there and we never get away from the fun discovered by Gestalt Psychology. The vertical axis in the middle brings out a solemn air, and the slanting axes liven it up by breaking up the mechanic repetition. The details of each work look similar because of their symmetry, and different forms, sizes and colors stimulate different pleasure in seeing them. *Botany 0.5* has an installation, the images are extended vertically and horizontally by mirrors at left and right, up and down. The infinite repeating visual effects are experienced when we enter the installation. In the space of multiple reflections, all the answers to math are infinity, which is beyond our physical sensation, conveying a mesmerizing effect.

—— Provided by the artist

P.148

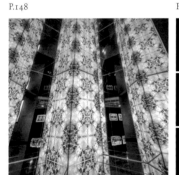

〈莓果〉 *Berry*

P.149

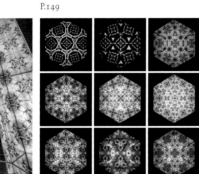

〈小花蛙〉 *Flower Frog*

P.150

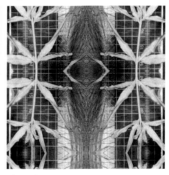

〈鳳尾 1〉 *Pteris fern 1*

P.150

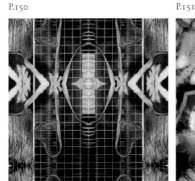

〈鳳尾 3〉 *Pteris fern 3*

P.151

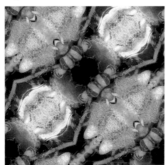

〈穗花〉 *Spike flower*

P.152

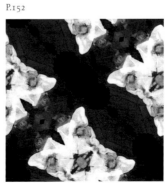

〈墨色澤瀉 2〉 *Inky Alisma 2*

P.153

〈項鍊眼〉 *Necklace*

蔡昌吉

生於雲林縣北港鎮，西班牙 Salamanca 大學藝術系藝術創作碩士，任教嶺東科技大學逾 30 年。獲得全國各大攝影獎項無數，包括新光三越國際攝影大賽首獎、EPSON 臺灣尊榮賞準優勝獎及評審獎、南瀛獎雙年展攝影類優選獎、全國美術展攝影類、高雄獎攝影類、TIVAC 攝影獎等獎項。

早期從事美術印刷業及視覺平面設計工作的蔡昌吉，於事業穩定之際受藝術家梵谷啟發，毅然遠赴西班牙學習西方當代藝術，並將過去積累的美術經驗轉化為攝影創作。個展有「邊陲的孤寂」、「攝影講像」、「情景 Situation」、「再現 象」、「存在 邊緣」、「都 視 景 悟」、「路徑入鏡」、「迴盪於生活中的潛層歡樂——2010 蔡昌吉數位影像藝術探索展」。

——章光和

〈牆〉

蔡昌吉的攝影作品〈牆〉，以黑白攝影，捕捉建築空間的局部立面，創作出如極簡抽象畫般的影像。影像中，建築牆面上的任何凹凸立面，皆成為其畫面的構成元素。齊整排列、深淺交錯的磁磚、以及有著龜裂痕跡的牆面，形同色塊與筆觸，讓影像自然地有如一幅畫作。光影折射所形成的陰影，增加了反差，亦讓畫面增添了富律動性的視覺感受。蔡昌吉透過對建築空間的觀察，以攝影視角，捕捉出建築空間的不同表情。

——藝術銀行

TSAI Chang-Chi

Tsai Chang-Chi was born in Beigang Township, Yunlin County, receiving his master's in Art Creation from the Department of Fine Arts, University of Salamanca, Spain, and having taught at Lingtung University of Technology for over 30 years. He has received numerous national photography accolades, including the first prize at Shin Kong Mitsukoshi International Photography Competition, EPSON Color Imaging Contest runner-up and Jury Prize, Nanying Biennial Award Photography Category, National Art Awards Photography Category, Kaohsiung Prize Photography Category, TIVAC Photography Prize, and other awards.

Early on, he worked in art printing and visual graphic design, and left his stable career to embark on study of Western contemporary art in Spain after being inspired by Van Gogh, thus transforming his cumulative art experience into photography creation. His solo exhibitions include *The Solitude of the Periphery; Photography. Talking Images; Situation, Representation. Phenomenon; Existence / Margin; City. Vision. Scape. Realization; Route. Subject; Deepest Pleasures of Life—2010 Tsai Chang-Chi Digital Image Art Exploration Exhibition*.

—— Chang Kuang-Ho

The Wall

Tsai Chang-Chi uses different photographic angles to observe and capture different expressions of architectural spaces. *The Wall* is a series of black and white photographs of local surfaces and planes in an architectural space that were assembled to create a minimalist and abstract image. The photographs show that any uneven surfaces on the wall could become a component of an artwork. Well-arranged and crisscrossed tiles as well as cracked walls form textures that resemble color patches and brushstrokes, allowing the photographs to appear more like paintings. Light, shadow, and reflection heighten the contrast, adding rhythmic visuals to the entire work.

—— Art Bank Taiwan

P.118

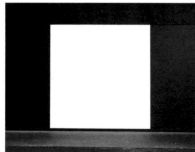

〈牆〉 *The Wall*

鄧博仁

熱衷於時尚、紀實、編導、觀念攝影，並擅長用影像拼貼說故事，創作議題關心人與城市及所生長的環境。目前從事媒體工作、攝影教學，及持續不斷的攝影藝術創作。

著有《再見，狐狸──鄧博仁影像小說》、《時間·酵母》和《遺失·時間》等書。《遺失·時間》系列作品獲得徐肖冰杯攝影大展最高榮譽「典藏作品」（首獎）之殊榮。其各系列作品獲藝術銀行、臺北市立美術館等機構典藏，並獲《中國攝影》雜誌（2016 年 6 月份）介紹為 10 位臺灣當代攝影家之一。近年專研攝影專書編輯，參與主編有《私風景》（郭英聲，2021）、《淬鍊·省思──康台生敘事影像》（康台生，2022）、《攝影訪談輯 3、4、5》（2020—2022）。

── 藝術家提供

《輕呼吸》系列

「我們看見自己想要尋找的，看見自己經由習慣或慣例的訓練所看到的……。」

── 喬治·尼爾遜

身處忙碌的 E 世代生活
唯一不會改變的就是改變
在刺激視覺的資訊充斥之下
什麼是你該尋找的

我試圖在都市叢林中
尋找喘息的空間
記錄細微的情感
記錄片刻的感動
實務與光影的交錯
堆疊深刻與靜謐成無可取代的呼吸空間

── 藝術家提供

TENG Po-Jen

Passionate about fashion, documentary, directing, conceptual photography, and skilled at video collage storytelling. His creation issues pertain to people, the city, and the environment of their upbringing. Currently works in media, photography education, and continued photography art creation.

Author of books such as *Goodbye, Fox — Teng Po-Jen Video Novel*, *A Twist of Time* and *Le Temps Perdu*. The work *Le Temps Perdu* series received the highest honor "Archival Work" (Grand Prize) at the *Xu Xiaobing Cup Photography Exhibition*. His various series have been archived by the Art Bank Taiwan as well as the Taipei Fine Arts Museum. He has also been introduced in *China Photography Magazine* (June, 2016) as one of 10 Taiwanese contemporary photographers. In recent years, he is focusing on photography book editing. He has served as chief editor for *My Own Landscape* (Kuo Ying-sheng, 2021), *Distilled. Reflection—Narrative Video of Kang Tai-sheng* (Kang Tai-sheng, 2022), *Interview Transcripts 3, 4, 5* (2020-2022).

── Provided by the artist

Quiet Breathing Series

"We see what we seek, we see what we are used to seeing or are trained to see...."

—George Nielsen

Living in the busy E-generation
The only constant is change
As visually stimulating information runs rampant
What is it you should be looking for

I try in the urban jungle
To find the space to breathe
To record minute emotions
To record a momentary feeling
The intersection of work, light and shadow
Compiles deep silence into an irreplaceable breathing space

── Provided by the artist

P.112

〈輕呼吸〉 *Quiet Breathing*

P.113

〈輕呼吸〉 *Quiet Breathing*

P.114

〈輕呼吸〉 *Quiet Breathing*

P.115

〈輕呼吸〉 *Quiet Breathing*

賴珮瑜

1976 年生於臺灣臺北，2018 年畢業於國立臺南藝術大學藝術創作理
論研究所博士班，2007 年畢業於臺南藝術大學造形藝術研究所，曾
於臺灣、日本及美國駐村，作品曾多次在臺灣、日本、德國、法國及
美國紐約等地展出。作品獲國立臺灣美術館、高雄市立美術館、澳洲
白兔美術館及日本橫濱 BankArt 1929 典藏。

—— 藝術家提供

《城市》系列

符號與其再現的意義一直以來都是賴珮瑜所關注的主題，其中最為人
熟知的便是《城市》系列作品。一幅幅乍看之下是城市風景的圖像，
在細看之後才發現是由大小不一的圓點符號所構成，而這些圓點像是
被極簡化的燈光，因此在觀看的同時，觀者必須對應符號與記憶中的
景像以拼湊完整的城市面貌，並在對應的過程中進而思考符徵與符旨
的關係。不同的城市景觀在藝術家再現過後，卻顯得單一相似，以此
試圖探討現今全球化下的同質性議題。

—— 藝術家提供

LAI Pei-Yu

Born in 1976 in Taipei, Taiwan, graduating in 2018 from the doctoral program
in Theory of Art Creation, Tainan National University of the Arts. In 2007, she
graduated from Tainan University of the Arts' Graduate Institute of Plastic Arts.
She has previously held residencies in Taiwan, Japan, and the United States, and
her works have been displayed in Taiwan, Japan, Germany, France, and in New
York. Her works have been collected by the National Taiwan Museum of Fine Arts,
Kaohsiung Museum of Fine Arts, White Rabbit Gallery in Australia, and BankArt
1929 in Yokohama, Japan.

—— Provided by the artist

City Series

Symbols and the meaning of their representation has always been one of Lai Pei-
Yu's issues of concern. Among these, the most well-known is the *City* series. One
by one, they seem to be images of cityscapes. Only upon closer inspection does one
realize they are made up of circles and symbols of differing size, and these circles
resemble highly simplified lights. Because of this, in the viewing experience, the
viewer must correspond these symbols with the image in their mind to construct
a complete cityscape, and in the process, consider the relationship between
signified and signifier. Different cityscapes, after being represented by artists, seem
highly similar. This work attempts to explore the issue of uniformity in the age of
globalization.

—— Provided by the artist

P.174

〈● City-Taipei Tokyo〉 ● *City-Taipei Tokyo*

P.175

〈● City-Taipei Tokyo〉 ● *City-Taipei Tokyo*

P.176

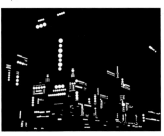

〈● City-Taipei〉 ● *City-Taipei*

P.177

〈● City-Taipei〉 ● *City-Taipei*

鍾順龍

CHUNG Soon-Long

出生於臺灣花蓮，視丘攝影藝術學院畢業、倫敦大學金匠學院 (London University of Goldsmiths College) 影像與傳達碩士。曾在良遠藝術工坊學習影像耐久保存，並於 (2003—2005) 擔任蘋果日報攝影中心攝影記者、董氏基金會攝影志工、國立臺灣藝術大學多媒體動畫藝術學系、視覺傳達設計系兼任講師 (2006—2009)、慈濟大學傳播學系兼任講師 (2011—2016)。作品《目擊現場》獲得「2002 臺北美術獎」優選獎，及《黑暗之光》獲「2003 高雄美術獎」高雄獎。創作以攝影為主，作品關注人類文明發展所帶來的社會變遷，呈現出時代樣貌下的奇觀，也喜於將日常生活的微觀重新建構，探討物質在影像空間狀態下的可能性。2009 年返鄉花蓮生活，作品延伸對農業及土地環境的關注，現職藝術創作外，以農為業並經營品牌「美好花生」。

—— 藝術家提供

Born in Hualien, Taiwan in 1974, Chung graduated from Fotosoft Institute of Photography, and received his master's degree from London University of Goldsmiths College in Image & Communication. Some of his experiences include training in photograph long-term preservation techniques at Liang-Yuan Art Workshop, photo journalist for Apple Daily (2003-2005), volunteer photographer for John Tung Foundation, and lecturer at the National Taiwan University of Arts Department of Multimedia and Animation Arts and Department of Visual Communication Design (2006-2009). Chung's artwork *Seeing Is Believing* received the 2002 Taipei Arts Award Selected, and *From the Dark* received the Kaohsiung Arts Award Selected. Chung is currently a free-lance photographer and a visual artist. His artworks concentrate primarily on the societal changes brought on by developments in civilization, as well as exploring the transformation of objects in image space by reconstructing subtle phenomena in daily life. In 2009, he settled down in his hometown, after which his work begin to incorporate his concerns for agriculture and environment. Aside from photography, he has taken on farming as a career and is currently managing his own brand "Goodeatss".

—— Provided by the artist

《星雨》系列

古人認為盤古開天闢地 (神話)，為宇宙的啟源，然而，現代人透過文明科技來探索宇宙 (科學)。在神話與科學兩者之間所存在的共性，都是在探索著宇宙間存在的未知。 太空中的灰塵形成行星、恆星、星系的基礎物質，透過天文學家的觀測讓人類看見宇宙間遙遠的星體，本系列的影像作品，對於雨滴的描寫，是透過大型相機截取時間與空間所堆疊的片段，閃光燈具瞬間爆發出的光線，凝結著每一顆掉往地面的雨滴，當液體結構經過光線的穿透，反射出空間中類似星光的空間層次，這個空間猶如太空中的類星體 (quasar)。攝影對於微觀世界的結果，擬仿出新的宇宙空間 (變異體) ，超越了人類對於真實世界觀看的想像。

—— 藝術家提供

Stardust Series

The ancient people believed in the mythological story of how the universe was formed through the legendary Pan-Gu's separation of the Heaven and the Earth. However, modern day people, with civilized technology, are discovering the universe through science. The link between mythology and science is the common search for the unknown. The many dusts in the cosmos are the fundamental elements for the formations of planets, stars, and galaxies. Through the observations of astronomers, people are able to see the celestial formations that are far away in the universe. This series of visual works are depictions of raindrops. The images are created through the use of view camera to capture time and space with layering of the various segments. The lights that are momentarily sparked from the flash bulb have frozen each raindrop that is falling to the ground, and when light penetrates liquid, spatial layers that resemble star lights are formed through the reflections, and this space is similar to the quasar in the cosmos. The result from the photography of the microcosm becomes an appropriation of a new cosmic space (a variant), and surpasses any realistic views that mankind may have had about the world.

—— Provided by the artist

P.58　〈星雨 A-11〉 *Stardust A-11*　　P.59　〈星雨 A-43〉 *Stardust A-43*　　P.60　〈星雨 B-15〉 *Stardust B-15*　　P.61　〈星雨 B-19〉 *Stardust B-19*　　P.62　〈星雨 B-20〉 *Stardust B-20*　　P.63　〈星雨 B-23〉 *Stardust B-23*

羅平和

畢業於臺灣師範大學美術研究所西畫創作組。早期創作專注油畫與版畫，1996 年遊學於巴黎的工作室學習當代藝術，並於 1998 年任教於國立臺東大學美術產業學系，至 2011 年以副教授退休。

羅平和自大學時期關注臺灣原住民反核環保等議題，並發表以臺灣原住民為題的系列作品為藝術界關注。

—— 藝術家提供

〈香格里拉蘭花島〉

採用盲胞注音點字法的形式來表達作者對社會各層面向的觀察，諸如，財富、愛情觀、權勢、信仰、貪瞋痴…等等，以單純的色彩和極簡的畫面，內容描述細膩、期待觀者看內文來參與省思其中。

一幅畫表達一篇「文字」，是一種對現象的觀察與生活省思的心得呈現，作者以書寫的解構形式來詮釋理念，是一種單純的釋明過程，當作品已被採用寫成的方式表現，外觀表面看似理性冷靜的表白，內在卻是情感豐富的澎湃洶湧著；讓讀者自己與作品之間的冥想空間加劇，感覺因人的認知有異，富有「觀念藝術」風格的文字形式表現，期待觀者參與的互動，卻又充滿反省嘲諷式的盲胞點字型式，用點字來描繪社會各階層面向的觀察；在點與點之間，時續時斷、高低起伏，是一項「內容」，一個「現實」，一種「冥想」，一次「視覺的挑戰」，是一種「符號」、「痕跡」……，它是解構的，也是抽象的，觀者可以想想或參與或省思。可謂「寫內在之實」又帶「閱讀書寫」方式的現代抽象表現新風格。

「香格里拉」內容如下：

傳說東方有一小島「香格里拉」，她叫「紅頭嶼」、「蘭嶼」……

住著一群安貧樂道的雅美人，北斗天狼星座每年重覆的出現有幾千次，種水芋補抓飛魚，日出而作日落而息，恆古不變的節奏，每天一樣的發生著。有一天，他們說要建造一座罐頭工廠，說日子會有多美好…大家都有新工作，日子一天天過去，海水變黑了，海魚不再來了，留下來的是成千上萬的核能罐頭。爺爺搖著吊床裡沉睡的孩子哼唱著「是雅美人無知？政府盲目？還是人類的貪念？」

傳說中東方的「香格里拉」是否無恙？安在乎？

—— 藝術家提供

P.103

LO Pin-Ho

A graduate of the Western-style Creation stream, Graduate Institute of Visual Art, National Taiwan Normal University. His early work focused on oil painting and woodblock printing. In 1996 he studied contemporary art at a studio in Paris. In 1998, he took up a position in the Department of Art Industries at Taitung University until retirement in 2011 as an Associate Professor.

From his undergraduate days, Lo Pin-Ho has paid attention to issues such as Taiwanese Indigenous anti-nuclear and environmental movements. His series featuring Taiwanese Indigenous subjects have been noticed by the art world.

—— Provided by the artist

Shangri-La's Orchid Island

The work takes Taiwanese Braille as a method to express the artist's observations toward various aspects of society, such as wealth, love, power, faith, the three poisons, etc. Using simple colors and images, the content is described in detail. We anticipate the viewer to come see the content and join in the reflection.

A work of art expresses a piece of "writing"; it is a sort of observation of phenomena, a presentation of thinking about life. The artist deconstructs writing in order to interpret his ideals. It is a simple process of explication. Once the work has been expressed using the writing method, its exterior seems like a rational and calm confession, but its interior is full of raging emotion. This allows the viewer to add themselves into the meditative space of the work. Because the reaction is different according to each person's consciousness, the writing method rich in "conceptual art" style lies in waiting to interact with the viewer. However, the Braille method, which is filled with reflection and irony, uses the dot system to illustrate observations upon various facets and levels of society. Between dots, which continue and break off, which rise and fall, lie "content", "reality", "meditation", "visual challenge", "symbol", "traces"…, it is deconstructive and also abstract. The viewer can consider whether to participate or to reflect. It could be said that "writing the internal truth" uses the modern abstract expressionism of 'reading and writing' to express a new style.

The contents of "Shangri-La" are as follows:

It is said that there is a small island in the east named "Shangri-La". She is called "Redhead Island", "Orchid Island"…

There lives a group of the Yami people content with living. Polaris and Sirius appear thousands of times repeatedly every year. They plant water taro and catch the flying fish, working in the day and resting in the night, a rhythm since time immemorial, occurring every day. One day, they said they were to build a can factory, saying how good their life would be… Everyone had a new job, and as the days passed, the seawater became black, the fish no longer came, and what was left were thousands and thousands of nuclear cans. Grandfather rocks the child sleeping in the hammock as he hums, "Is it the Yami who were oblivious? The government who was blind? Or the people who were greedy?"

The legendary "Shangri-La" of the east, are you healthy? Are you well?

—— Provided by the artist

展覽紀實
Exhibition Scenes

物介質

攝影的物體系隨著科技進化而改變，其體系分類從傳統銀鹽攝影
與數位攝影再細分為黑白與彩色底片，黑白與彩色相紙，再加上
黑白與彩色暗房的相洗技巧與藥水，交叉組合變化多端。進入數
位攝影時代也依然可以因為螢幕呈現、網路傳輸、軟體應用、印
表輸出等而產生各式稀奇古怪的視覺作品。

攝影剛發明時就有實物投影的「光畫」（Photogram）。我們仔
細思考廣義的攝影的原理，會發現影像是靠「成像物」與「成像源」
合作而完成，例如底片或相紙是「成像物」，而實物或光是
「成像源」，它是被表現出來的源頭。一個會感受光線的
「成像物」接受「成像源」的訊號而形成影像。而這個概念已經
將我們這個「物介質」的抽象攝影概念推進到最極致了。

非象具象
Figurative and Non-Figurative

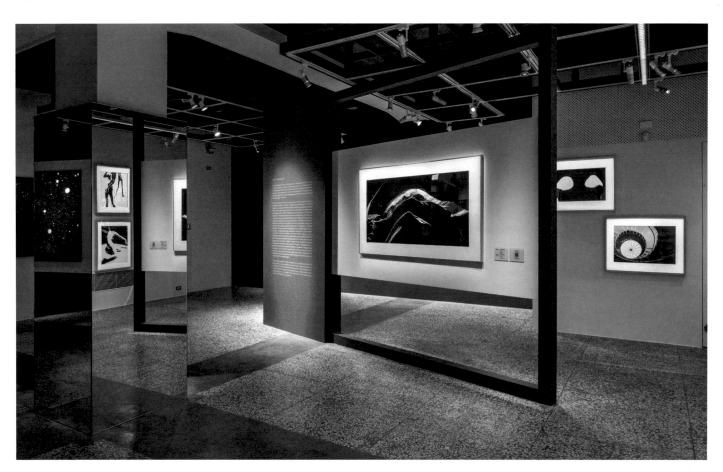

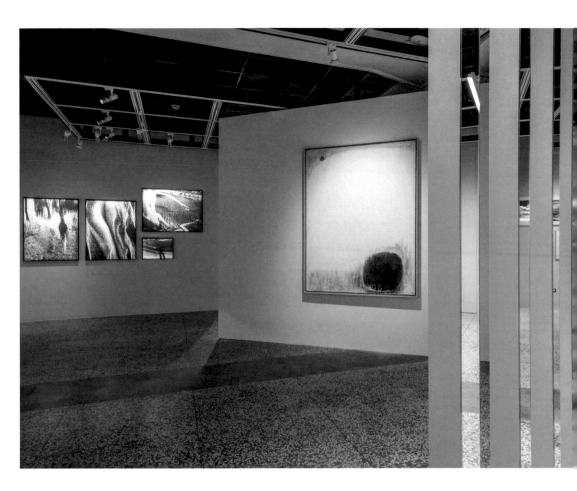

理性與感性
Sense and Sensibility

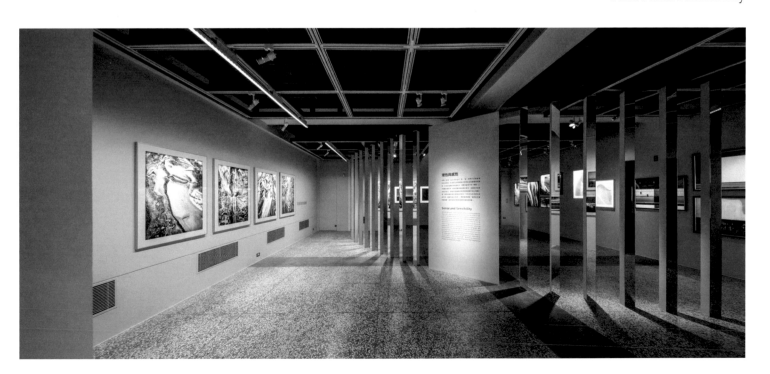

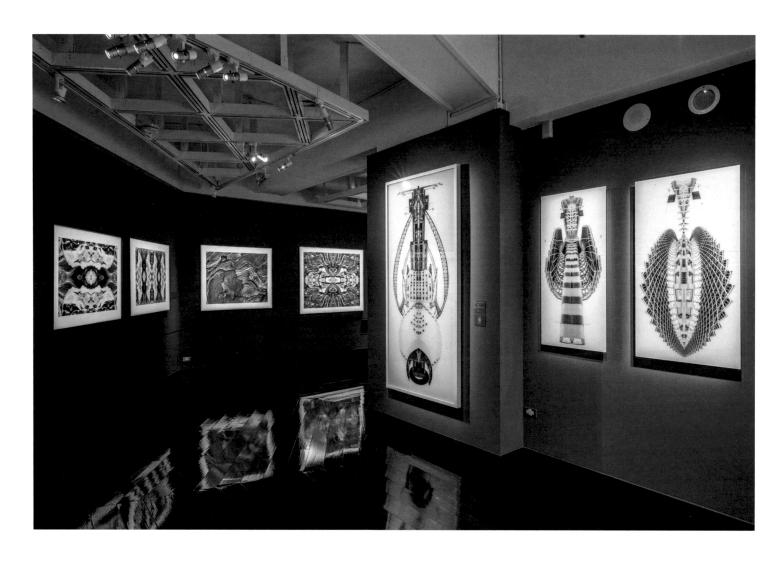

完形
Gestalt

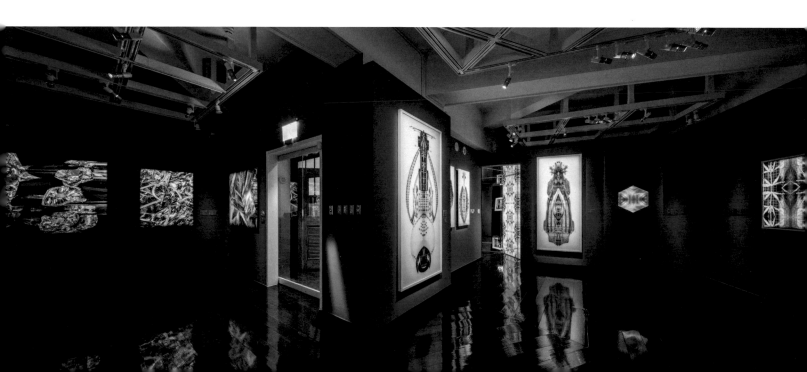

物介質
Material Mediums

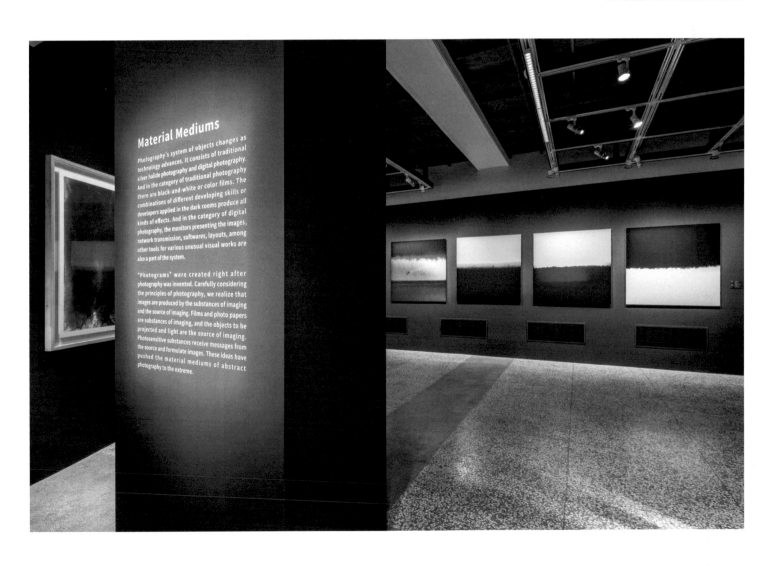

Material Mediums

Photography's system of objects changes as technology advances. It consists of traditional silver halide photography and digital photography. And in the category of traditional photography there are black-and-white or color films. The combinations of different developing skills or developers applied in the dark rooms produce all kinds of effects. And in the category of digital photography, the monitors presenting the images, network transmission, softwares, layouts, among other tools for various unusual visual works are also a part of the system.

"Photograms" were created right after photography was invented. Carefully considering the principles of photography, we realize that images are produced by the substances of imaging and the source of imaging. Films and photo papers are substances of imaging, and the objects to be projected and light are the source of imaging. Photosensitive substances receive messages from the source and formulate images. These ideas have pushed the material mediums of abstract photography to the extreme.

抽象之眼
The Eye of Abstraction

2023.03.18—07.30

展覽

指導單位	文化部
主辦單位	國立臺灣美術館、國家攝影文化中心
總策劃	廖仁義
副總策劃	汪佳政
策展人	章光和
展覽總監	蔡昭儀
展覽執行監督	傅遠政、鄭舒媛
展覽執行	莊晉丞
展場製作	帝威廣告設計有限公司
空間設計	張道銘、凌玉峯
視覺設計	康學恩、林憶如
展場燈光設計	牧暘有限公司
展場攝影	王基守
翻譯	吳介禎、張依諾
網站	ncpi.ntmofa.gov.tw
展覽日期	2023 年 3 月 18 日至 2023 年 7 月 30 日
展覽地點	國家攝影文化中心臺北館
	臺北市中正區忠孝西路一段 70 號

專輯

指導單位	文化部
主辦單位	國立臺灣美術館、國家攝影文化中心
發行人	廖仁義
編輯委員	汪佳政、亢寶琴、蔡昭儀、黃舒屏、賴岳貞、林明賢、尤文君、曾淑錢、吳榮豐、粘惠娟、駱正偉
主編	蔡昭儀
執行編輯	莊晉丞
專文撰稿	章光和、徐婉禎、黃文勇
校對	莊晉丞、林學敏、鄭舒媛
編輯製作	凌玉峯、康學恩
書籍設計	康學恩
翻譯	吳介禎、張依諾
譯文審稿	羅祖兒
出版單位	國立臺灣美術館、國家攝影文化中心
	403414 臺中市西區五權西路一段 2 號
	電話：04-23723552 傳真：04-23721195
	www.ntmofa.gov.tw
製版印刷	四海圖文傳播股份有限公司
出版日期	2023 年 3 月
GPN	1011200260
ISBN	978-986-532-808-5
售價	NTD 950 元

Exhibition

Supervisor	Ministry of Culture
Organizers	National Taiwan Museum of Fine Arts, National Center of Photography and Images
Commissioner	LIAO Jen-I
Vice Commissioner	WANG Chia-Cheng
Cutator	CHANG Kuang-Ho
Exhibition Director	TSAI Chao-Yi
Exhibition Supervisor	FU Yuan-Cheng, CHENG Su-Yuan
Exhibition Coordinator	CHUANG Ching-Cheng
Exhibition Production	De.Wei Advertising Design
Exhibition Design	CHANG Dao-Ming, LING Yu-Feng
Graphic Design	KANG Hsueh-En, LIN Yi-Ju
Lighting Design	L'atelier Muxuan
Photographer	WANG Blake
Translator	C.J. Anderson WU, Elliott Y.N. CHEUNG
Website	ncpi.ntmofa.gov.tw
Exhibiton Date	March 18, 2023-July 30, 2023
Venue	National Center of Photography and Images No.70, Section 1, Zhongxiao W. Road, Zhongzheng Dist., Taipei, Taiwan

Catalogue

Supervisor	Ministry of Culture
Organizers	National Taiwan Museum of Fine Arts, National Center of Photography and Images
Director	LIAO Jen-I
Editorial Commitee	WANG Chia-Cheng, KANG Pao-Chin, TSAI Chao-Yi, Iris Shu-Ping HUANG, LAI Yueh-Chen, LIN Ming-Hsien, YU Wen-Chun, TSENG Shu-Chi, WU Rong-Feng, NIEN Hui-Chun, LUO Zheng-Wei
Chief Editor	TSAI Chao-Yi
Executive Editor	CHUANG Ching-Cheng
Contributors	CHANG Kuang-Ho, HSU Woan-Jen, HUANG Wen-Yung
Proofreaders	CHUANG Ching-Cheng, LIN Hsieh-Min, CHENG Su-Yuan
Production Coordination	LING Yu-Feng, KANG Hsueh-En
Book Design	KANG Hsueh-En
Translator	C.J. Anderson WU, Elliott Y.N. CHEUNG
Translation Editor	Joe Russo
Publisher	National Taiwan Museum of Fine Arts, National Center of Photography and Images No.2, Section 1, Wuquan W. Rd., West Dist., Taichung, Taiwan TEL: 04-23723552 FAX: 04-23721195 www.ntmofa.gov.tw
Print	SUHAI DESIGN AND PRINTING COMPANY
Publishing Date	March 2023
GPN	1011200260
ISBN	978-986-532-808-5
Price	NTD 950

國家圖書館出版品預行編目（CIP）資料

抽象之眼＝ The Eye of Abstraction / 蔡昭儀主編 . --
臺中市：國立臺灣美術館，國家攝影文化中心，2023.03；
224 面；23×27.5 公分
ISBN 978-986-532-808-5 （平裝）

1.CST：藝術展覽

957.9 112003463

脫離視覺符號的依附，擺脫一張照片必須要有可以辨識的
事物，探討抽象的攝影裡所有可能的閱讀觀點，我們找尋
看向鏡中抽象之眼。

Breaking away from its reliance on identifiable visual signs, the
readable perspective that abstract photography carries is the
eye of abstraction we are looking for in the mirror.